NATIONAL GALLERY OF ART
Washington

A World of Art

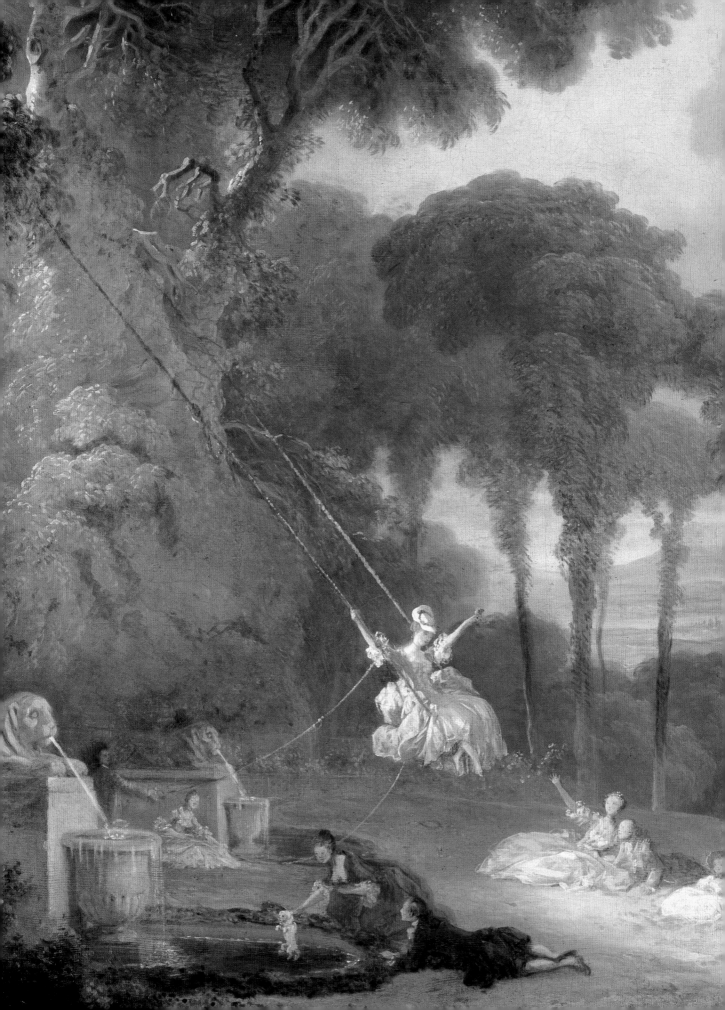

NATIONAL GALLERY OF ART
Washington

A World of Art

MARTHA RICHLER

Scala Books

First published in 1997 by
Scala Books, an imprint of
Philip Wilson Publishers Limited
143–149 Great Portland Street
London W1N 5FB

Distributed in the USA and Canada by
Antique Collectors' Club Limited
Market Street Industrial Park
Wappingers' Falls
NY 12590
USA

Library of Congress 97-061688
ISBN 1-85759-176-3 (hardback edition)
ISBN 1-85759-187-9 (paperback edition)

Title page: *The Swing*. Jean-Honoré Fragonard, French, 1732-1806.
Contents page: *The City Square*. Alberto Giacometti, Swiss, 1901-1966.
Page 6: The East Building photographed by Dennis Brack/Black Star.

Editor: Cherry Lewis
Designed by Gillian Greenwood

Printed and bound by Snoeck, Ducaju & Zoon, NV, Ghent, Belgium

Contents

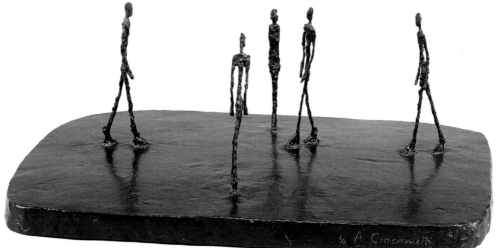

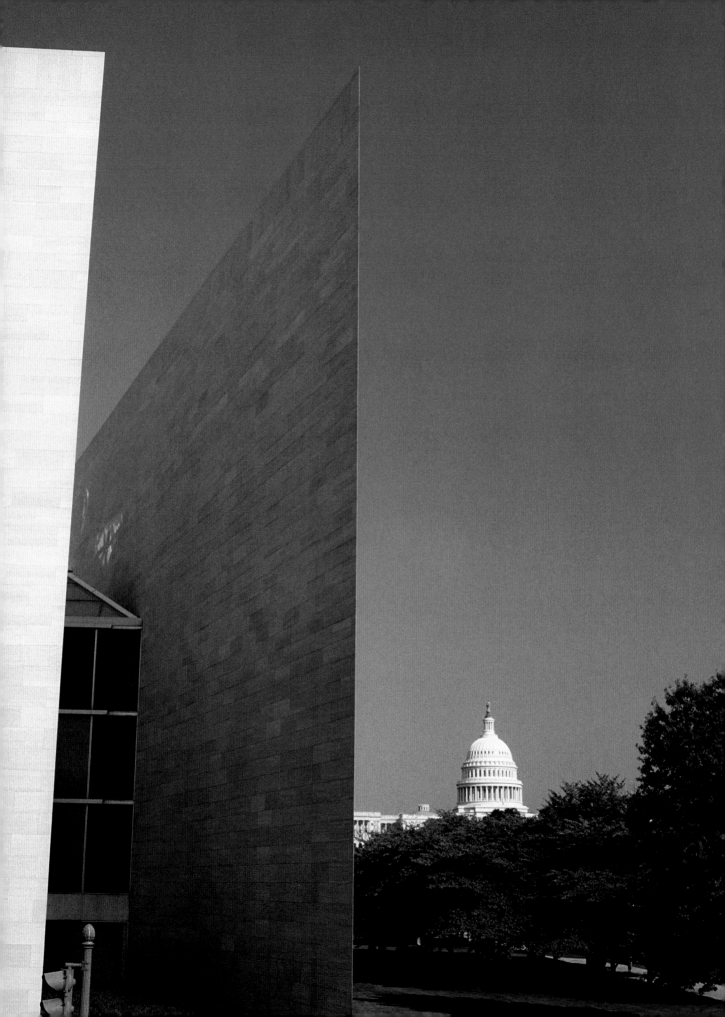

Introduction

When Andrew W Mellon, the Pittsburgh financier and industrialist, first expressed his desire to give to the nation his spectacular collection of works by Raphael, Bellini, Constable, Van Dyck, and Rembrandt, he described in a heartfelt letter to President Roosevelt in December 1936 how he wanted these treasures to become "the property of the people."

Mellon's paintings and sculpture, together with the equally rare and important works of Chester Dale, Joseph E. Widener, Lessing J. Rosenwald, and Samuel H. Kress, were to form the core of the gallery's permanent collection, the subject of this book.

All of the works of art seen today at the gallery have been donated through private funds—committees, foundations, or individuals ranging from philanthropists to the artists themselves. How each work came to the gallery presents a fascinating history in itself: Miró's revolutionary surrealist work, *The Farm* (Chapter nine), once belonged to the writer Ernest Hemingway, who met Miró in Paris in the 1920s. His wife, Mary, gave the painting to the gallery in 1987.

The development of the gallery has always been a passionate enterprise, inspired by American philanthropic and democratic ideals. The original neo-classical gallery, now known as the West Building, was designed by John Russell Pope, who had also designed the Jefferson Memorial and had once proposed a pyramid for the Mall as a memorial to Lincoln. It is a measure of Pope's fierce idealism that in the spring of 1937, despite being diagnosed with cancer, he refused treatment in order to finish his grand designs for the Gallery. He died on 27 August 1937—by extraordinary coincidence, only one day after Andrew Mellon's death. Neither man lived to see America's first national gallery completed.

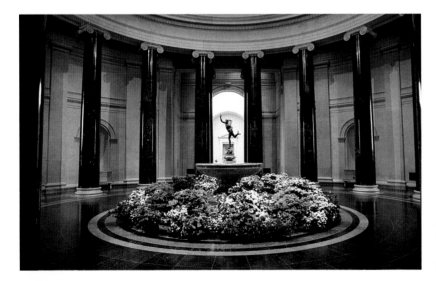

Opposite page: The exterior of the East Building

Left: The West Building Rotunda

In 1941, the National Gallery of Art opened its doors to the public, the graceful figure of Mercury inviting visitors within. Mercury has since witnessed the comings and goings of tens of millions, many of them art devotees, others simply curious to look and learn. By an Act of Congress passed in 1937, admission to the gallery remains free. And such is the range of free information—from the Micro Gallery computer banks to films, lectures and gallery talks—that many regular visitors treat the Gallery as an open university of art.

In the spring of 1978, a new building was opened to house the growing twentieth-century collection and provide new gallery space, offices, and a study center. This project was to be financed again by the Mellon family. True to his father Andrew's memory, Paul Mellon dedicated the East Building to "the use and enjoyment of the people of the United States." His phrase, "A Gift to the Nation", is inscribed in stone near the East Building entrance.

In taking on the design of the new building, the architect I.M. Pei was keenly aware of the need for a modern art museum to embrace its public. "I would like to stress," he said, "that the majority of people who visit the museum are not connoisseurs of art...I would like this museum to make the viewing of art an interesting experience ...and an exciting place to be."

This book, too, is dedicated to that majority, for whom art is an object of endless discovery. It is intended as an introduction to art history, based on examples from the gallery's permanent collection. The works are ordered chronologically and the links between them explained in terms of style, contemporary politics, religion, and everyday life. Together, these selected works form a pathway of stepping stones across nine centuries of art.

Wherever possible, the works chosen not only serve to illustrate the evolution of styles and movements in art history, but also represent those powerful human emotions and universal experiences that transcend time and place. Rembrandt's *Self-Portrait* (Chapter four), for instance, is more than the artist's reflection in the mirror —it is a portrait of wisdom. Jasper Francis Cropsey's *Autumn—On the Hudson River* (Chapter seven) continues to be enjoyed as a monumental American landscape. But viewed in historical context—it was first shown in London in 1862—it also speaks eloquently of a nation's pride in its own natural history. Anselm Kiefer's enormous painting, *Zim Zum* (Chapter eleven), inspires awe in the viewer. When Günter Grass, the writer who also grappled with postwar German history, wrote "The artist brings to paper what makes him speechless," he might have been describing the visceral impact of Kiefer's cataclysmic imagery.

Many writers, poets, artists, and even scientists are quoted in this book, from Shakespeare and Emerson to Freud and Einstein. Their voices will evoke the spirit of the age in which the artist was working, guiding the reader, century by century, through this vast and infinitely varied world of art.

Martha Richler

Opposite page: Detail from *Rio de Janeiro Bay* by American artist Martin Johnson Heade, 1819–1904.

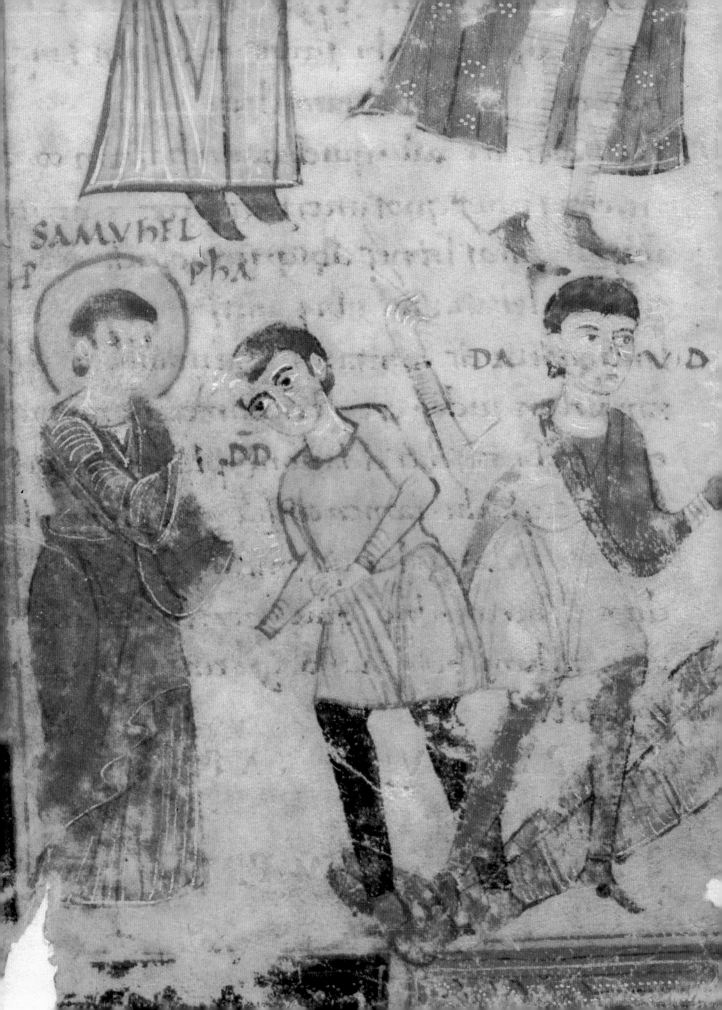

Chapter one
12th-14th centuries

What are ten centuries to eternity?
Less than the blinking of an eye compared to the
turning of the slowest of the spheres.

DANTE (1265–1311)
The Divine Comedy

GOLIATH

INCIP SAMVHEL

ANNA HELCHANA heli

LIB REGVPRIMVS

ANNA HELHA HELI

SAMVHEL DAVVD GOLIATH

The National Gallery of Art includes among its treasures monumental works by Italian Renaissance masters, scintillating landscapes by the French impressionists, and robust "action paintings" by the New York abstract expressionists. But it is with a miniature from a medieval Bible, inscribed and illuminated by anonymous monks in a monastery outside Rome nine hundred years ago, that this historical art tour begins.

This rubbed and tattered page [1], showing scenes from the *First Book of Samuel*, is an example of a page from a fully illustrated Bible of the late eleventh century. Bibles such as this were produced by clerics in an age when art in Europe was virtually inseparable from the Christian faith. The second half of the eleventh century was a period of papal reform. Pope Gregory VII (1073–1085), who had been a prior at the monastery of Cluny, a center of the reform movement, called for a new austerity. Artisans responded by rejecting the rich materials and sensual imagery favored by the secular princes and their courts, from Burgundy to Bavaria, and developed the more austere forms of the Romanesque style, which dominated European art and architecture in the twelfth century.

Romanesque imagery is characterized by the imaginative use of shallow space, a disregard for relative scale, and colorful, clearly outlined forms—all of which are seen here. The human figures appear to float in the same paper-thin plane as the lettering and architecture. In the lower register, David straddles the vanquished figure of Goliath, who is portrayed here as a gigantic medieval knight-in-armor.

By the twelfth century, Bibles illuminated in the Romanesque style often were paid for by contributions from large numbers of people. The priest Gerardus of Pisa filled four volumes with the names of donors, from bakers to fishermen, all of whom contributed to the Calci Bible, begun in the year 1168. Although scribes could also be illuminators, in larger towns in Italy professional artisans offered their services to churches and monasteries producing Bibles, and worked alongside members of the religious community. Some artisans developed specialities, such as the decoration of initials.

2

1 Italian 11th century
Leaf from a Giant Bible:
Four Scenes from the First Book of Samuel
16 3/8 in x 10 3/4 in (41.4 cm x 27.3 cm)
Rosenwald Collection
1950.16.289

2 Detail of [1]

PREVIOUS PAGES
Leaf from a Giant Bible [1, detail]

13

He drank avidly of the one fountain which is the Holy Writ.

WILLIAM OF SAINT THIERRY

Biography of Saint Bernard (1090–1153)

3 Detail of [4]

4 Italian 12th century
Two Bifolios from a Giant Bible: Luke (B)
21 ¼ in x 14 ³⁄₈ in (54 cm x 36.5 cm)
Rosenwald Collection
1964.8.34

3

4

These two pairs of pages—or bifolios—from a Bible made in Tuscany in the late twelfth century, show how elaborate this form of illumination became. In the first example, the letter Q [3] introduces the Gospel of Saint Luke with an image of the evangelist, shown seated at his lectern inside the Q-shape, which serves as a decorative frame for the miniature, or *historia*, as it was called in the Middle Ages. According to legend, Luke painted the Virgin; many painters in Florence from the 1330s consequently joined the Fraternity of St Luke, one of the first guilds of medieval craftsmen. In the second example from the same Bible, an elaborate letter I marks the beginning of the Gospel of Saint Mark [5]. Like Luke, Mark is seen writing at a lectern similar to those used by scribes of the time.

A story told by the monk Ordericus Vitalis indicates that scribes could save their souls with such illuminations. "In a certain monastery," he wrote, "there dwelt a brother who had committed every sin…but he was a scribe, devoted to his work [who] had completed a huge volume of the divine law." After the death of the scribe, "the letters were carefully weighed one by one against his sins" and the monk was spared. This story suggests that it was not only for aesthetic reasons that the decoration of letters played such an important role in bible illumination throughout the twelfth and thirteenth centuries.

5 Italian 12th century
Two Bifolios from a Giant Bible: Mark (A)
21 ¼ in x 14 ⅜ in (54 x .36.5 cm)
Rosenwald Collection
1964.8.35

5

6 Italian 13th century
Leaf from a Choir Book (Gradual):
Nativity with Six Dominican Monks
18 ½ in x 14 ¼ in (46.8 cm x 36 cm)
Rosenwald Collection
1946.21.12

By the late thirteenth century, illuminators were being influenced by Byzantine and Gothic painting, and by the Crusaders' contact with the East. As well as illustrating giant Bibles, scribes and illuminators were providing illuminations for psalters or collections of psalms. In the *Leaf from a Choir Book*, made in Italy around 1275 [6], various scenes relating to the Nativity are linked by an ornamental background with an arabesque pattern—a scrolling plant motif derived from Islamic art and architecture. In a composition characteristic of Gothic art, a peaked shape leads the eye up to the heavenly realm of angels and exotic birds perched in the treetops.

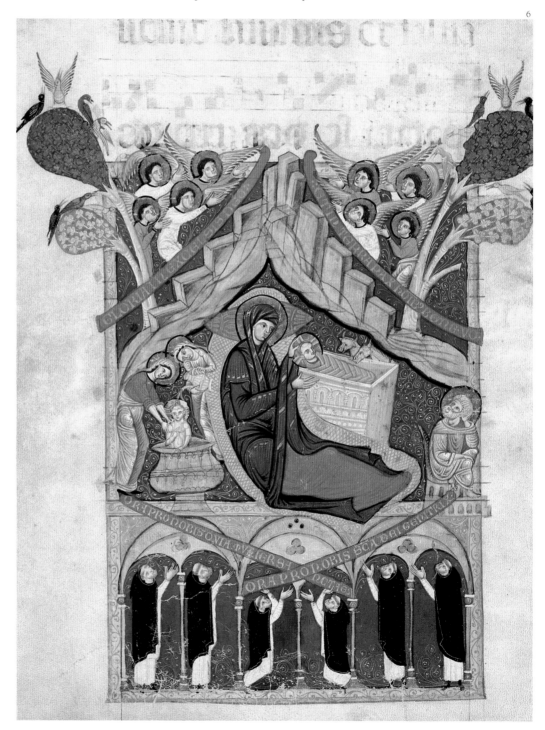

6

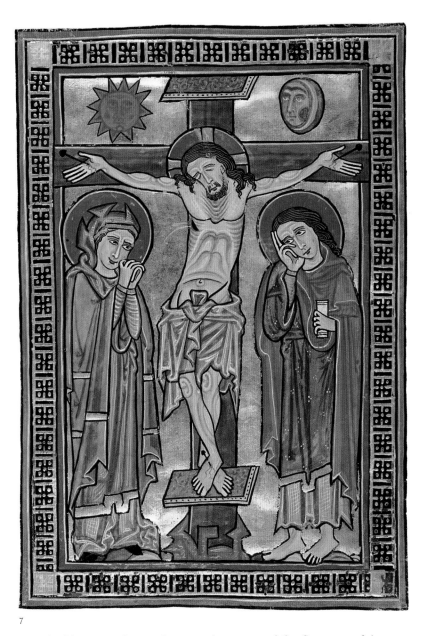

7

A leaf from a psalter made in South Germany [7] reflects one of the many regional variations on Gothic illumination. Known as *Zackenstil*, this highly expressive German style first appeared in the thirteenth century. In his depiction of the Crucifixion, the unknown artist has heightened the sense of anxiety with a mass of knotted and angular drapery folds. The use of sharp, jagged line—from the drapery to the furrowed brows of the two Marys and the emaciated body of Christ—serves to intensify the viewer's empathy.

Medieval art fluctuated between two opposing ideals: the decorative and realistic, and the austere and abstract. The choice of style depended on religious interpretation, as witnessed in the twelfth-century debate between the reformers Abbot Suger of Saint-Denis, monk, author, builder, biographer, and confidant of King Louis VI of France, and Saint Bernard of Clairvaux, the founder of the Cistercian order and one of the most eloquent voices of the Christian Church of the twelfth century.

7 German 13th century
Leaf from a Psalter:
Crucifixion
7 1/4 in x 5 1/16 in (18.4 cm x 12.7 cm)
Rosenwald Collection
1947.7.5.a

8

8 French 12th century
Chalice of the Abbot Suger of Saint-Denis
sardonyx cup (Alexandrian second/first
century B.C.) with heavily gilded silver
mounting, adorned with filigrees set with
stones, pearls, glass insets, and opaque white
glass pearls
height: 7¼ in (18.4 cm)
diameter at top: 4⅞ in (12.4 cm)
diameter at base: 4⅝ in (11.7 cm)
Widener Collection
1942.9.277 (C-1)

9 Byzantine 13th century
Madonna and Child on a Curved Throne
tempera on panel
32⅛ in x 19⅜ in (81.5 cm x 49 cm)
Andrew W. Mellon Collection
1937.1.1

Abbot Suger believed that the spiritual world was best expressed by luxurious holy objects. He presided over the building of the abbey church of Saint-Denis, near Paris, the first Gothic church in Europe. His chalice [8], a sacramental vessel used in the celebration of the Eucharist at the altar, was made from an antique sardonyx cup, dating from the second or first century B.C., which he had set in a gilded silver mount, decorated with filigree, reliefs, pearls, and multi-colored glass insets, resembling the cup's original gemstones. The high altar and great cross of Suger's church were equally lavish. Such gilded surfaces, encrusted with gems, reflected God's divine light, Suger wrote, "transferring that which is material to that which is immaterial."

Saint Bernard, on the other hand, disapproved of such "costly polishings" because they tended to "attract the worshipper's gaze and hinder his attention." He believed in a religious faith unencumbered by precious objects, and in an atmosphere of serenity conducive to reading and meditation. His teachings inspired an austere, Cistercian architecture, epitomized by the abbey of Fontenay, near Poitiers, built while Saint Bernard was abbot.

Fundamentally different beliefs about the function of religious art also were held by the Church of Rome, which decried the worship of images, and the Eastern Church of Constantinople, and the schism widened in the eleventh century. The Byzantine style reflects the orthodoxy of the Eastern Church, and its tradition of venerating images of Christ, the Virgin, and saints since the fifth century. *Madonna and Child on a Curved Throne* [9] is a Byzantine icon, or holy image, dating from the thirteenth century. The gold background and arrested movement of the figures of the Madonna and Child, depicted as linear and flat, evoke an ethereal, rather than a natural world. The Madonna's multi-tiered throne reflects the majesty of the Church of Hagia Sophia that crowned the city of Constantinople (ancient Byzantium, now Istanbul). The throne's curve and tilted aspect create a concave, semi-circular space within the painting, unlike the impenetrable space of traditional Byzantine icons. This illusion of depth suggests Western influence: the work was probably painted by a Byzantine artist living in exile in Italy after the looting of Constantinople by crusaders in 1204. The Virgin's stylized features and mesmeric eyes are elements of the Byzantine style that are still seen today in the mass-produced icons of the modern-day Greek Orthodox Church.

Two late medieval Italian painters were to revolutionize European art, by transforming the more hieratic forms of the Byzantine tradition through the

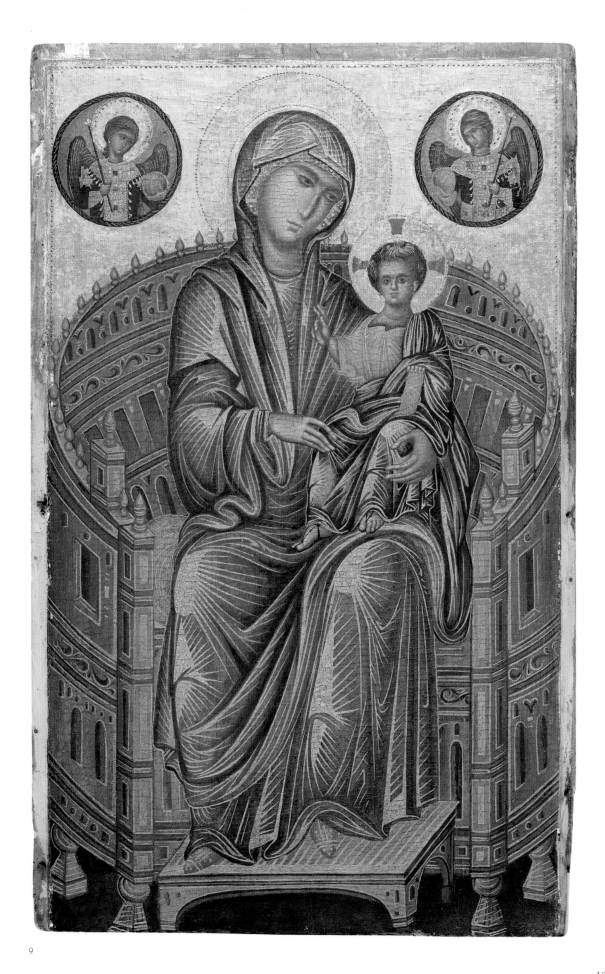

9

addition of space and life. Duccio di Buoninsegna of Siena and Giotto of Florence declared their individuality by *signing* their work, thus beginning a change in the status of the artist from anonymous craftsman in the thirteenth century to internationally famous artist in the sixteenth. Both were to enjoy unprecedented fame by the early fourteenth century. As the poet Dante wrote in his *Divine Comedy*, "Giotto now is all the rage."

In Duccio's *Nativity with the Prophets Isaiah and Ezekiel*, dating from 1308/1311 [10], the scriptures are interpreted with a sense of human drama and entrancing detail. The artist used the traditional medieval device of telling several stories at once, known as simultaneous narrative. The Nativity scene is accompanied by various events that appear to the left and right of the manger, such as the angel with a scroll who would later announce the birth of Christ to the shepherds and their attentive flock. Duccio's animals convey a sense of wonder and tenderness at the birth of Christ. The ox and ass rest their muzzles on the edge of the makeshift crib, gazing adoringly at the Christ Child and warming the newborn with their breath.

This panel was originally part of Duccio's most ambitious altarpiece, the Maestà, or "Virgin in Majesty," one of the largest paintings of medieval art. Composed of more than ninety panels, it towered some seventeen feet over the high altar of the Siena Cathedral. This work, which was paraded in triumph through the streets of Siena on completion, was famously signed with Duccio's name, and a plea for salvation (and possibly fame): "Holy Mother of God, be the cause of peace for Siena and life for Duccio because he painted you thus."

10 Duccio di Buoninsegna
Italian, *c*.1255-1318
Nativity with the Prophets Isaiah and Ezekiel
1308/1311
tempera on panel
middle panel: 17 1/4 in x 17 1/2 in
(43.8 cm x 44.4 cm);
side panels each: 17 1/4 in x 6 1/2 in
(43.8 cm x 16.5 cm)
Andrew W. Mellon Collection
1937.1.8.a-c

10

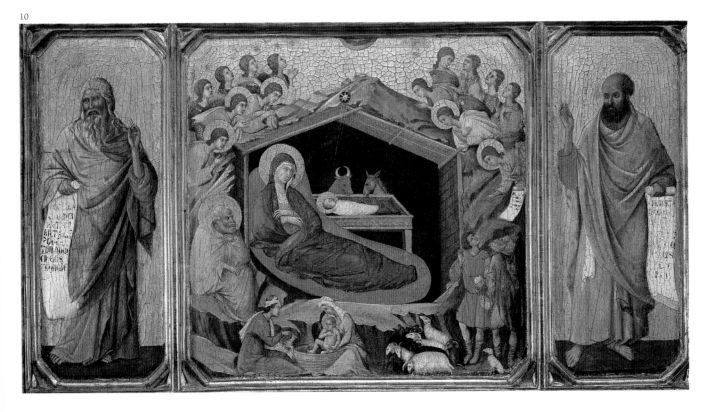

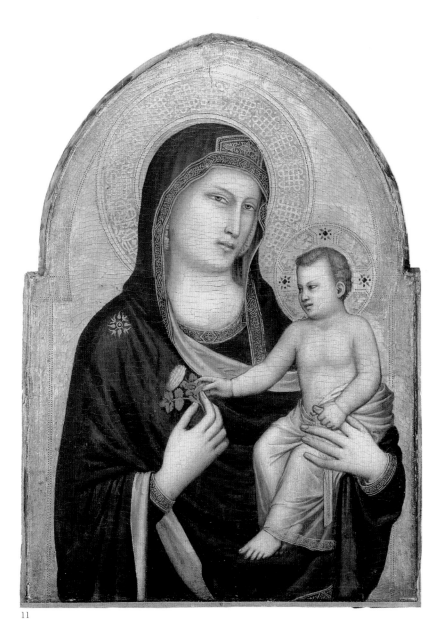

11

Once Cimabue thought to hold the field
as painter;
Giotto now is all the rage,
dimming the lustre of the other's fame.

DANTE, *The Divine Comedy*
(begun 1308)

11 Giotto
Italian, probably 1266–1337
Madonna and Child
probably 1320/1330
tempera on panel
33 5/8 in x 24 3/8 in (85.5 cm x 62 cm)
Samuel H. Kress Collection
1939.1.256 (367)

12 Detail of [11]

Giotto's fame, too, was proclaimed in his own lifetime. One of his remarkable contributions was the break he made from a Byzantine formula that artists had followed for centuries—in which the Madonna usually directly faces the viewer, with wide staring eyes and outlined, symmetrical features, and the Christ Child is portrayed as a small man. In Giotto's *Madonna and Child* [11], the Virgin *considers* the viewer with a thoughtful tilt of the head, her eyes lowered. She is portrayed as a compassionate mother, clasping the Christ Child protectively, and the Child grips her index finger [12, detail] in a spontaneous, instinctive gesture familiar to parents across the ages. By adding such naturalistic detail observed from life, Giotto humanized the traditional "hieratic" style—the highly organized, formal conventions reserved for sacred images. Yet, by retaining the traditional gold background of Byzantine icons, the artist preserved the holy aura of his subject.

12

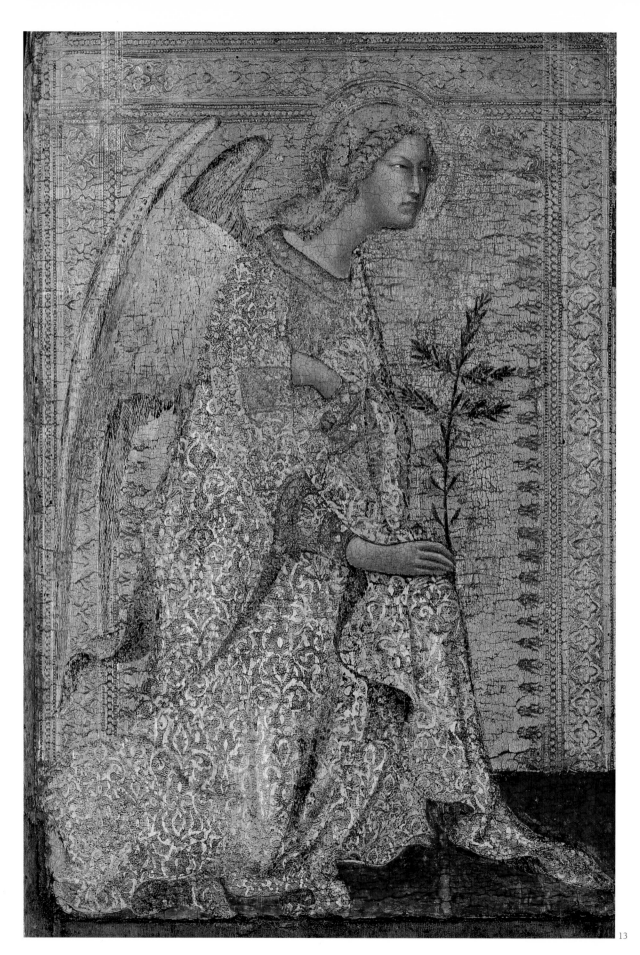

13

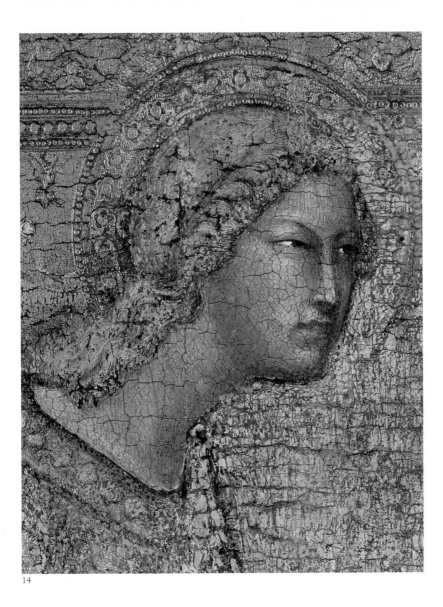

14

It was Duccio who inspired a new generation of Italian artists, including Simone Martini, to introduce elegant hairstyles and dress as expressions of heavenly grace, as in *The Angel of the Annunciation* of about 1333 [13]. Martini was probably a student of Duccio, and the younger artist's style was yet more decorative and refined. Luxurious silk brocades and damasks, imported from the East, served as models for the angel's exquisitely patterned robe, while the Islamic alphabet inspired the intricate incised patterns in the golden halo. The figure's hands, face, and crown of curls are delicately modeled and illuminated, softening the starker contrasts of Byzantine art. The angel's face is shown in three-quarter profile, his intent gaze and parted lips suggesting he is about to speak. The graceful and ornate qualities of Martini's painting anticipated the International Gothic Style which was to spread from the courts of France and Burgundy by the late-fourteenth century to Italy, Spain, and Germany, appealing to religious patrons as well as to the cosmopolitan princes, merchants, and traders of Europe on the eve of the Renaissance.

13 Simone Martini
Italian, *c.*1284-1344
The Angel of the Annunciation
*c.*1333
tempera on panel
12 1/8 in x 8 1/2 in (30.8 cm x 21.6 cm)
Samuel H. Kress Collection
1939.1.216 (327)

14 Detail of [13]

Chapter two
15th century

*When the darkness breaks,
the generations to come
may contrive to find their way
back to the clear splendor
of the ancient past.*

PETRARCH (1304–1374)
Letters of Old Age

2

The early Renaissance, from about 1400, was a pivotal period in the arts. In Italy and then northern Europe, artists sought to emulate the grandeur of classical art and architecture, and at the same time to capture the vitality of the natural world. "The clear splendor of the ancient past," the guiding light of the Renaissance, shines through Giovanni di Domenico's stained-glass windows [1], which once illuminated the choir chapel behind the high altar of the church of Santa Maria Maddalena dei Pazzi in Florence. The artist, a priest, chose a classical setting: the Angel Gabriel kneels in a courtyard, and the Virgin stands within a scalloped niche beside a lectern with a Corinthian pedestal. Her *contrapposto* pose, with one leg bent, emulates classical sculpture.

Jacopo della Quercia, one of Siena's most famous sculptors, blended elements from the Gothic and classical traditions with the close observation of life in his *Madonna of Humility* [3] Mary is seated on the ground as the Madonna of Humility, rather than being enthroned as the Queen of Heaven. Although her drapery is still Gothic in style, the informality of her pose and the restless movement of the Child show a new interest in naturalistic representation. The artist portrays the Madonna in pale polished marble, evoking the Song of Songs, "Thou art fair my beloved, there is no spot in thee."

The theme of the Madonna and Child was central to the piety of fourteenth- and fifteenth-century Italy. In a panel painting of *c.*1422 [2] by the international Gothic master Gentile da Fabriano, the Virgin is portrayed as a tender, maternal figure. In his pursuit of naturalism, the artist abandoned the centuries-old Byzantine formula for the face—flat, symmetrical features and transcendent gaze—reserved for sacred images. Gentile's Virgin, shown in three-quarter profile, gazes with modestly lowered eyes at the Christ Child, her gentle humanity expressed in her classically proportioned, sensitively modeled features.

3

3 Jacopo della Quercia
Italian, 1371/1374 –1438
Madonna of Humility
*c.*1400
marble, traces of gilding
22 7/8 in x 19 1/4 in x 11 1/8 in
(58.4 cm x 48.8cm x 28.3cm)
Samuel H. Kress Collection
1960.5.2 (A-157)

4

4 Filippo Lippi
Italian, *c*.1406–1469
Madonna and Child
1440/1445
tempera on panel
31 ³/₈ in x 20 ¹/₈ in (79.7 cm x 51.1 cm)
Samuel H. Kress Collection
1939.1.290

5 Masolino da Panicale
Italian, 1383, probably 1440/1447
The Annunciation
probably *c*.1425/1430
tempera on wood
58 ¹/₄ in x 45 ¹/₄ in (1.48 m x 1.15 m)
Andrew W. Mellon Collection
1937.1.16

A later artist, Fra Filippo Lippi, was master of the Renaissance theme of the Madonna as Divine Mother [4]. In Lippi's interpretation, the Virgin has a strong physical presence, her graceful contours accentuated by translucent veils and pleated drapery. Her parted lips suggest a sensuality far removed from the sacred style of the Byzantine tradition. As in Domenico's stained-glass windows, Lippi's statuesque Madonna is contained within an elegant scalloped niche inspired by classical architecture. This illusion of depth in the setting is designed to bring the viewer into direct contact with the Madonna—a dramatic departure from the flat, gold backgrounds of Byzantine icons that defined sacred space as a world apart.

A more sensual and worldly style is evident in Masolino's *The Annunciation* [5]. The Archangel Gabriel's elegant robes, fashionable curls, and graceful pose epitomize the ornate international Gothic Style, a courtly art combining French and Italian influences, which was well established in western Europe by the early fifteenth century.

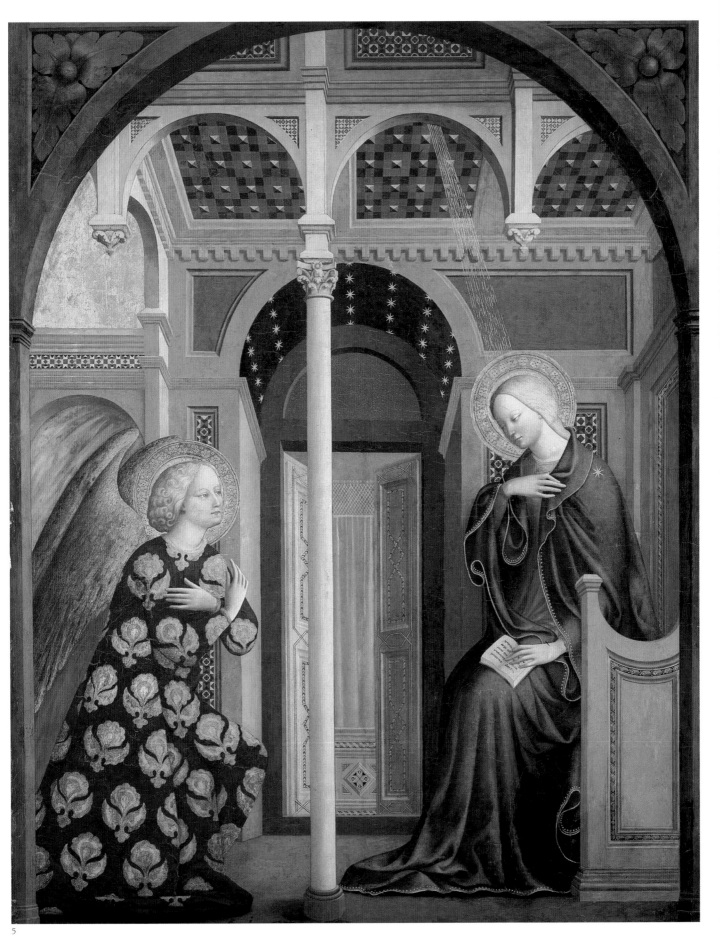

5

6 Fra Angelico
Italian, *c*.1400–1455
The Healing of Palladia by Saint Cosmas and Saint Damian
probably 1438/1443
tempera on panel
14 3/8 in x 18 3/8 in (36.5 cm x 46.7 cm)
Samuel H. Kress Collection
1952.5.3

Fra Angelico, a Dominican monk, rejected the decorative richness of the international Gothic Style in his paintings of the lives of the saints. In *The Healing of Palladia by Saint Cosmas and Saint Damian* [6], he created a powerful composition using simple, geometric architecture, without color or ornament. An arched doorway reveals the miraculous healing of the bed-ridden Palladia by the twin saints, both doctors who later became Christian martyrs. To the right, after her cure Palladia offers a gift of thanks to Damian. Fra Angelico divided the picture into two clearly defined spaces in order to show the beginning and end of the story in the same panel, a technique known as simultaneous narrative, which was popular in medieval art.

Scenes of religious passion are often depicted in stark and jagged landscapes, as in Domenico Veneziano's *Saint John in the Desert* [7] and *Saint Francis Receiving the Stigmata* [8]. Both paintings were originally in a large altarpiece, of which the parts are now dispersed, from the church of Santa Lucia dei Magnoli in Florence.

6

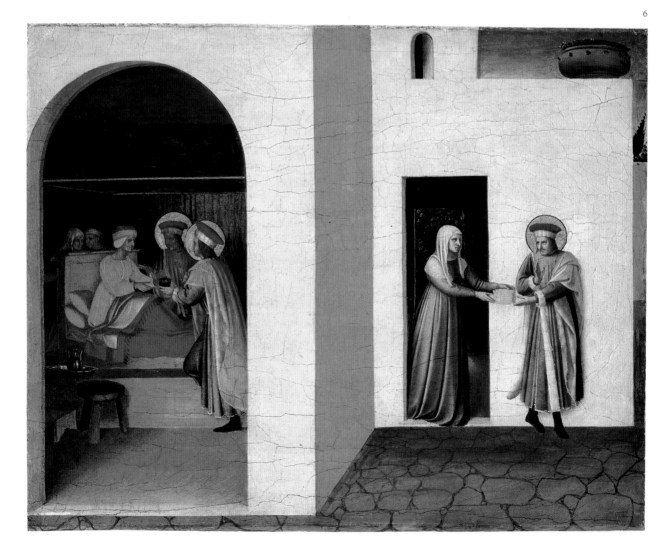

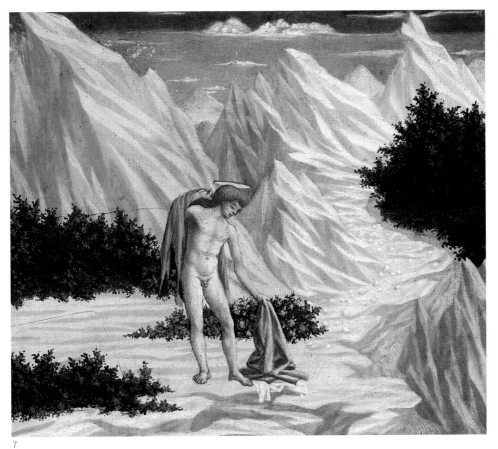

7

7 Domenico Veneziano
Italian, *c*.1410–1461
Saint John in the Desert
c.1445
tempera on panel
11 1/8 in x 12 3/4 in
(28.4 cm x 32.4 cm)
Samuel H. Kress Collection
1943.4.48 (715)

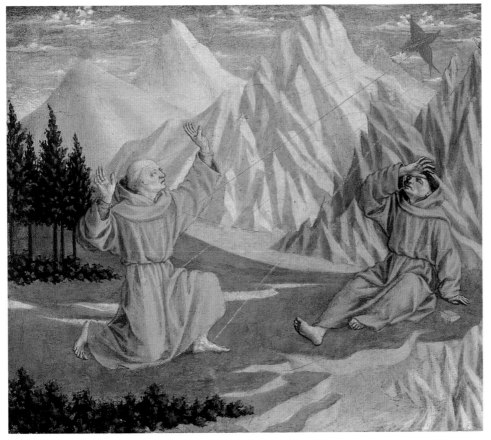

8 Domenico Veneziano
Italian, *c*.1410–1461
*Saint Francis Receiving the
Stigmata*
c.1445
tempera on panel
10 7/8 in x 12 in
(26.7 cm x 30.5 cm)
Samuel H. Kress Collection
1939.1.40 (251)

9 Desiderio da
Settignano
Italian
1428/1430–1464
Saint Jerome in the Desert
*c.*1461
marble
16³/₄ in x 21¹/₂ in
(42.7 cm x 54.8 cm)
Widener Collection
1942.9.113 (A-107)

10 Andrea Riccio
(Andrea Briosco)
called Riccio
Italian, 1470–1532
The Entombment
bronze
19⁷/₈ in x 29³/₄ in
(50.4 cm x 75.5 cm)
Samuel H. Kress
Collection
1957.14.11

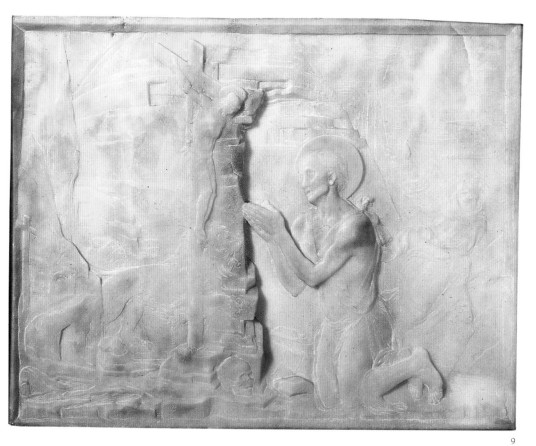

9

10

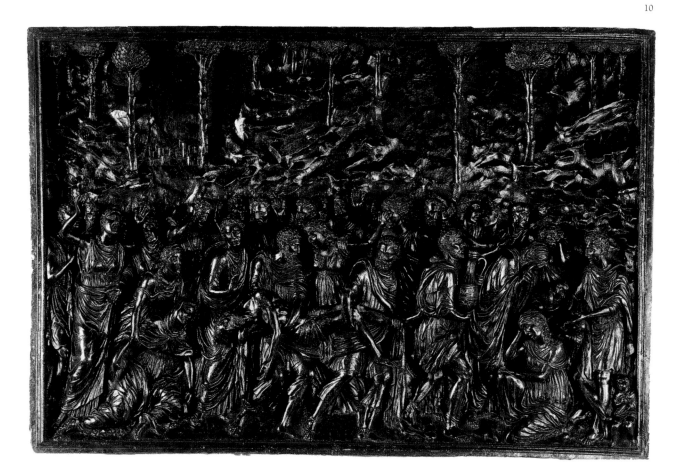

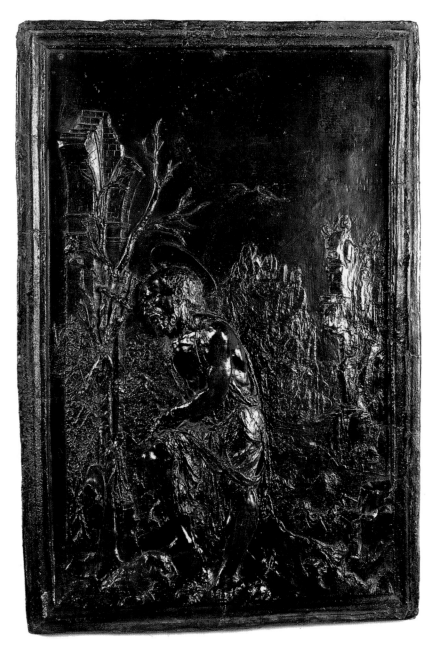

11

The sculptor Riccio, who lived and worked in Padua, used the model of a classical frieze—a row of interlaced figures in three-dimensional relief—for this intense depiction of the procession of mourners carrying the body of Christ, in *The Entombment* [10]. The mood of despair conveyed by their distraught faces and gestures is heightened by the inhospitable, rocky landscape.

A barren landscape also plays an expressive role in two reliefs depicting Saint Jerome, by Desiderio da Settignano [9] and Francesco di Giorgio Martini [11]. Jerome, the scholar who translated the Bible into Latin in the fourth century, is one of the four Fathers of the Church. In both relief sculptures, the scholar-saint kneels before a crucifix in the desert, where he lived for years as a hermit, in remorse for his sins.

11 Francesco di Giorgio Martini
Italian, 1439–1501/1502
Saint Jerome
c.1477
bronze
21 ⅝ in x 14 ¾ in (55 cm x 37.3 cm)
Samuel H. Kress Collection
1957.14.12 (A-165)

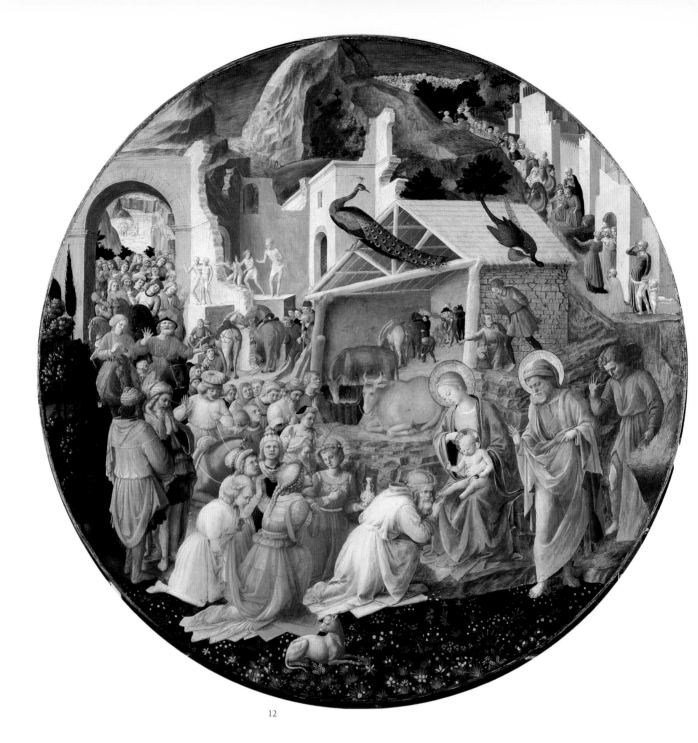

12

12 Fra Angelico
Italian, *c*.1400–1455
and Filippo Lippi
Italian, *c*.1406–1469
The Adoration of the Magi
c.1445
tempera on panel
diameter: 54 in (1.37 m)
Samuel H. Kress Collection
1952.2.2

In *The Adoration of the Magi* [12], painted jointly by Fra Angelico and Filippo Lippi around 1445, many themes of early Renaissance art were brought to fruition. The refined classical beauty of the Virgin recalls Lippi's *Madonna and Child*, while the steep perspective reveals the individual faces and gestures of the crowd. The unusual round format helps create a sense of dynamism as the figures stream down the mountain to the manger. This is a simple hut, an emblem of the origin of all classical architecture, according to the famous treatise by the ancient Roman architect Vitruvius. The painting is itself a treatise on architecture, as interpreted by Fra Angelico—from the cantilevered walls of the city to the ascending terrace of houses beyond.

Andrea del Castagno's *The Youthful David* of *c.*1450 [14] was painted on a ceremonial shield of leather mounted on wood. David's heroic defiance of Goliath made him an apt symbol for Florence; reinterpreted as a youthful guardian of republican freedom against powerful neighboring princes, the myth of David was celebrated by Renaissance masters from Donatello to Michelangelo. Castagno portrays an intense, young David, hair flying, hand outstretched, poised to sling a rock, with the bloody head of Goliath already at his feet. In a sheet of drawings possibly inspired by the myth, Filippino Lippi, the son of Filippo, depicted a more introspective youth [13], and a sensitively modeled hand clutching a stone.

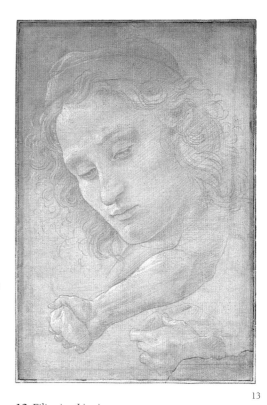

13

13 Filippino Lippi
Italian, 1457–1504
Head of a Youth Wearing a Cap; a Right Forearm with the Hand Clutching a Stone; and a Left Hand Holding a Drapery
1480/1485
metalpoint heightened with white gouache on mauve-prepared paper
11 5/16 in x 7 15/16 in (28.7 cm x 20.1 cm)
Woodner Family Collection, Patrons' Permanent Fund
1991.190.1.a

14

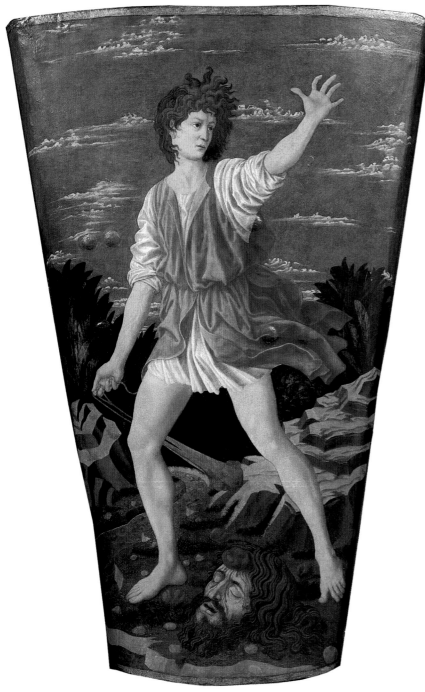

14 Andrea del Castagno
Italian, 1417/1419–1457
The Youthful David
*c.*1450
tempera on leather mounted on wood
width at bottom: 45 1/2 in x 16 1/8 in
(1.15 m x 41 cm); width at top:
45 1/2 in x 30 1/4 in (1.15 m x 76.9 cm)
Widener Collection
1942.9.8 (604)

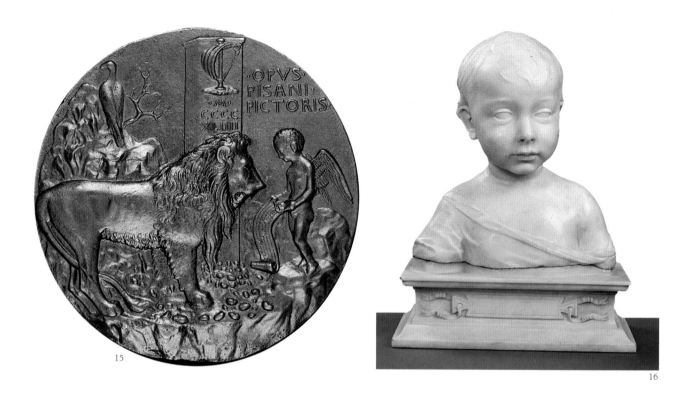

15

16

17

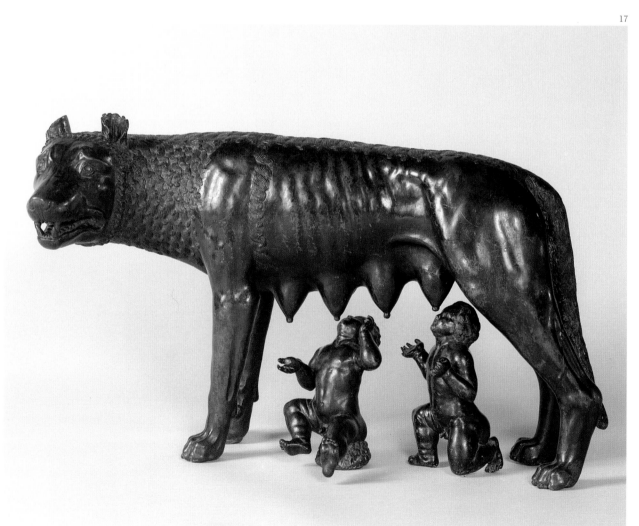

The study by humanist scholars of Greek and Roman history, philosophy, literature, and religion inspired many Renaissance artists to reinterpret ancient subjects. In *The She-Wolf Suckling Romulus and Remus* [17], the unknown sculptor combined archaic Roman forms—such as the wolf's enormous eyes—with Renaissance naturalism, seen in the modeling and anatomy of the suckling children. Settignano's *A Little Boy* [16] and Verrocchio's *Putto Poised on a Globe* [18] reinterpret classical sculpture in the Renaissance spirit of natural movement and spontaneous expression. On a smaller scale, artists of the time also revived the ancient art form of the coin for miniature portraits and symbolic imagery, such as Pisanello's lion [15].

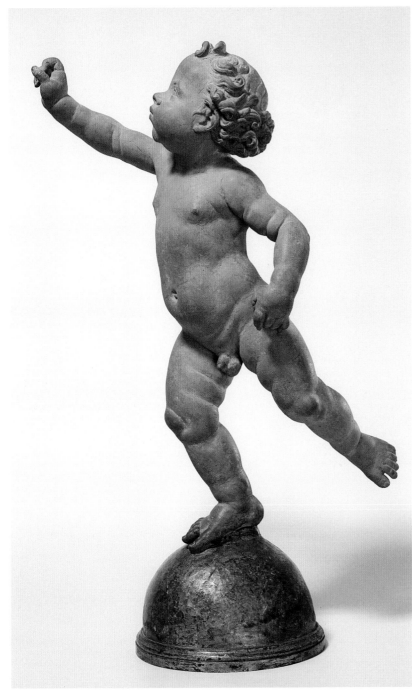

18

15 Pisanello
Italian, *c.*1395–1455
Lion Being Taught by Cupid to Sing (reverse)
1444
bronze
diameter: 4 1/16 in (10.3 cm)
Samuel H. Kress Collection
1957.14.602.b

16 Desiderio da Settignano
Italian, 1428/1430–1464
A Little Boy
1455/1460
marble
10 3/8 in x 9 3/4 in x 5 7/8 in
(26.3 cm x 24.7 cm x 15 cm)
Andrew W. Mellon Collection
1937.1.113

17 Central Italian 15th or 16th century
(possibly Roman)
The She-Wolf Suckling Romulus and Remus
late 15th–early 16th century
bronze
She-wolf: 14 7/8 in x 25 1/4 in x 6 1/4 in
(38 cm x 64.2 cm x 15.9 cm)
Samuel H. Kress Collection
1957.14.8 (A-155)

18 Andrea del Verrocchio
Italian, 1435–1488
Putto Poised on a Globe
probably 1480
terra cotta
29 1/2 in x 15 in x 11 3/4 in
(75 cm x 38.3 cm x 23 cm)
Andrew W. Mellon Collection
1937.1.128 (A-17)

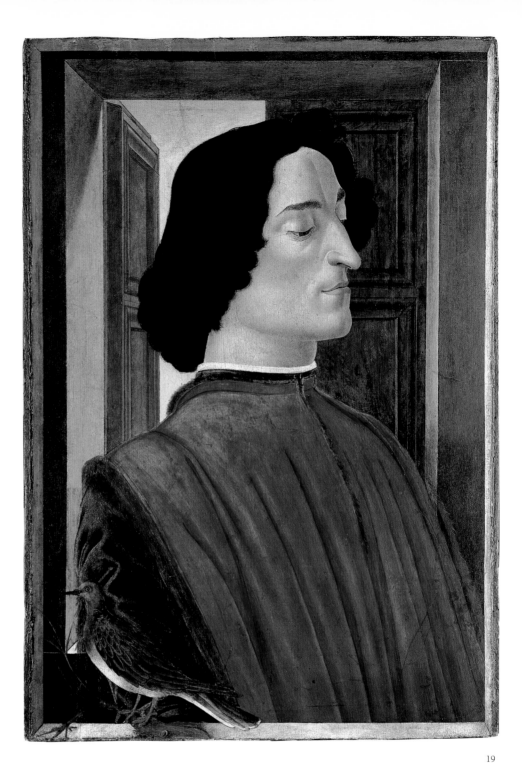

19

19 Botticelli
Italian, 1444/1445–1510
Giuliano de' Medici
*c.*1478
tempera on panel
29 3/4 in x 20 5/8 in (75.6 cm x 52.6 cm)
Samuel H. Kress Collection
1952.5.56

Portraiture of the early Renaissance reflected new standards of naturalism and the humanists' faith in the individual, as artists sought to reveal the psychology of the sitter—what Leonardo called "the motions of the mind." The earliest examples were profile-heads, modeled after antique medals and coins, such as Botticelli's *Giuliano de' Medici* [19], whose sharp features are especially pronounced in three-quarter-profile. The Medici, a family of merchants and bankers, ruled Florence on and off for two centuries. They were among the most influential patrons of humanism and the arts in Renaissance Italy, but were

also much feared and hated. Botticelli's portrait commemorates Giuliano's violent death in 1478 at the hands of the rival Pazzi family.

Until the late fifteenth century, most paintings in Italy were made in tempera—egg yolk mixed with ground pigment—on wooden panels. Leonardo da Vinci was one of the pioneers of oil painting, a technique of binding pigments with oil instead of egg. Oil paint dries more slowly than tempera,

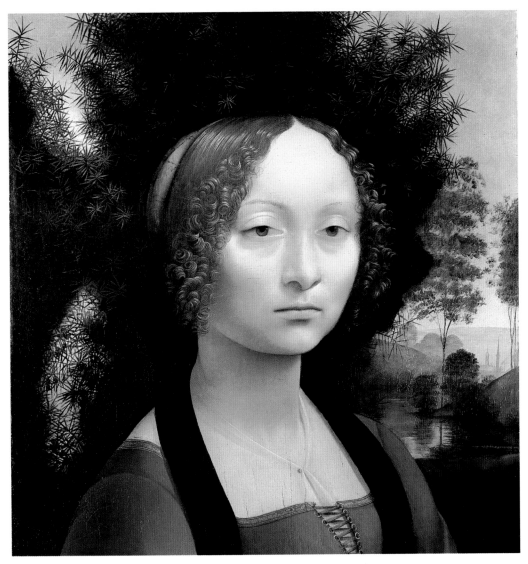

20

which enables the artist to blend and rework the paint, creating more subtle contours and atmospheric effects. Leonardo's understanding of the new medium is revealed in an early portrait of about 1474, *Ginevra de' Benci* [20]. He captured Ginevra's grace and equanimity with translucent glazes of paint that give her skin a luminous quality. The bluish haze in the distant landscape lends the atmosphere a mysterious stillness. A juniper bush, keenly observed from nature, acts as a framing device, but also symbolizes chastity. The choice of the juniper is a playful tribute to Ginevra, for the Italian for juniper is *ginepro*.

20 Leonardo da Vinci
Italian, 1452–1519
Ginevra de' Benci (obverse)
*c.*1474
oil on panel
15 ¼ in x 14 ½ in (38.8 cm x 36.7 cm) Ailsa Mellon Bruce Fund
1967.6.1.a (2326)

21 Jan Van Eyck
Netherlandish, *c*.1390–1441
The Annunciation
c.1434/1436
oil on canvas transferred from panel
painted surface: 35 ³⁄₈ in x 13 ⁷⁄₈ in
(90.2 cm x 34.1 cm)
Andrew W. Mellon Collection
1937.1.39

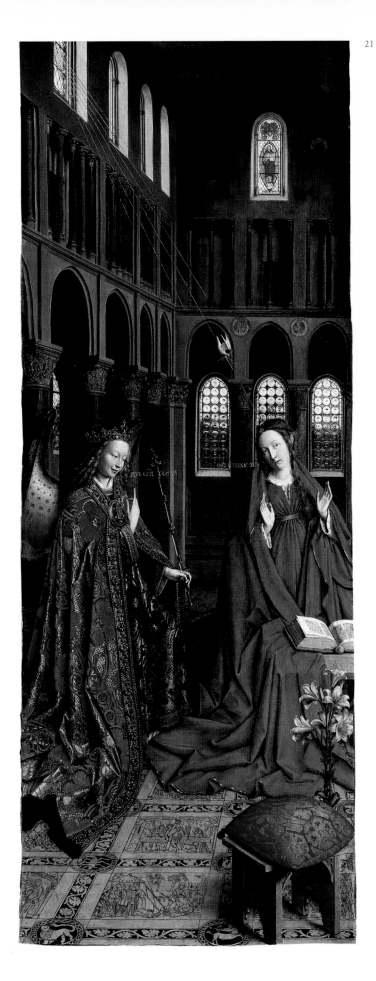

Fluency in the use of oil came first in the North, where the Flemish master Jan van Eyck perfected the art of oil painting. In his masterwork, *The Annunciation* [21], painted in the mid-1430s, he created a majestic cathedral in a hybrid of Romanesque and Gothic styles, its height accentuated by the narrow composition. Rays of divine light, resembling spun gold, descend from the window above, creating a diagonal across the painting from the Holy Ghost to the crown of the Virgin's head. An open Bible lies in the trajectory of the golden rays. In Van Eyck's painting, light is divine, but so is color: the Archangel Gabriel's wings appear to be made of rainbows. The artist's minute, jewel-like brushstrokes delineate every detail, from the delicate locks of hair tumbling on either side of her left ear, to the embroidery of Gabriel's resplendent robes, to the inlaid flagstones of the church.

Religious painting in northern Renaissance art often exposed brutal truths about human nature, as seen in the moral allegories of the Netherlandish painter Hieronymus Bosch. His unsettlingly graphic depiction of human foibles can be seen in the painting *Death and the Miser* [22], where diabolical goblins creep around the bedroom of the dying miser, discovering sacks of gold coins. Essentially a moralist, Bosch created images fired by the popular lore and devotional literature of the time—culminating in his apocalyptic altarpiece, *The Garden of Earthly Delights* (Madrid).

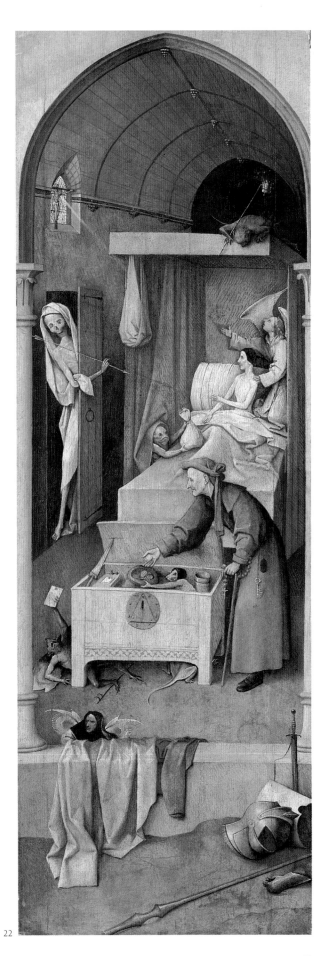

22 Hieronymus Bosch
Netherlandish, *c.*1450–1516
Death and the Miser
*c.*1485/1490
oil on panel
36 ⅝ in x 12 ³/₁₆ in (93 cm x 31 cm)
Samuel H. Kress Collection
1952.5.33

22

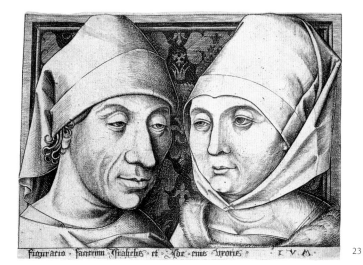

23 Israhel van Meckenem
German, *c*.1445–1503
Double Portrait of Israhel van Meckenem and His Wife Ida
c.1490
engraving
5 1/8 in x 6 7/8 in (13 cm x 17.5 cm)
Rosenwald Collection
1943.3.99

24 Martin Schongauer
German, *c*.1450–1491
Christ Carrying the Cross
c.1475
engraving
11 3/8 in x 17 5/16 in (28.9 cm x 43.9 cm)
Andrew W. Mellon Fund
1968.17.1 (B-25281)

The Flemish master Rogier Van der Weyden was as preoccupied with the overall design of his portraits as with the distinctive character of his sitters. In *Portrait of a Lady*, *c*.1460 [25], the dark background isolates the figure, whose features are illuminated as if by moonlight. Rings accentuate her hands, which are tightly clasped almost as if in prayer. She appears thoughtful, her eyes averted from the viewer's gaze. The darkness of the background and robes envelop her with interlocking geometric shapes that emphasize her state of absorption. Unlike Leonardo's portrait of Ginevra, in which landscape performs a symbolic role in deciphering her character, Van der Weyden's painting is more abstract in its design.

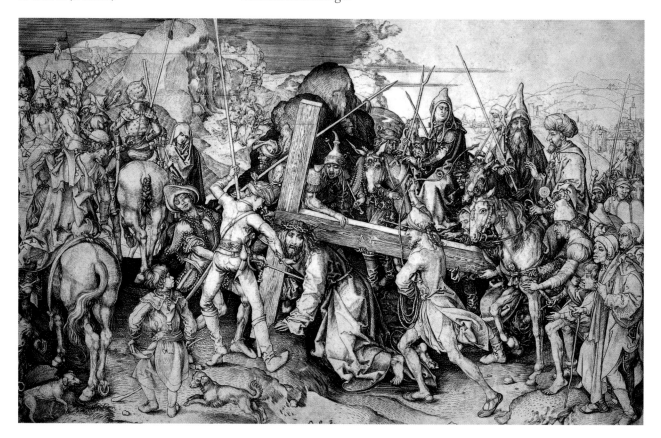

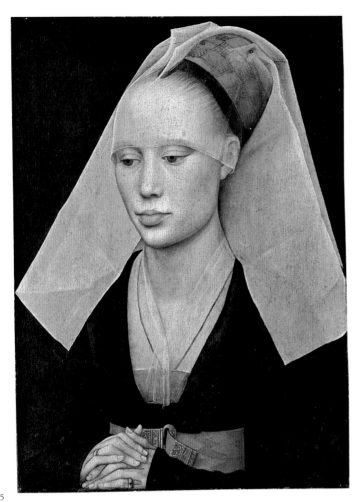

25

By the late fifteenth century, artists in Germany had eschewed the courtly international Gothic Style, with its ornate surfaces and graceful flourishes, and turned for inspiration to Van der Weyden, whose work epitomized the sharply focused realism that would characterize the art of the German Renaissance. Many painters were also printmakers, perfecting their line with wood-engraving, a technique that demands extreme skill and discipline. After tracing the image, in reverse, on the wood block, the engraver must then chip away everything but the area to be printed. Israhel van Meckenem attained a lively line in his engraving of *c*.1490, showing the artist with his wife Ida [23]. The double portrait reveals a sense of humor and intimacy rare even in German naturalism.

Martin Schongauer, from a family of artists and craftsmen in Augsburg, was profoundly influenced by Van der Weyden. The German artist's sharp, staccato line has none of the sensuality of the International Gothic Style. Until Schongauer, popular religious prints had served as private devotional imagery, inserted between the leaves of prayer-books. He elevated printmaking to an art form. *Christ Carrying the Cross* [24] is one of several Passion scenes engraved by Schongauer, whose fine line was to inspire one of the great German artists of the Renaissance, Albrecht Dürer.

25 Rogier Van Der Weyden
Netherlandish, 1399 or 1400–1464
Portrait of a Lady
c.1460
oil on panel
wood, painted surface: 13 3/8 in x 10 1/16 in
(34 cm x 25.5 cm)
Andrew W. Mellon Collection
1937.1.44

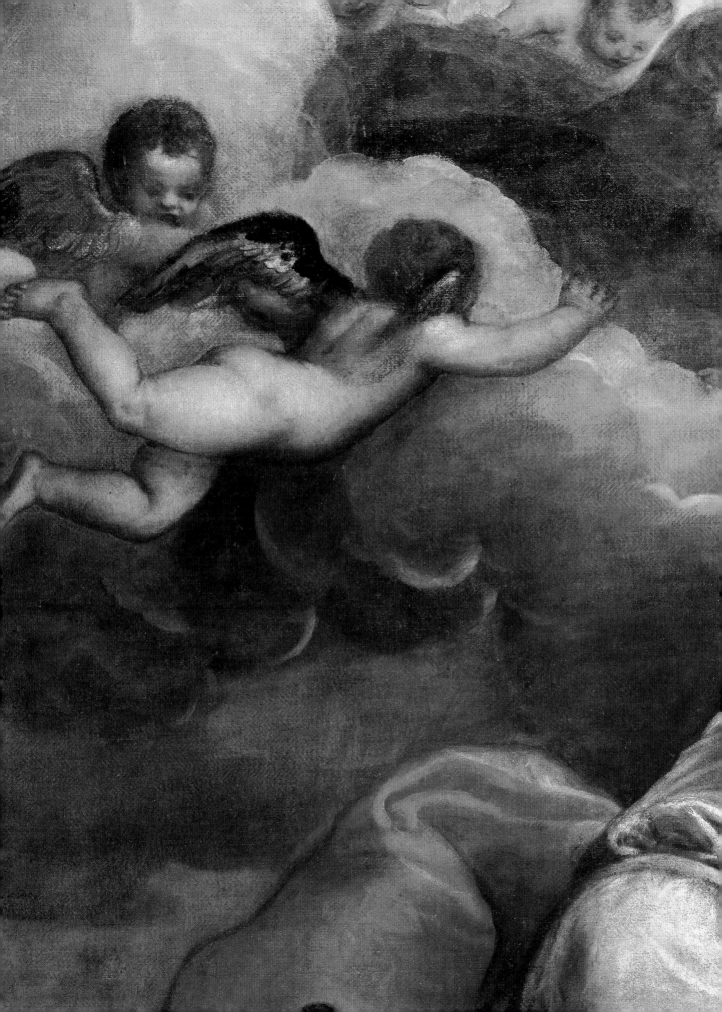

Chapter three
16th century

In fact, whereas pictures by others may be called simply pictures, those painted by Raphael are truth itself: for in his figures the flesh seems to be moving, they breathe, their pulses beat, and they are utterly true to life.

GIORGIO VASARI (1511–1574)
Lives of the Painters

Many of today's Old Masters were celebrated in their own lifetimes. Leonardo, Michelangelo, Raphael, and Titian all appeared in a Renaissance bestseller by Giorgio Vasari called *Lives of the Most Excellent Painters, Sculptors and Architects*. Published in 1550 and revised in 1568, Vasari's *Lives* elevated these artists to Olympian heights—a world apart from the anonymous craftsmen of medieval guilds.

Vasari, himself a successful painter and architect, was also court historian to the Medici family, among the most powerful art patrons of the Renaissance. His biographies are, in part, an inventory of new techniques—from the study of perspective, foreshortening, and anatomy to the dramatic use of light and shade, known as *chiaroscuro*. Perfection in art, according to Vasari, was a synthesis of skill and vision, exemplified by good rule, order, proportion, design, style, and, above all, *invenzione*, or inventiveness.

Sixteenth-century art encompassed both religious and secular subjects, breaking down the boundaries between the sacred and profane. The studies of the Humanist scholars, who translated and interpreted ancient Latin and Greek texts, profoundly influenced artists of the period. Humanism was a pervasive influence in the art of the Renaissance, which drew inspiration from this revival of interest in ancient mythology and allegory.

The epitaph on Raphael's tomb reads: "While he lived he made Mother Nature fear to be vanquished by him." He did not merely imitate nature but produced, in Vasari's words, art that breathed. His refined style and technique were in part influenced by his teacher, Perugino, from Umbria, close to Urbino in the Marches, Raphael's birthplace. The contrast between mountain and plain in this district in the heart of Italy fostered a tranquil, harmonious and humanizing style, as seen in Perugino's *Madonna and Child*, painted after 1500 [2]. Naturalism, or the imitation of nature, is in the details—the parting of the Virgin's hair, or the chubby folds beneath the Christ Child's belly. Perugino's mastery won him many public commissions, including the decoration of a bankers' hall, the Collegio del Cambio, Perugia, in 1500, for which he was assisted by Raphael, then seventeen years old.

1 Detail of [2]

2 Perugino
Italian (Umbrian), *c.*1448–1524
Madonna and Child
after 1500
oil on panel
27 ⅝ in x 20 in (70.2 cm x 50.8 cm)
Samuel H. Kress Collection
1939.1.215

1

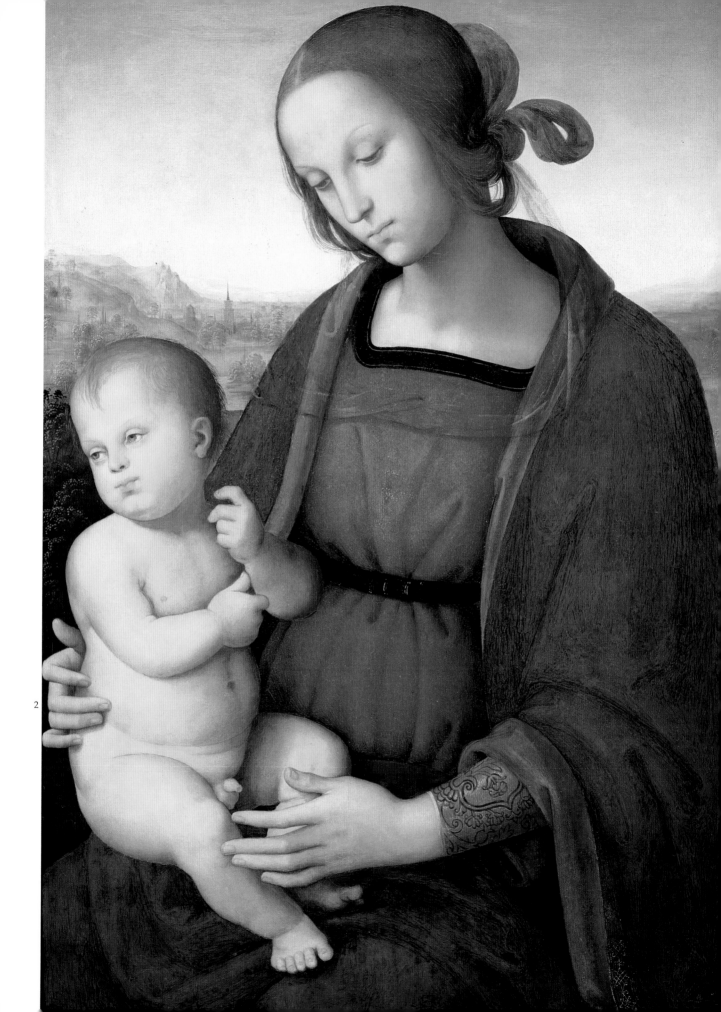

2

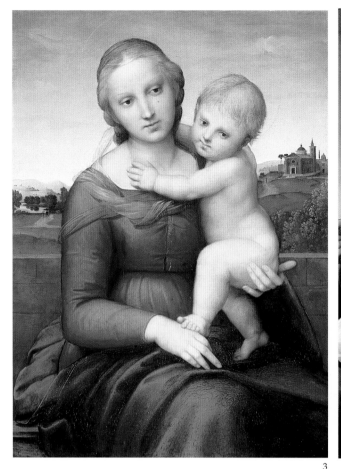 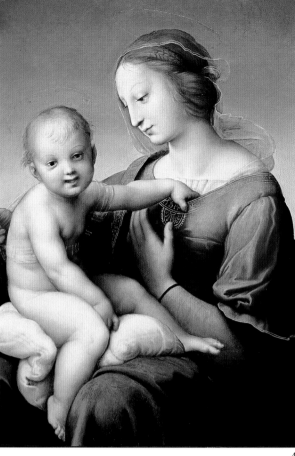

3 4

3 Raphael
Italian (Umbrian), 1483–1520
The Small Cowper Madonna
*c.*1505
oil on panel
23 ³/₈ in x 17 ³/₈ in (59.5 x 44 cm)
Widener Collection
1942.9.57

4 Raphael
Italian (Umbrian), 1483–1520
The Niccolini-Cowper Madonna
1508
oil on panel
31 ³/₄ in x 22 ⁵/₈ in (80.7 cm x 57.5 cm)
Andrew W. Mellon Collection
1937.1.25

5 Raphael
Italian (Umbrian), 1483–1520
The Alba Madonna
*c.*1510
oil on panel transferred to canvas
diameter: 37 ¹/₄ in (94.5 cm)
Andrew W. Mellon Collection
1937.1.24

In Raphael's *Small Cowper Madonna* [3], painted around 1505, the Virgin appears preoccupied, with an abstracted gaze, while the Christ Child also looks away. Their intimacy is clear, nevertheless, as the Child clasps the Virgin about the neck, stepping on to her hand as if to climb higher into her arms. The Christ Child is even more animated in the later *Niccolini-Cowper Madonna* [4], looking directly at the viewer as he playfully tugs at the Virgin's bodice, where the artist's signature appears: "1508 Raphael of Urbino painted it."

The year 1508 was a momentous one for Raphael. He moved to Rome, which was becoming an important artistic center and where Michelangelo had just begun work on the Sistine Chapel. *The Alba Madonna*, painted around 1510 [5], reflects a new, Roman monumentality in Raphael's style, evident not only in the larger scale of the canvas, but also in the imposing presence and solidity of the figures. The Virgin appears in ancient Roman costume, with intricately woven leather sandals and flowing robes. Seated on the ground—a granular, russet earth, she cradles a heroic Christ Child, influenced by the muscular figures of Michelangelo. The Child's stately gesture—as he holds the cross with outstretched hand and resolute gaze—shows none of the intimacy and playfulness of Raphael's earlier representations [3, 4]. The geometric center of the pyramidal arrangement of figures coincides with that of the circular canvas, imposing a sense of stability and order.

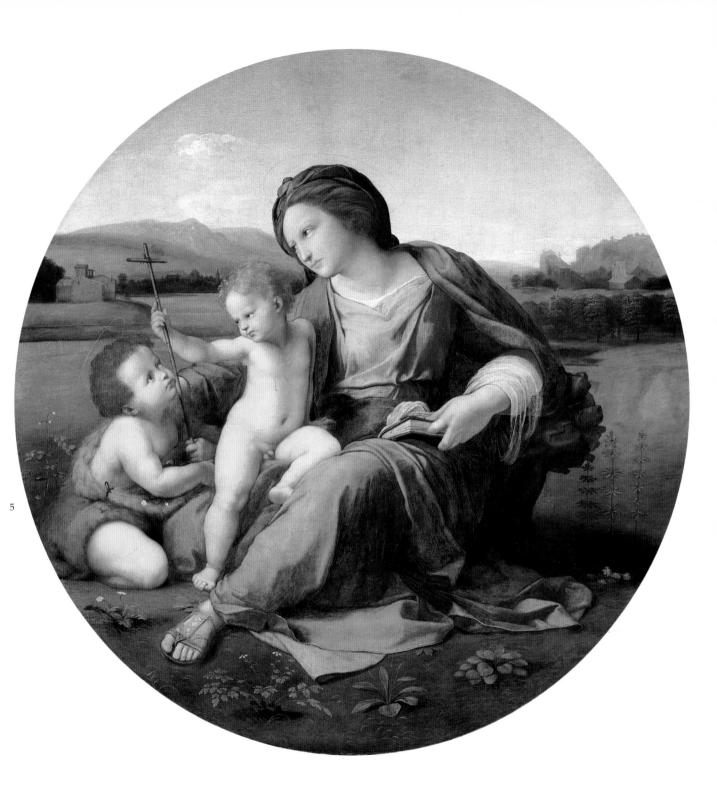

5

This is Raphael's Tomb, while he lived he made Mother Nature
Fear to be vanquished by him and, as he died, to die too.

PIETRO BEMBO
inscribed on the artist's tomb, 1520

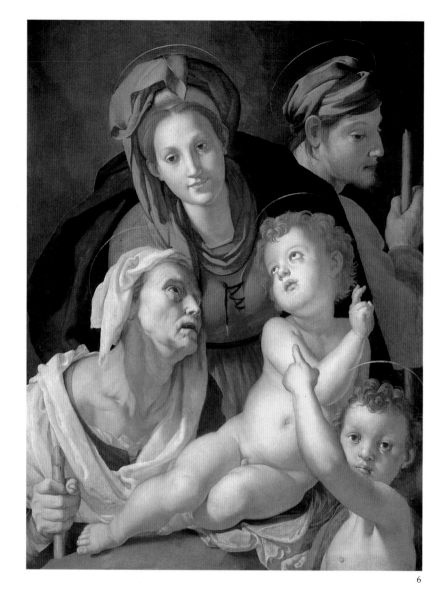

6

6 Agnolo Bronzino
Florentine, 1503–1572
The Holy Family
c.1527/1528
oil on panel
39 7/8 in x 31 in (1.01 m x .78.7 cm)
Samuel H. Kress Collection
1939.1.387

7 Circle of Giorgione
Venus and Cupid in a Landscape
c.1505/1515
oil on panel
4 3/8 in x 8 in (11 cm x 20 cm)
Samuel H. Kress Collection
1939.1.142

8 Annibale Carracci
Italian, 1560–1609
River Landscape
c.1590
oil on canvas
34 3/4 in x 58 1/4 in (88.5 cm x 1.48 m)
Samuel H. Kress Collection
1952.5.58

Works by a younger generation of Italian artists, born around 1500, challenged the sense of order, harmony, and classical proportions pioneered by Perugino and Raphael. The Florentine painters Pontormo and his pupil Bronzino discovered that by departing from classical proportions and distorting the human anatomy, they could create figures that both expressed and elicited powerful emotion. This style became known as mannerism. In Bronzino's *The Holy Family*, painted around 1527/1528 [6], the artist rejected the pyramidal organization exemplified by Raphael's *The Alba Madonna* [5] and introduced a new sense of dynamism, with a composition of twisting figures and sinuous lines. The twirled form of Bronzino's Christ Child is a moderate example of the serpentine form, or S-shape, known as the *figura serpentinata*, a hallmark of mannerism.

The development of landscape painting in the late sixteenth century revived the classical theme of Arcadia, the utopian landscape of ancient poetry and myth. Some of these paintings were intimate and evocative—for example, *Venus and Cupid in a Landscape*, from the circle of Giorgione of the early sixteenth century [7], and Annibale Carracci's *River Landscape* from around 1590 [8].

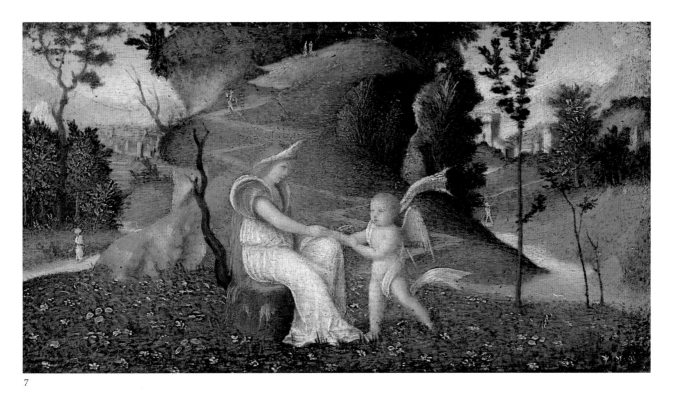

7

8

9 Giovanni Bellini
Italian (Venetian), *c.*1430–1516
and Titian
Italian (Venetian), *c.*1490–1576
The Feast of the Gods
1514/1529
oil on canvas
67 in x 74 in (1.7 m x 1.88 m)
Widener Collection
1942.9.1

Giovanni Bellini's monumental work, *The Feast of the Gods* [9], begun in 1514, and completed long after his death, is a complex interpretation of the Arcadian myth. It is an elaboration of the theme of the ancient bacchanal—named after Bacchus, the god of wine. Bellini's painting was inspired by a classical poem, Ovid's *The Feasts* (Fasti), in which Priapus, the god of fertility, attempts to ravish the sleeping nymph Lotis, who represents chastity, when the other gods are too drunk to notice. However his attempt is interrupted by the braying of the ass.

While *The Feast of the Gods* is Bellini's creation, two other artists had a hand in it. The painting was commissioned for his castle by the Duke of Ferrara,

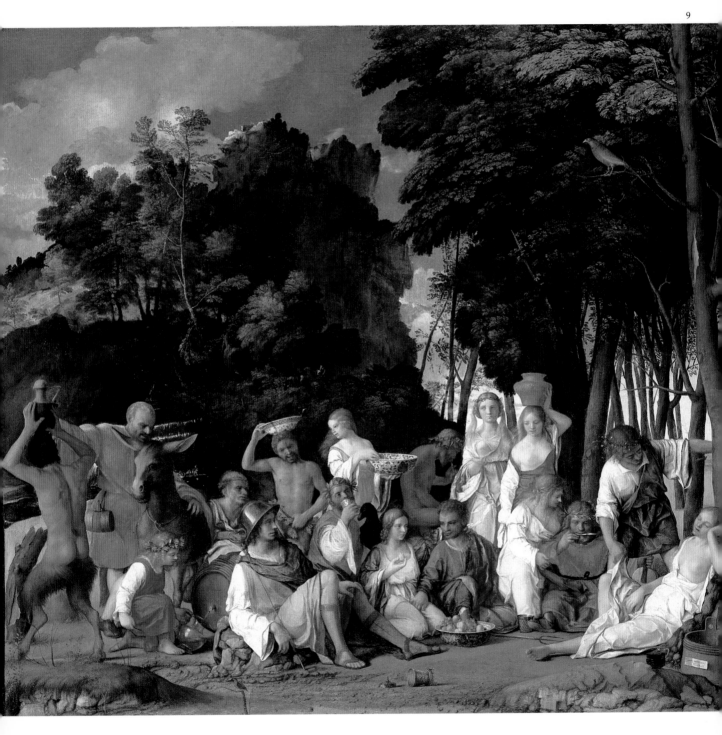

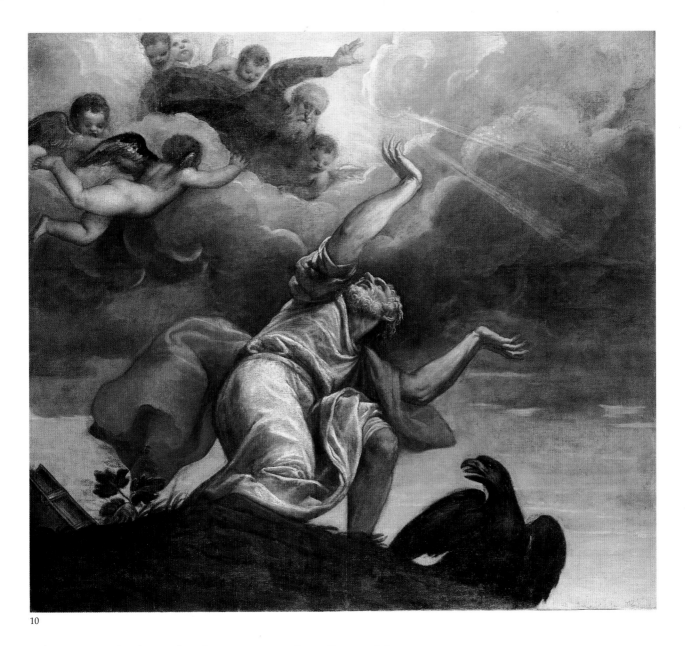

10

Alfonso d'Este, who also employed as court painters Dosso Dossi and the young Titian. Both artists modified Bellini's composition: X-radiographs reveal that the background landscape was twice repainted, first by Dosso and later by Titian, who spared only Dosso's bird on a branch and a passage of blue sky. The combination of Bellini's vision, light, and color, with Titian's lively brushwork, exemplifies Venetian painting.

Titian's *Saint John the Evangelist on Patmos*, painted around 1547 [10], planned as a ceiling painting, recreates Saint John's vision of the apocalypse, transporting the viewer to the summit of Mount Patmos. The presentation of the scene at a precipitous tilt demands a radical foreshortening of the saint's body, but not all the distortions are for the sake of perspective. While the head and torso are tilted backward and contracted, the saint's legs and arms are larger than life. His impossibly long arms are held out in wonder; his massive legs buckle in awe.

10 Titian
Italian (Venetian), *c.*1490–1576
Saint John the Evangelist on Patmos
*c.*1547
oil on canvas
93 1/2 in x 103 1/2 in (2.37 cm x 2.63 m)
Samuel H. Kress Collection
1957.14.6

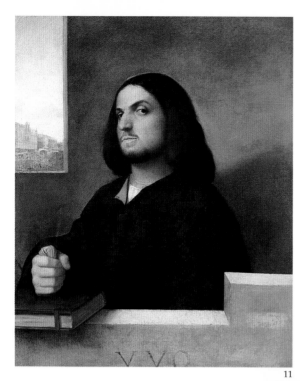

Portraiture of the Italian Renaissance celebrates an age of individualism. In Giorgione's and Titian's *Portrait of a Venetian Gentleman*, *c*.1510 [11] the sitter's strength of character is immediately apparent; he makes an almost audible thump with his fist as he glowers at the viewer. The elegant geometry of the composition frames a Venetian landscape seen through the window in the background. Sebastiano del Piombo's *Portrait of a Humanist*, *c*.1520 [12] portrays a classical scholar, accompanied by his books, quill pen, and globe, as a high priest of learning, his enormous dark cloak and white collar giving added emphasis to his luminous brow and lucid gaze. Sebastiano was a Venetian who worked with Michelangelo in Rome and combined the monumentality of Michelangelo's figures with Venetian color and light. This image is as much a portrait of an era as of an individual; for the sixteenth century was an age of inquiry, when the world was circumnavigated for the first time, and Copernicus first proposed that the sun, not the earth, was at the center of the universe.

11

11 Giorgione
Italian (Venetian), 1477/1478–1510
and Titian (Venetian) *c*.1490–1576
Portrait of a Venetian Gentleman
c.1510
oil on canvas
30 in x 25 in (76.2 cm x 63.5 cm)
Samuel H. Kress Collection
1939.1.258

12 Sebastiano del Piombo
Italian (Venetian), 1485–1547
Portrait of a Humanist
c.1520
oil on panel transferred to a hardboard
53 in x 39 ¾ in
(1.35 m x 1.01 m)
Samuel H. Kress Collection
1961.9.38

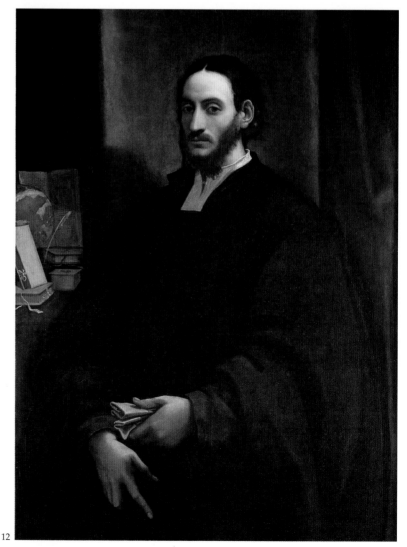

12

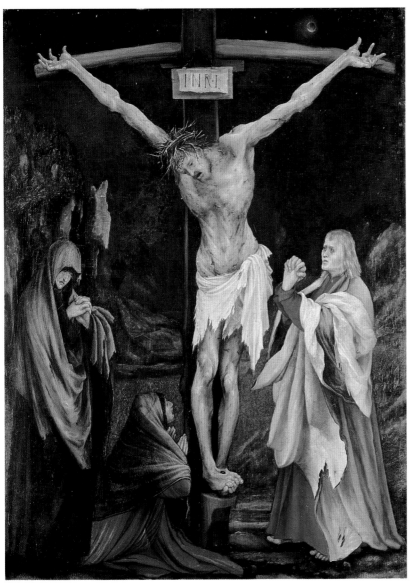

13

13 Matthias Grünewald
German, c.1475/1480–1528
The Small Crucifixion
c.1511/1520
oil on panel
24 1/8 in x 18 1/8 in (61.3 cm x 46 cm)
Samuel H. Kress Collection
1961.9.19

14 Detail of [13]

14

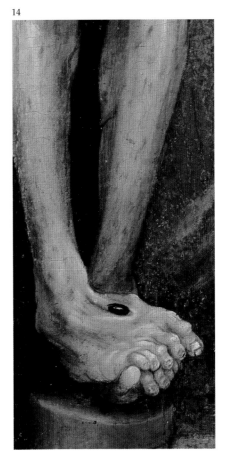

While the historian Vasari praised the foremost artists of Renaissance Italy, he did not include the northern Renaissance masters—from Grünwald to Dürer—in his *Lives*. Matthias Grünwald was a visionary religious painter who had strong sympathies with the ascetic beliefs of Martin Luther, leader of the Protestant Reformation that took hold of Germany around 1519. Between 1511 and 1520, Grünwald painted *The Small Crucifixion* [13], and also completed the famous Isenheim Altarpiece (Colmar). The artist's vision of the crucified Christ is brutally real, and unsparing in its detail, with its rictus of death and flesh pierced, bleeding, and swollen with thorns [14, detail]. Grünwald's painting is partly based on fact, for he had witnessed an outbreak of the plague in Germany. The ghastly thinness of his figures and their tattered drapery, the contorted hands of Saint John, and the angular body of Christ—his bones protruding, his face ashen, his hands and feet coiled in pain—are mesmerizing.

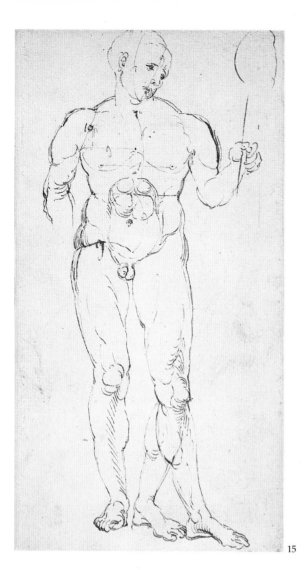

15

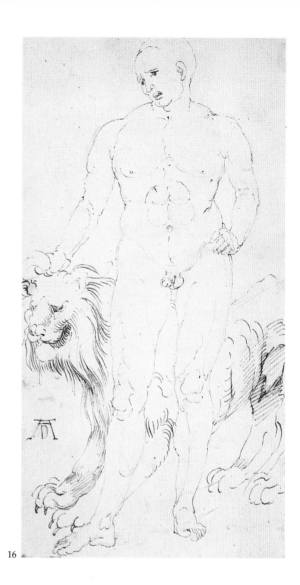

16

15 Albrecht Dürer
German, 1471–1528
Male Nude Holding a Mirror (recto)
*c.*1500
pen and brown ink on laid paper
10 9/16 in x 5 9/16 in (26.7 cm x 14.1 cm)
Woodner Collection
1991.182.11.a

16 Verso of [15]
Male Nude with a Lion
1991.182.11.b

17 Verso of [15]
detail of the artist's monogram

Grünewald's nearly exact contemporary Albrecht Dürer was to become the most celebrated Renaissance artist north of the Alps. A master draftsman, painter and printmaker, he never tired of devising new theories and methods in his quest for beauty—drawing inspiration from classical sculpture, ancient treatises of proportion, and the art of Italian contemporaries as diverse as Leonardo, Raphael and Michelangelo. "Beauty, what that may be, I do not know," Dürer wrote.

In possibly the earliest surviving study of male proportions, Dürer's drawing, *Male Nude Holding a Mirror, c.*1500 [15], offers valuable insight into the artist's creative process. A numbered grid as well as puncture-marks from two compasses appear across the torso of the figure, revealing the concern of the Renaissance artist for a mathematically based theory of perfect human proportions. The likely model for this muscular male nude—freely interpreted by Dürer—was the ancient sculpture excavated in Rome shortly before 1500, known as the Borghese Hercules. The artist then turned the sheet of paper over and traced the male figure from the other side, or verso [16]. The second drawing, in which a lion appears like a faithful dog at his side, is the final image, which Dürer sealed with his monogram.

Dürer's unique monogram [17, detail] remains an emblem of perfection in the history of art. His pride in craftmanship was deeply ingrained, for he came from a family of goldsmiths. He probably learned engraving and silverpoint (an ancestor of the pencil) in his father's workshop in Nuremberg, and he later became a master of all the techniques of drawing and engraving. In *Knight, Death and Devil* [18], engraved in 1513, a knight, accompanied by his dog, rides through the woods, his eyes fixed on the trail ahead, seemingly oblivious to the horrors around him. Death rides beside him holding up a strictly contemporary *memento mori*—an hour-glass with an attached clock (invented in 1509). A skull peers at a plaque inscribed with the artist's initials. When Dürer died in 1528, he was praised, above all, for his fine line. Comparing him to the legendary Greek painter, the humanist scholar Erasmus christened Dürer "the Apelles of black lines."

When I was young,
I engraved new, varied works;
now … I am beginning to consider
nature in its original purity and to
understand that the supreme
expression of art is simplicity.

ALBRECHT DÜRER

18

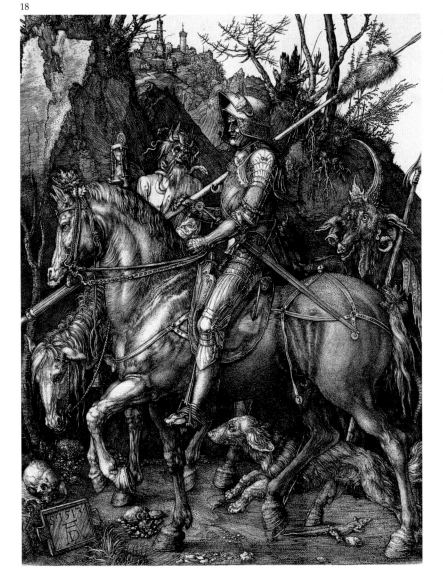

18 Albrecht Dürer
German, 1471–1528
Knight, Death and Devil
1513
engraving
9³/₄ in x 7¹/₂ in (24.8 cm x 19 cm)
Gift of W.G. Russell Allen
1941.1.20

19

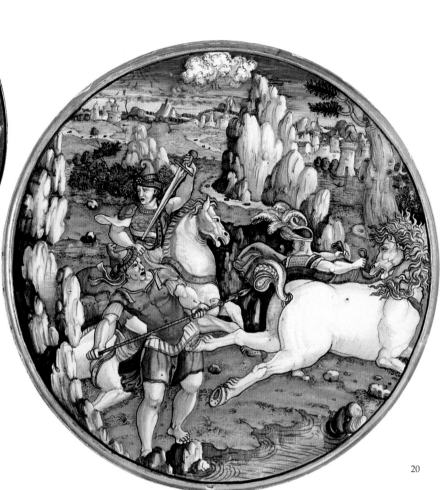

20

19 Giovanni Desiderio Bernardi
Italian, 1496–1553
Christ Expelling the Moneychangers from the Temple
c.1540/1549
engraved rock crystal
oval: 4 1/4 in x 3 1/2 in (10.8 cm x 8.9 cm)
Gift of David Edward Finley and Margaret Eustis Finley
1984.5.1

20 Maestro Giorgio,
Workshop of Andreoli of Gubbio,
and Painter of the Three Graces
Italian
Flat plate with a battle scene
1525
tin-glazed earthenware (maiolica)
diameter: 11 7/8 in (30.3 cm)
Widener Collection
1942.9.334

The Renaissance represented a flourishing of all the arts, from painting and sculpture to ceramics and rock crystal engravings. Maiolica—a hand-painted, tin-glazed earthenware that grew popular during this period—often showed subjects worthy of painting or sculpture, like this battle scene painted on a flat plate in 1525 [20]. Crystal engravers also copied monumental compositions originally made by artists working in other media. The intricacy and precision of Giovanni Desiderio Bernardi's rock crystal design, *Christ Expelling the Moneychangers from the Temple* [19], from the mid-sixteenth century, testifies to Renaissance standards of craftmanship—and virtuoso, or technical wizardry.

The Florentine statuette, the *Farnese Hercules* [20], shows both the influence of the antique and a mannerist interpretation of human anatomy. The bronze is based on a third century A.D. statue from Naples of Hercules, a popular subject among mannerists, who were attracted by the figure's musculature and distorted proportions. Shown in repose, Hercules' sensuality is also revealed, his *contrapposto* thrusting his right hip thrust outward into a feline curve. His languorous left arm is draped over a support decorated with a lion's head and lion skin, traditional attributes of this heroic lion-killer. The dramatic figure was made in the second half of the century, but the sculptor remains unknown.

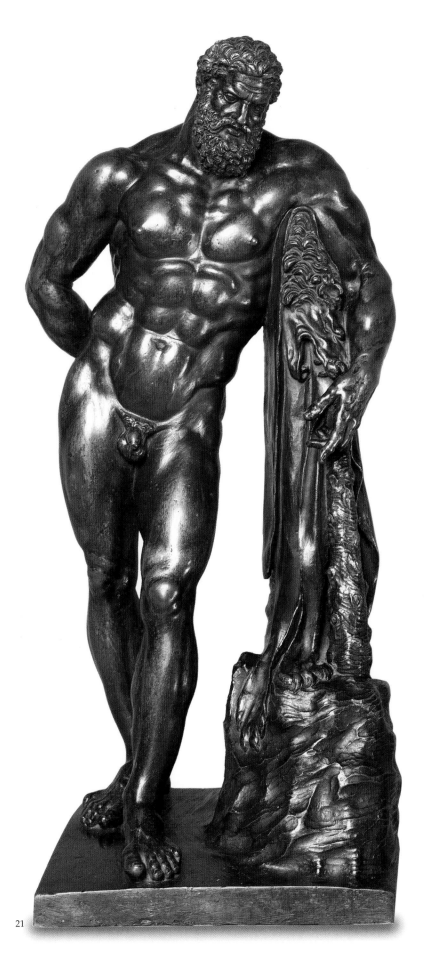

21

21 Italian 16th century
Farnese Hercules
c.1550/1599
bronze
22 3/8 in x 10 3/4 in x 10 in
(56.8 cm x 27.3 cm x 25.4 cm)
Gift of Stanley Mortimer
1960.10.1

17th century

I regard all the world as my country.

PETER PAUL RUBENS
(1577–1640)
In a letter to Valavez, 10 January 1625

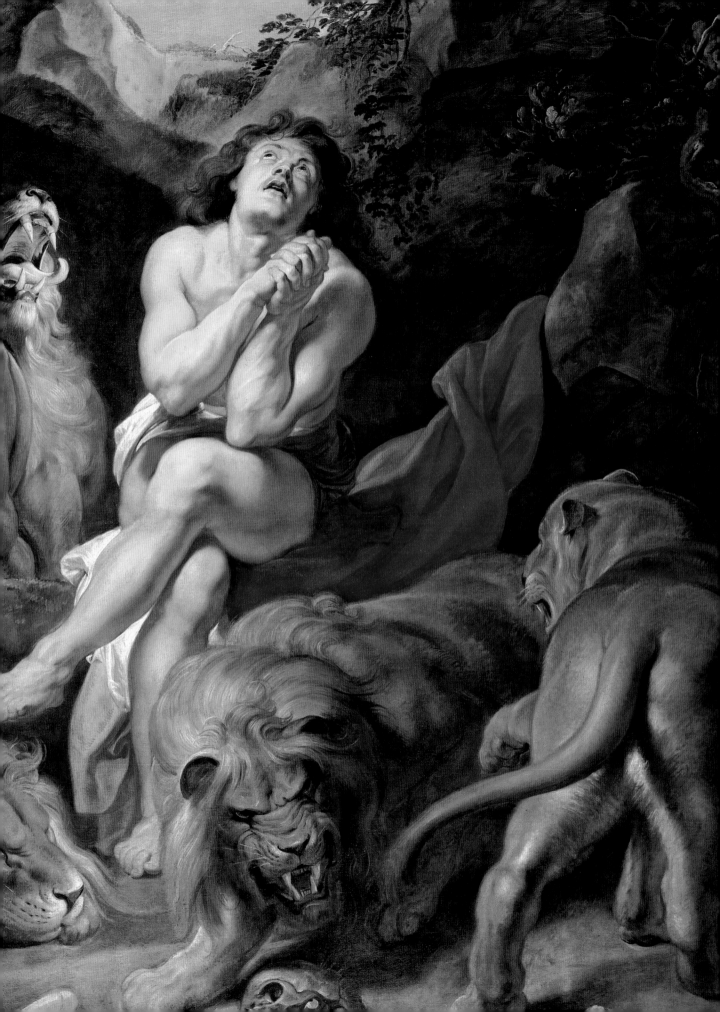

1 Peter Paul Rubens
Flemish, 1577–1640
The Fall of Phaeton
*c.*1605
oil on canvas
38 ¾ in x 51 ⅛ in (98.4 cm x 1.31 m)
Patrons' Permanent Fund
1990.1.1

From Rome to Antwerp, baroque artists of seventeenth-century Europe were masters of illusion. The viewer plunged with them into a field of light and shadow, where bodies move through space with an unprecedented dynamism. *The Fall of Phaeton* [1], painted in Rome around 1605 by the young Flemish artist Rubens, dramatizes this vision. It is as if the viewer were suspended in mid-air, strategically placed to witness Phaeton's chariot being exploded by Zeus' thunderbolt.

Even today, Rome remains the consummate baroque city, bustling and extravagant, boasting the masterpieces of Caravaggio and Bernini. But while it was the Italians who undoubtedly shaped the dominant style of the seventeenth century, other artists beyond Rome were equally great and influential—and none more so than the Flemish master, Peter Paul Rubens.

In 1605 Rubens was twenty-seven years old and on the brink of a long and brilliant career—as artist *and* diplomat—that led to some of the most glorious

1

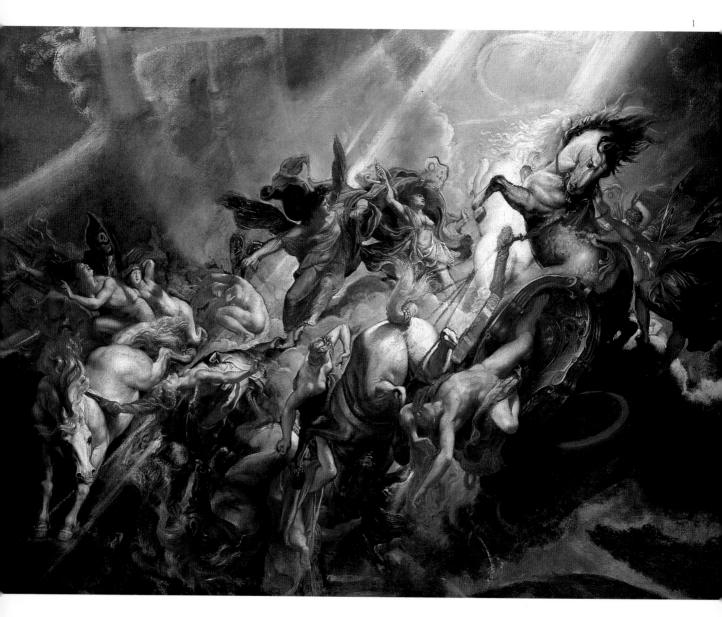

royal commissions of the time. His mother had helped prepare him for the world stage from an early age. He was ten years old when his father died and his mother moved with the children to Antwerp, where she sent the young Rubens to Latin School and then to serve the Countess of Lalaing as a page. After his apprenticeship in artists' studios, he became a member of the Painters' Guild in Antwerp in 1598. Two years later, Rubens traveled to Italy. He soon became court painter to the Duke of Mantua, Vicenzo Gonzaga, who sent the young artist to Rome to serve as proxy at the marriage of Marie de' Medici, who would later inspire one of his great decorative cycles.

But it was in Antwerp, not Rome, where Rubens ultimately lived and worked, creating the Flemish baroque—a synthesis of the Italian grand manner and his native Flemish technical mastery. Rubens' baroque vision is exemplified by the scale and ambition of his canvas *Daniel in the Lions' Den*, *c*.1613 [2]. Baroque artists magnified the world—not only by executing very large

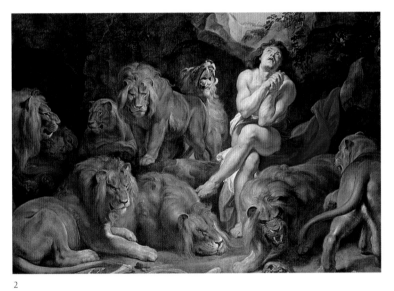

2

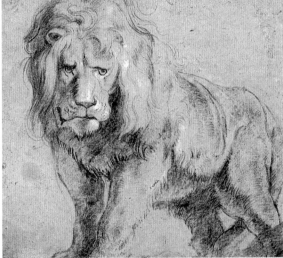

3

canvases, but also by enhancing nature with intense color, focus, and light. As seen in the illuminated figure of Daniel in the shadowy den, Rubens also made dynamic use of *chiaroscuro* (literally, "light-dark" in Italian). This was the technique of contrasting light and shadow, which had been developed by Renaissance artists, and perfected by Caravaggio in Rome at the turn of the sixteenth century.

While the robust figure of Daniel is indebted to Titian and Michelangelo, the palpable warmth of the lions' bodies as they prowl, life-size, before the viewer, is uniquely Rubensian. The artist, whose leonine, red beard became legendary through his self-portraits, once said: "I am by natural instinct better fitted to execute very large works than little curiosities" (1621). In this age of passionate individualists, even the lion's gaze in Rubens' drawing [3] transcends mere animal intelligence .

2 Peter Paul Rubens
Flemish, 1577–1640
Daniel in the Lions' Den
c.1613
oil on canvas
88 1/4 in x 130 1/8 in (2.24 m x 3.3 m)
Ailsa Mellon Bruce Fund
1965.13.1

3 Peter Paul Rubens
Flemish, 1577–1640
Lion
c.1612–1613
black chalk heightened with white
14 3/4 in x 9 7/8 in (37.5 cm x 25.1 cm)
Ailsa Mellon Bruce Fund
1969.7.1

4 Peter Paul Rubens
Flemish, 1577–1640
Young Woman in Profile
*c.*1613
black chalk, heightened with white,
yellow chalk in the background
14 3/4 in x 9 7/8 in (37.5 cm x 25.1 cm)
Ailsa Mellon Bruce Fund
1978.18.1

5 Peter Paul Rubens
Flemish, 1577–1640
Marchesa Brigida Spinola Doria
1606
oil on canvas
60 in x 39 in (1.53 m x 99 cm)
Samuel H. Kress Collection
1961.9.60

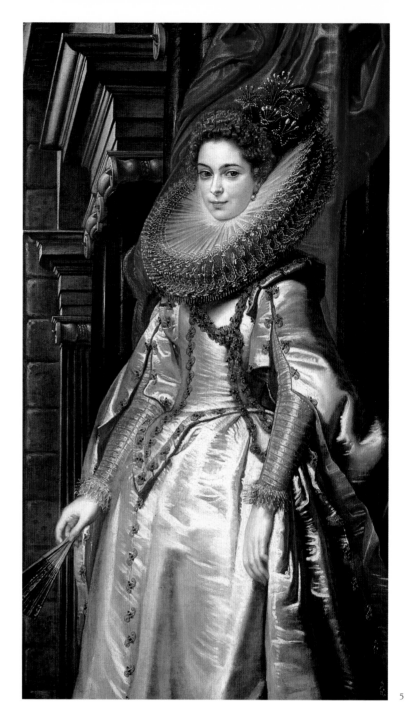

5

4

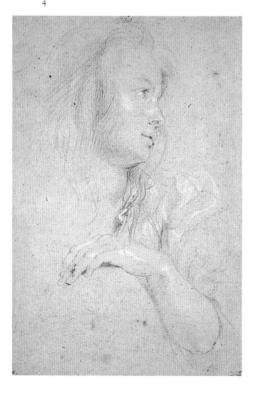

Rubens, the arch-diplomat, also portrayed his noble patrons as larger than life. In his portrait, *Marchesa Brigida Spinola Doria*, painted in Genoa in 1606 [5], he devoted considerable attention to the subject's social trappings—from her cascading golden dress and extraordinary silvery-white collar to the classical columns draped in red velvet. Her diminutive head is radiant, with blushing cheeks and lips piqued with pleasure. The artist reserved a more spontaneous approach for more intimate sketches, such as *Young Woman in Profile* [4]. In this economical black chalk drawing, her lively features are enhanced by the artist's use of white highlights, animating her expression, and accentuating the folds in her ruffled dress and open collar.

The master of baroque portraiture, Anthony van Dyck, had been one of Rubens' star pupils. Van Dyck appealed to the vanity of his noble patrons by exaggerating their height and arranging them in the regal posture that became a signature of his style. He won major commissions and even a knighthood from Charles I of England (who was famously short). The artist portrayed the Marchesa Elena Grimaldi [6] dressed in black, standing before a classical façade on a stormy evening. Her pale, aquiline features are offset further by a brilliant red parasol held by an African servant. In the same year, 1623, Van Dyck painted an equally authoritative portrait, of her son Filippo [7], a mere boy, whose regal pose, with one arm akimbo and his right foot forward, demonstrates the artist's ability to endow his subjects with a commanding presence.

6 Anthony van Dyck
Flemish, 1599–1641
Marchesa Elena Grimaldi,
Wife of Marchese Nicola Cattaneo
probably 1623
oil on canvas
97 in x 68 in (2.46 m x 1.73 m)
Widener Collection
1942.9.92

6

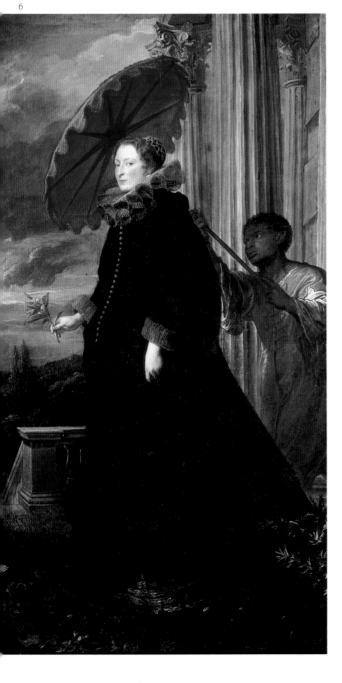

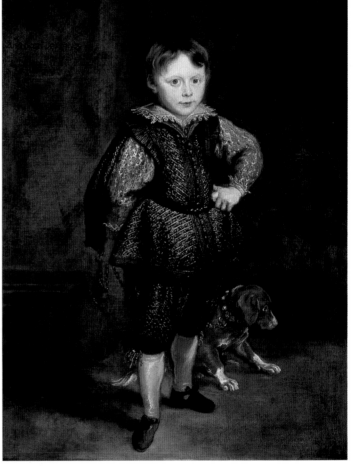

7

7 Anthony van Dyck
Flemish, 1599–1641
Filippo Cattaneo,
Son of Marchesa Elena Grimaldi
1623
oil on canvas
39 7/8 in x 31 in (1.01 m x 78.7 cm)
Samuel H. Kress Collection
1939.1.387

8 El Greco (Domenikos Theotokopoulos)
Greek, 1541–1614
Laocoön
c.1610/1614
oil on canvas
54 1/8 in x 67 7/8 in (1.38 m x 1.73 m)
Samuel H. Kress Collection
1946.18.1

The unique style of Domenikos Theotokopoulos, or El Greco ("The Greek"), arose from the mysticism of the Catholic church during the Counter-Reformation in Spain. He was born in 1541 in Crete of an orthodox family, and moved to Venice before settling in Toledo, Spain, in 1577.

Although El Greco's eccentric style, characterized by elongated figures and unstable, spiralling compositions, is often identified with Italian mannerism, he was an individualist who belonged to no school or movement. *Laocoön* [8], completed shortly before his death in 1614, was his only painting of a mytho-logical subject. As told by Virgil, Laocoön was the priest who warned the citizens of Troy not to admit the Greeks' gift of the wooden horse. Laocoön and his sons were then attacked and killed by sea-serpents, sent by Athena, the protector of the Greeks. The ensuing struggle is the subject of a sculpture, one of the most famous works of antiquity, which was discovered in 1506 and on display at the Vatican when El Greco visited Rome in 1570.

El Greco's *Laocoön* is a macabre dance of death. One son, in a bow-shaped posture (far left), frames the composition as he flinches from the serpent looping around to bite at his waist. The other son's sinewy thighs and twisted, fore-

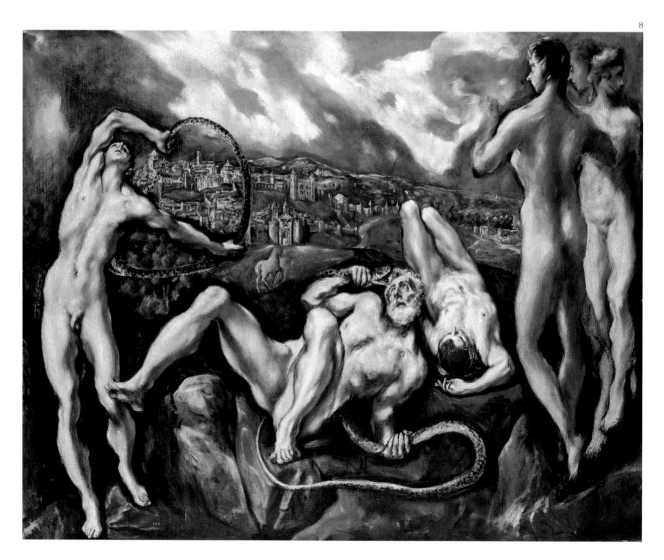

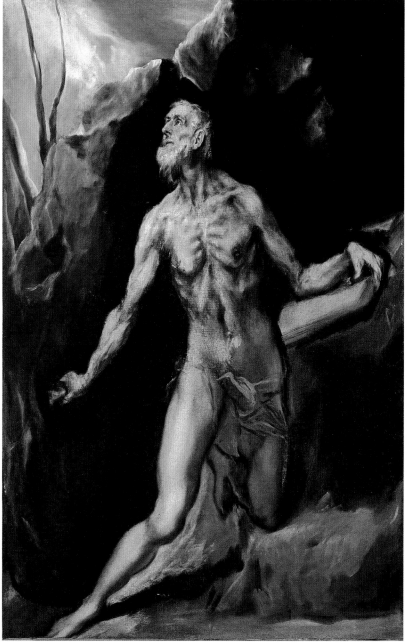

9

9 El Greco (Domenikos Theotokopoulos)
Greek, 1541–1614
Saint Jerome
c.1610/1614
oil on canvas
66 ¹/₈ in x 43 ¹/₂ in (1.68 m x 1.1 m)
Chester Dale Collection
1943.7.6

shortened torso are flexed in agony. Laocoön topples backward as he holds the snake's jaws within inches of his face. Three Trojan witnesses watch in impotent horror (far right), their bodies levitating and revolving around an invisible spiral. In El Greco's *Saint Jerome* [9], the saint cranes toward the heavens, his gesture emphasized by his elongated body. Jerome (c.342–420) was one of the most popular saints of the Renaissance. Artists often portrayed him as a scholar, since he translated the Bible into Latin, or as a hermit clutching a rock, because he beat himself in penitence. El Greco's representation is more abstract. Saint Jerome's expression is one of ecstasy, inspiring awe in the viewer. Even in the secular setting of the Gallery, visitors have fallen to their knees before this painting.

10 Jusepe de Ribera
Spanish, 1591–1652
The Martyrdom of Saint Bartholomew
1634
oil on canvas
41¼ in x 44⅞ in (1.05 m x 1.14 m)
Gift of the 50th Anniversary Gift
Committee
1990.137.1

Spanish artists of the Counter-Reformation used the baroque techniques of *chiaroscuro* and dramatic perspective to bring to life the saints and martyrs of Christendom. Jusepe de Ribera's *The Martyrdom of Saint Bartholomew* of 1634 [10] concentrates on the saint's outstretched arms, a characteristic baroque gesture that draws the viewer into this grisly portrayal of martyrdom.

Ribera's exact contemporary, Francisco de Zurbarán, painted praying monks and saints for Spanish and Latin American monasteries and churches. Saint Lucy was a virgin martyr who, according to legend, gouged out her eyes and presented them to her suitor, as he had found them seductive. Later, her vision was miraculously restored. Saint Lucy, named after *luceo*, or light, was invoked during the Counter-Reformation by those suffering from blindness, as well as by those seeking divine light. Zurbarán's *Saint Lucy* from *c*.1625/1630 [11] presents her watchful eyes on a platter [12, detail] like a still life of surreal fruit.

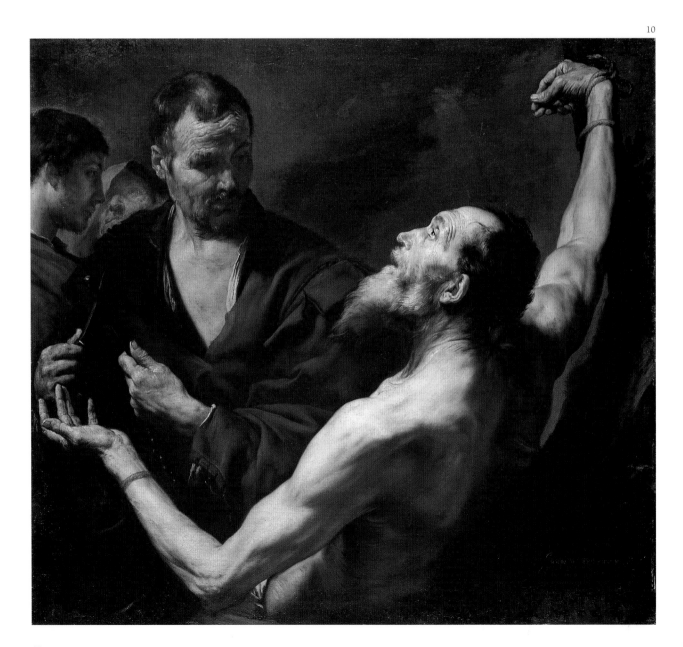

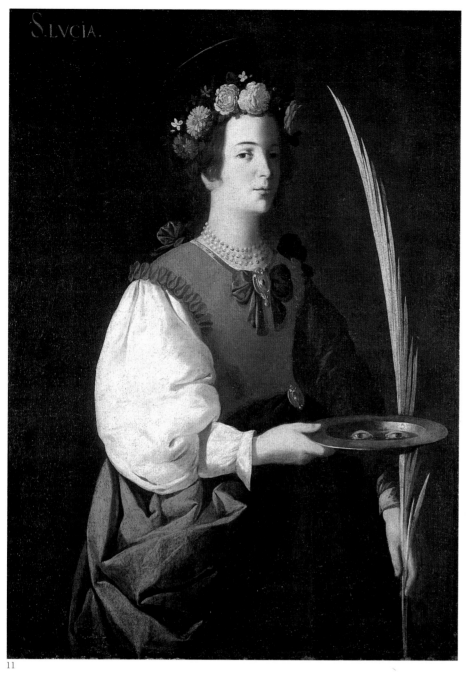

S.LVCIA.

11

But between a person and a destiny stands the world, and Zurbarán now makes it enter the stage through the bias of a dream.

CARLOS FUENTES (b.1928)
Zurbarán's Theater of Martyrs,
1987

11 Francisco de Zurbarán
Spanish, 1598–1664
Saint Lucy
*c.*1625/1630
oil on canvas
41 3/8 in x 30 1/4 in
(1.05 m x 77 cm)
Chester Dale Collection
1943.7.11

12 Detail of [11] showing eyes on platter.

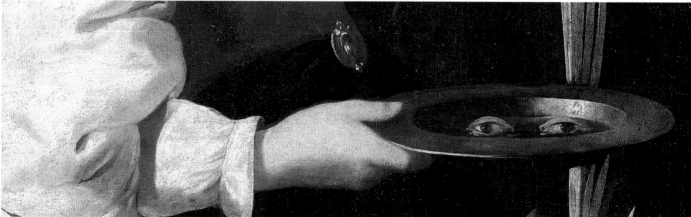

12

13 Nicolas Poussin
French, 1594–1665
The Baptism of Christ
1641/1642
oil on canvas
37 ⅝ in x 47 ⅝ in (95.5 cm x 1.21 m)
Samuel H. Kress Collection
1946.7.14

In French art of the seventeenth century, a more reserved, classical style prevailed. The French painters Nicolas Poussin and Claude (Claude Gellée, also known as Claude Lorrain) lived and worked in Rome, painting classical themes. An ideal landscape often plays a vital role in Poussin's mythological and religious paintings. In *The Baptism of Christ* [13], begun in Rome and completed in Paris in 1641/1642, Poussin recreated the river landscape where the Baptism took place. In this balanced composition, the undulating river divides the painting into halves: the right bank, where two wingless angels appear, symbolizes Paradise; the left is the earthly side.

But the true subject of this painting is invisible, for Poussin has chosen the moment—indicated by the Holy Ghost, in the form of a dove, seen over Christ's

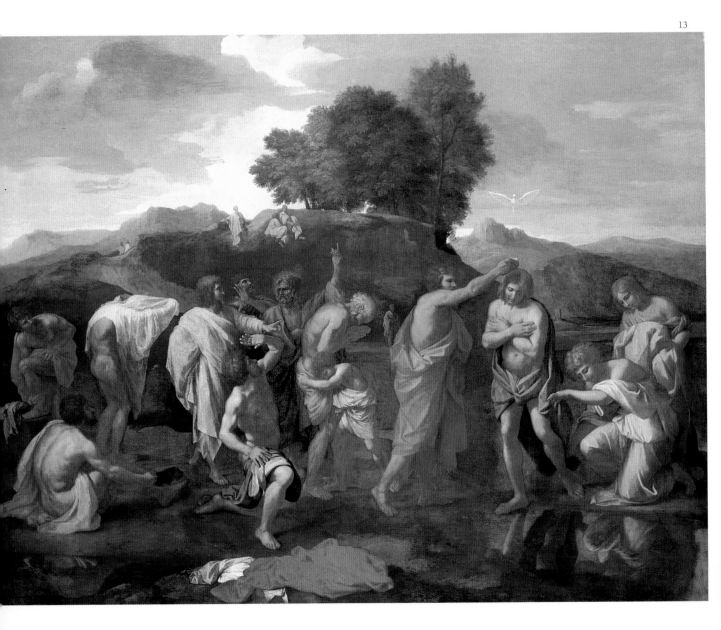

head—when God proclaims, "This is my beloved son; in whom I am well pleased" (Matthew 3:17, Luke 3:22). In a carefully orchestrated succession of poses, Poussin conveys the presence of God through the variety of responses to His invisible voice.

Claude perfected a classical vision of an Arcadian landscape, often inspired by Virgil or Ovid, as in *The Judgment of Paris* of 1645/1646 [14], another river landscape. While figures often dominated Poussin's paintings, landscape was Claude's true subject and he composed his perfectly balanced landscapes from ancient architecture and ruins, often framed by feathery trees. The extraordinary luminosity of his skies conveyed the timelessness of his Arcadian world.

14 Claude Lorrain
French, 1600–1682
The Judgment of Paris
1645/1646
oil on canvas
44 ¼ in x 58 ⅞ in (1.12 m x 1.5 m)
Ailsa Mellon Bruce Fund
1969.1.1

14

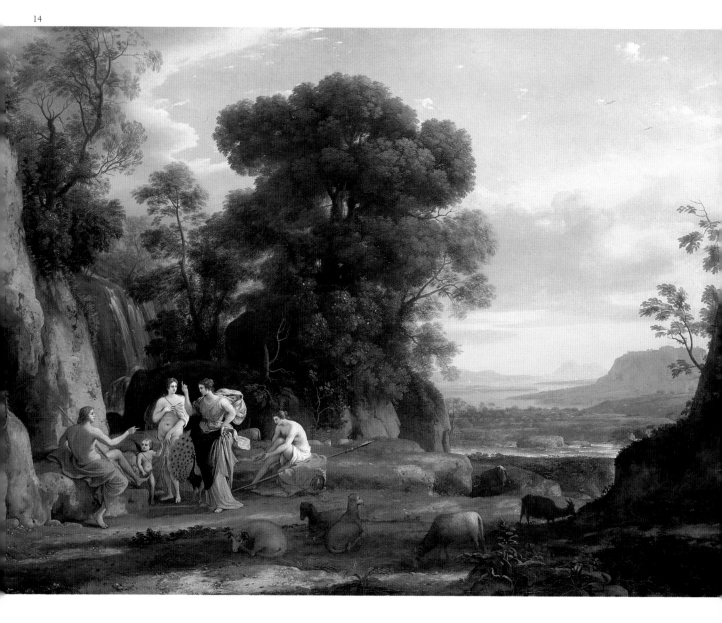

15 Frans Hals
Dutch, c.1582/1583–1666
Adriaen van Ostade
1646/1648
oil on canvas
37 in x 29 ½ in (94 cm x 75 cm)
Andrew W. Mellon Collection
1937.1.70

16 Detail of [15] showing brushstroke
and glove-in-hand

17 Adriaen van Ostade
Dutch, 1610–1685
The Cottage Dooryard
1673
oil on canvas
17 ³⁄₈ in x 15 ⁵⁄₈ in (44 cm x 39.5 cm)
Widener Collection
1942.9.48

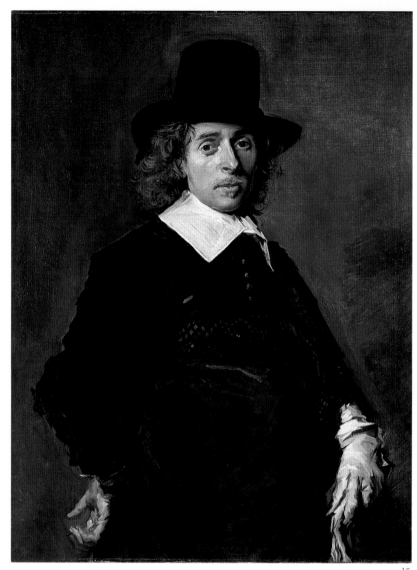

15

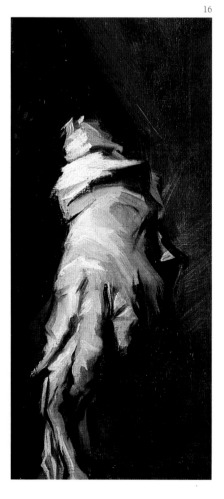

16

In the protestant North, Dutch artists from Rembrandt to Vermeer developed easel painting on a more modest scale. They dedicated themselves to landscapes, seascapes, still lifes and scenes of daily life, or genre paintings. Dutch genre painters not only captured the boisterousness and variety of everyday life, but also its spiritual quality.

Frans Hals specialized in portraits of his fellow citizens of Haarlem. Eschewing the idealization of society portraits, he portrayed his contemporaries with accuracy and humor, painted with remarkably free, abstract brushstrokes. Hals' portrait of his former apprentice, the painter Adriaen van Ostade [15], records his large eyes and generous mouth, but also his weak chin. Hals, then in his late sixties, reveals an authoritative, assured brushstroke in his trademark glove-in-hand [16, detail]. Van Ostade himself was a prolific genre painter, whose affectionate scenes of village life portrayed collies and chickens with as much personality as the human inhabitants, as in his *The Cottage Dooryard* of 1673 [17].

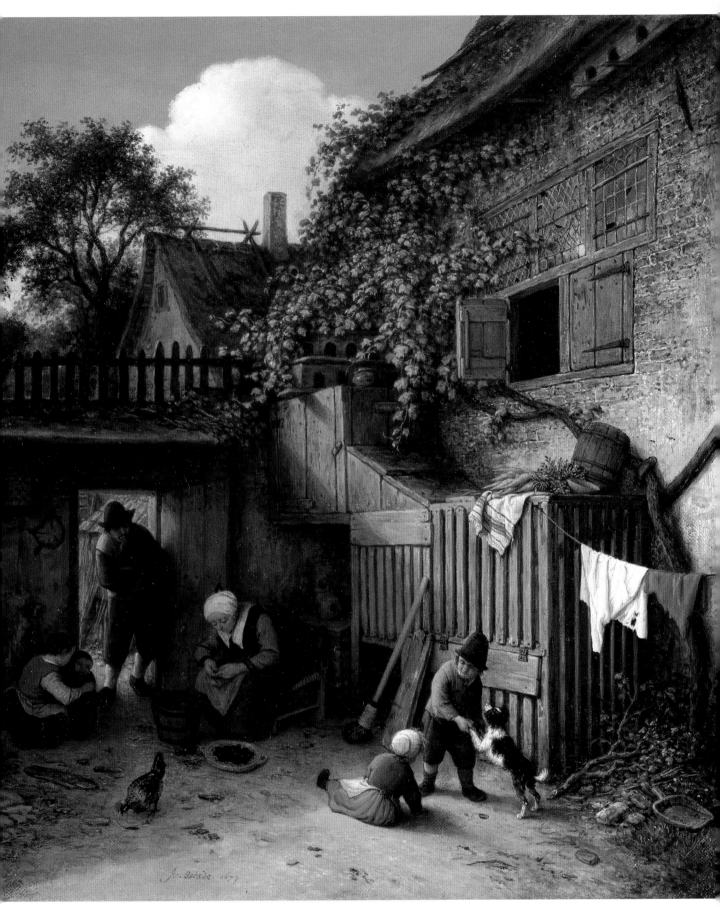

17

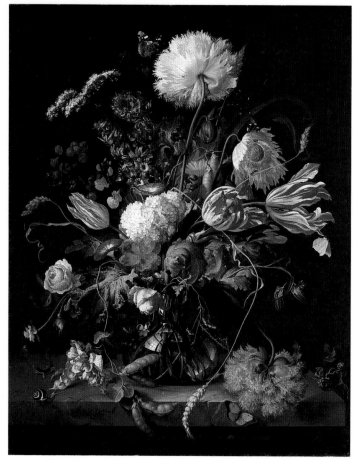

18

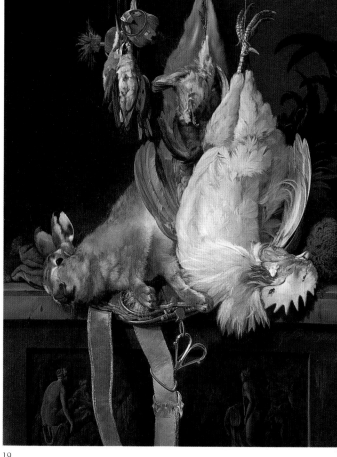

19

18 Jan Davidsz. de Heem
Dutch, 1606–1683 or 1684
Vase of Flowers
*c.*1645
oil on canvas
27 3/8 in x 22 1/4 in (69.6 cm x 56.5 cm)
Andrew W. Mellon Fund

19 Willem van Aelst
Dutch, 1625 or 1626–1683
Still Life with Dead Game
1661
oil on canvas
33 3/8 in x 26 1/2 in (84.7 cm x 67.3 cm)
Pepita Milmore Memorial Fund

20 Jan van Goyen
Dutch, 1596–1656
View of Dordrecht from the Dordtse
1644
oil on panel
25 1/2 in x 37 3/4 in (64.7 cm x 95.9 cm)
Ailsa Mellon Bruce Fund
1978.11.1

21 Aelbert Cuyp
Dutch, 1620–1691
The Maas at Dordrecht
*c.*1660
oil on canvas
45 1/4 in x 67 in (1.15 m x 1.7 m)
Andrew W. Mellon Collection
1940.2.1

While Van Ostade's genre paintings bustled with activity, the Dutch still life stopped time. Van Ostade's contemporary, Jan Davidsz. de Heem, arrested all movement to reveal the minutiae of nature in his flower paintings [18]. Dutch still life could be startling in its accuracy and lack of sentimentality, as in the bloodied nose of the dead rabbit that appears in lucid detail in Willem van Aelst's painting [19].

Still life meets landscape in the work of Aelbert Cuyp, with its clarity of detail and tranquil atmosphere. Especially when compared with the older master Jan van Goyen's painting of the bustling port of Dordrecht of 1644 [20], Cuyp's *The Maas at Dordrecht* of around 1660 [21] is remarkably still. The slackened sails and glassy waters create an atmosphere of quietude that is typical of this later, classical phase of Dutch landscape painting.

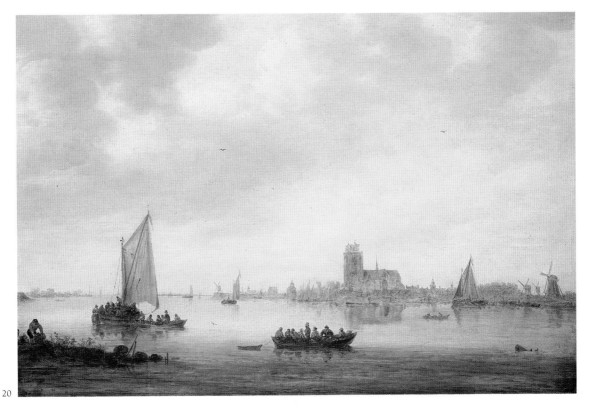

20

21

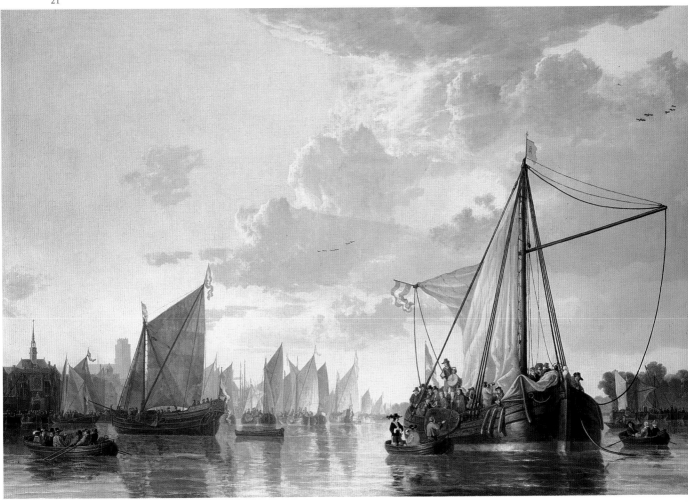

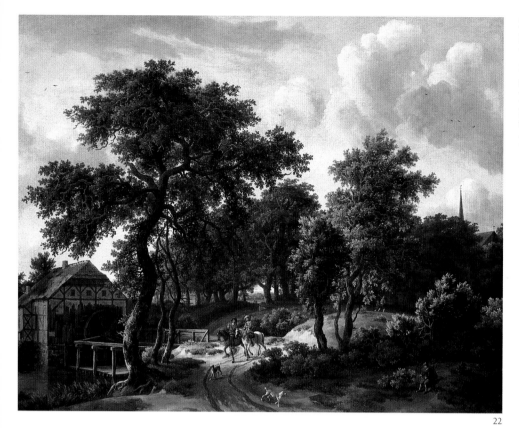

22

22 Meindert Hobbema
Dutch, 1638–1709
The Travelers
166(2?)
oil on canvas
39 7/8 in x 57 in
(1.01 m x 1.45 m)
Widener Collection
1942.9.31

23

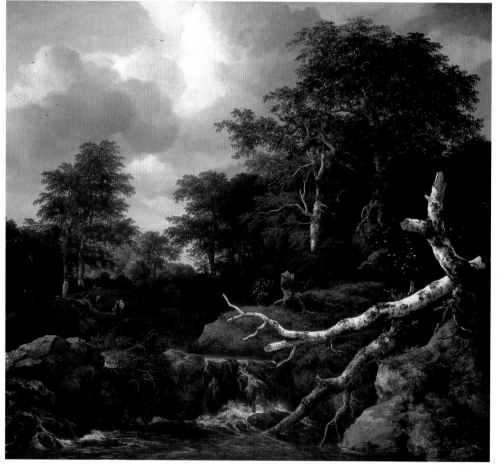

23 Jacob van Ruisdael
Dutch, 1628 or
1629–1682
Forest Scene
c.1660/1665
oil on canvas
41½ in x 51½ in
(1.05 m x 1.31 cm)
Widener Collection
1942.9.80

24 Rembrandt van Rijn
Dutch, 1606–1669
View over the Amstel
from the Rampart
c.1646
pen and brown ink
with brown wash
3½ in x 7¼ in
(8.9 cm x 18.5 cm)
Rosenwald Collection
1954.12.114

25 Detail of [24]
showing square-rigged
boat

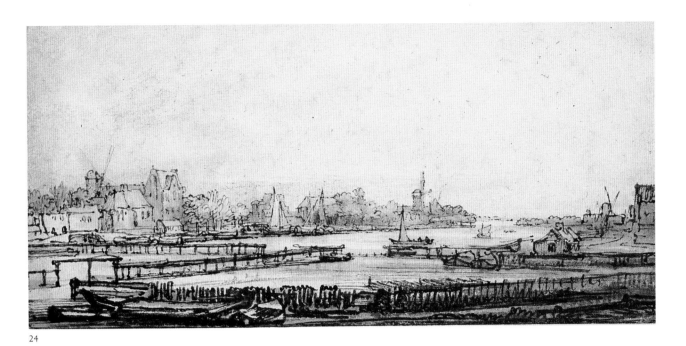

24

There is no more gracious invitation into the peaceful world of the Dutch countryside than Meindert Hobbema's signature, a winding road [22]. Like his teacher, the master Jacob van Ruisdael, Hobbema sketched from life. Hobbema's finished paintings reflect the artist's sense of balance and composition, enriched by his faithful study of nature. And yet Ruisdael was the master of poetic detail, imbuing his landscapes with spiritual meaning, often suggesting themes of death and decay. A stark, severed tree appears in the foreground of *Forest Scene* [23], a painting of the early 1660s of a verdant forest with a stream running through it. The tip of a dead branch dips into the coursing stream, as if to suggest that death and decay are part of the life cycle. The scene is illuminated by the silvery light of overcast skies.

Yet it was the son of a miller, called Rembrandt van Rijn, who, in his drawings and prints, was to invest the flat farmland, windmills and cottages of the Dutch landscape with an idyllic quality rivaling Italian Arcadia. Rembrandt's drawings reveal the master's sense of economy and impeccable knowledge of the Dutch countryside. With a few strokes of a pen, he was capable of conjuring the tips of a wooden fence poking through the snow—as well as a profound sense of spiritual quietude. Many of Rembrandt's landscape drawings date from the 1640s, a period of introspection for the artist after the death of his wife Saskia. A consummate example of his direct studies from nature is his *View over the Amstel from the Rampart* [24], from around 1646. The square-rigged boat that bobs in the water [25, detail] arguably conveys more life and air and realism in a square inch (centimeter) than entire landscape paintings by his more literally-minded contemporaries.

25

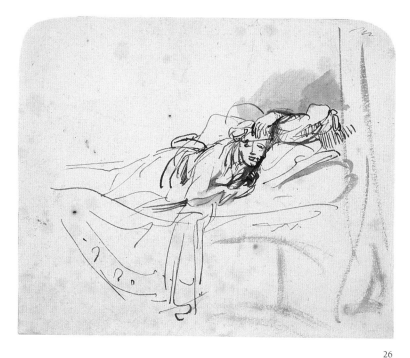

26

Ah, fading joy, how quickly art thou past!
Yet we thy ruin haste.

JOHN DRYDEN (1631–1700)
Song from *The Indian Emperor*

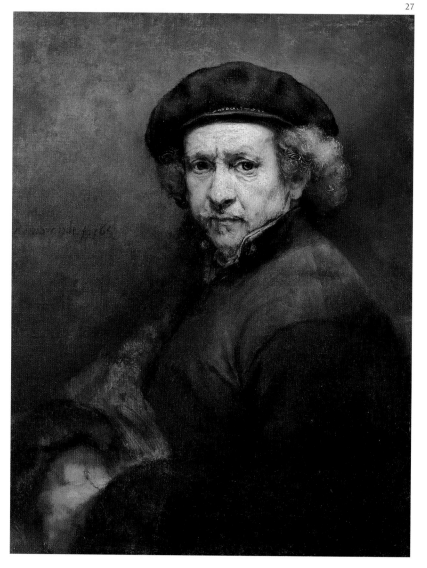

27

26 Rembrandt van Rijn
Dutch, 1606–1669
Saskia Lying in Bed
*c.*1638
pen and brush with brown ink on laid paper
5 ¾ in x 7 in (14.7 cm x 17.8 cm)
Ailsa Mellon Bruce Fund
1966.2.1

27 Rembrandt van Rijn
Dutch, 1606–1669
Self-Portrait
1659
oil on canvas
33 ¼ in x 26 in (84.5 cm x 66 cm)
Andrew W. Mellon Collection
1937.1.72

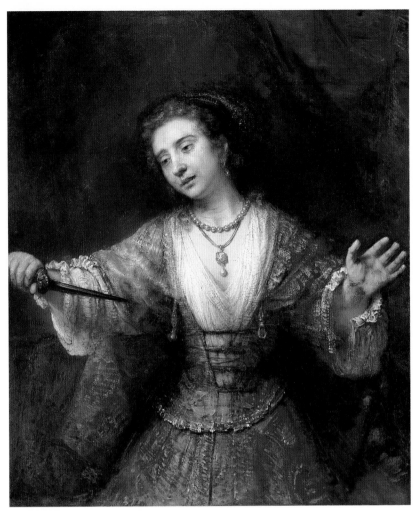

28

Even here she sheathed in her
 harmless breast
A harmful knife, that thence her soul
 unsheathed.

WILLIAM SHAKESPEARE (1564–1616)
The Rape of Lucrece

Rembrandt's portraits, from his most intimate sketches to his more formal compositions, have a directness and accessibility that give the viewer the impression of encountering a person, not a painting. In a drawing of his beloved Saskia from the late 1630s [26], his sensitive line not only inscribes her feminine form, but also his feelings of tenderness and intimacy. Rembrandt is also renowned for his self-portraits. The artist was about fifty years old and living in Amsterdam when he painted his *Self-Portrait* of 1659 [27]. He does not include any reference to the material world, but focuses instead on his fully lit wrinkled face framed by darkness. His expression is philosophical, reflecting Descartes' defiant words, written in exile in Holland in 1637, "I think, therefore I am."

Rembrandt was fascinated by psychological torment, and often turned to the Bible or Roman history for inspiration. In 1664, he portrayed Lucretia [28] in her moment of decision before committing suicide, after being raped by Sextus, the son of the tyrannical king of Rome. Before dying, she told her father and husband what Sextus had done, inciting a rebellion against the king that led to republican government. In Rembrandt's painting, Lucretia appears almost life-size, her outstretched hands pressed close to the picture plane as the impotent viewer looks on.

28 Rembrandt van Rijn
Dutch, 1606–1669
Lucretia
1664
oil on canvas
47 1/4 in x 39 1/4 in (1.2 m x 1 m)
Andrew W. Mellon Collection
1937.1.76

29 Johannes Vermeer
Dutch, 1632–1675
Woman Holding a Balance
*c.*1664
oil on canvas
15 7/8 in x 14 in (39.7 cm x 35.5 cm)
Widener Collection
1942.9.97

Johannes Vermeer, born in 1632 in Delft, was the son of a weaver of fine satin fabrics who later purchased an inn, where he bought and sold art. Nothing is known of Vermeer's apprenticeship before he was registered as a master painter in the Saint Luke's Guild in Delft in 1653. He began his career painting mythological and biblical subjects before turning to small, entrancing canvases that portrayed scenes of daily life. Vermeer made simple, domestic tasks appear transcendent. In *Woman Holding a Balance* [29], a filtered shaft of light plays

29

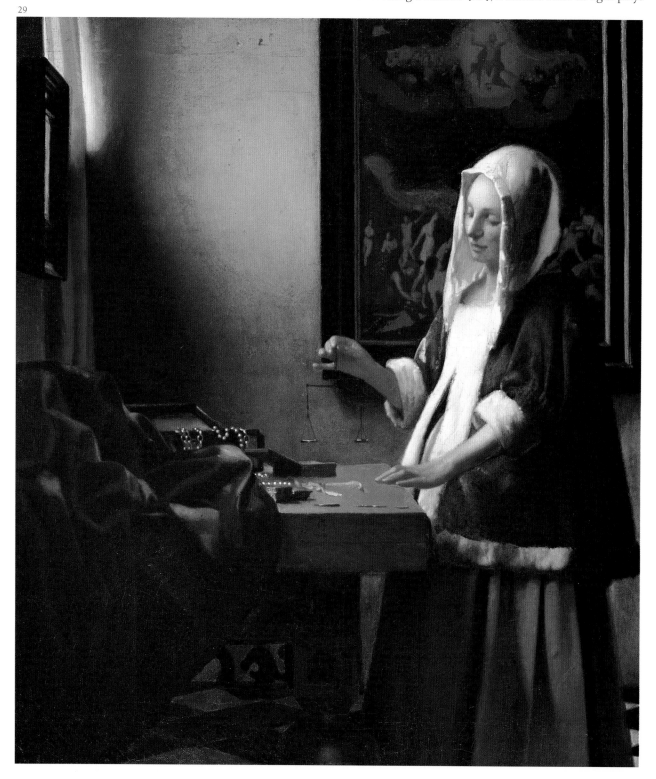

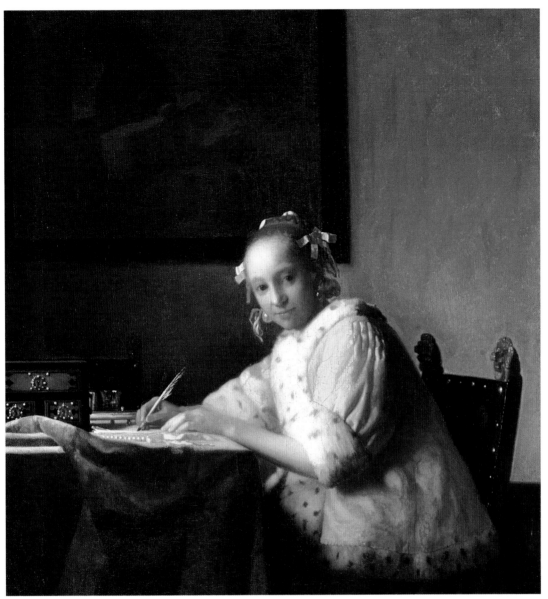

30

But true expression, like the unchanging sun,
Clears and improves whate'er it shines upon;
It gilds all objects, but it alters none.

ALEXANDER POPE (1688–1744)

across the pearls on the table, the blue cloth, and metal pans of the balance, which she holds with luminous fingertips. Microscopic examination reveals that the pans are empty. Questions multiply: does the painting refer to the value of worldly possessions? Or to the Last Judgment—the subject of the painting in the background? In *A Lady Writing* [30], a woman dressed in an elegant, fur-lined jacket writes at her desk. It appears from her expectant smile that somebody has interrupted her. Yet her concentration is unbroken; for her quill pen holds her place. Both works possess the lucidity and calm of still life, and the solemnity of religious painting.

30 Johannes Vermeer
Dutch, 1632–1675
A Lady Writing
*c.*1665
oil on canvas
17 ¾ in x 15 ¾ in (45 cm x 39.9 cm)
Gift of Harry Waldron Havemeyer and
Horace Havemeyer, Jr., in memory of their
father, Horace Havemeyer
1962.10.1

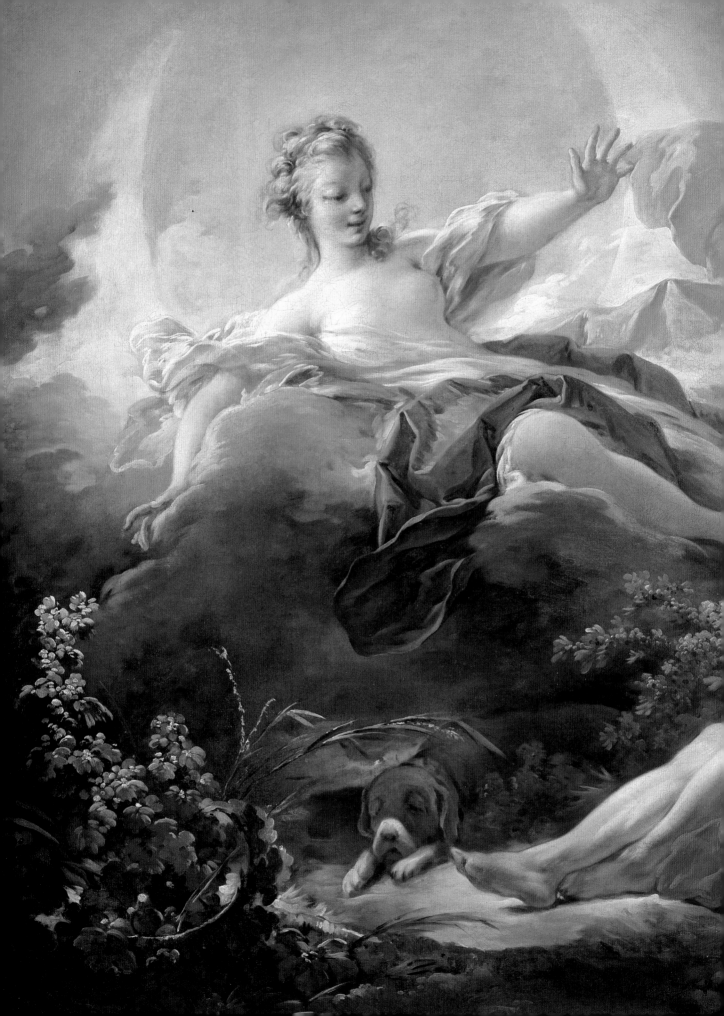

18th century

Of lords, and earls, and dukes, and gartered knights,
While the spread fan o'ershades your closing eyes;
Then give one flirt, and all the vision flies.
Thus vanish sceptres, coronets, and balls,
And leave you in lone woods, or empty walls.

ALEXANDER POPE (1688–1744)
Epistle to Miss Blount

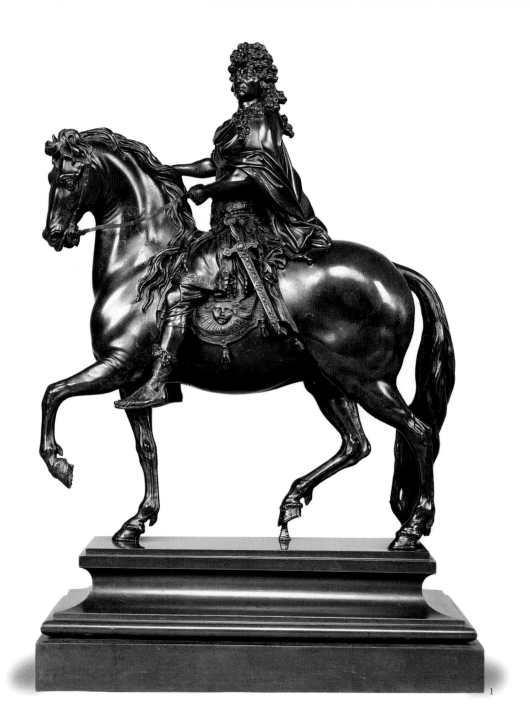

1

1 After Martin Desjardins
French (n.d.)
Louis XIV
*c.*1683/1699
cast *c.*1699 in Paris by Roger Schabol
(b. Brussels *c.*1656)
bronze
(with base) 22 1/4 in x 8 5/8 in x 15 3/4 in
(56.6 cm x 21.9 cm x 40 cm)
Andrew W. Mellon Fund
1971.5.2

PREVIOUS PAGES
Jean-Honoré Fragonard
Diana and Endymion [9]

T he eighteenth century was an age of revolution and reform. Styles in art across Europe ranged from the rococo fantasies of Boucher and Fragonard, to the realism of Chardin and Canaletto, to the visionary, sometimes nightmarish fantasies of Piranesi and Goya. In this century of revolutions—1776 in America and 1789 in France are dates emblazoned in the collective memory—artistic styles provoked passionate debate. By the late 1700s, the rococo style was disdained by anti-royalists because it was associated with the aristocratic tastes of the *ancien régime,* while the neoclassicism of Jacques-Louis David, a revival that would have been considered conservative at the beginning of the century, was seen as revolutionary.

"Rococo"—a derogatory term devised in retrospect by the neoclassicists—first emerged in the decorative arts in France after the death of Louis XIV in 1715 [1]. With the transfer of court from Versailles to Paris, the aristocracy had grown disenchanted with classicism and with the operatic grandeur of seventeenth-century baroque. A more light-hearted style was preferred, to suit the more modest scale of Parisian houses. The word "rococo" originally described a type of ornament, called *rocaille*, inspired by the shell-and-pebble mosaics in the grottoes of the Versailles gardens. The style quickly evolved in the decorative arts and, by mid-century, every fashionable *salon* from Paris to Munich was decorated with rococo furnishings and decorative garlands, vines, tendrils, and shells. The master craftsman Charles Cressent's writing table [2], dating from mid-century, represents the height of rococo craftmanship.

Rococo evolved more gradually in painting. Antoine Watteau is considered the first rococo painter, although his style was transitional and firmly rooted in baroque tradition. *Ceres (Summer)* [3], from 1715/1716, marks the transition from baroque grandeur to rococo elegance. The imposing figure of the goddess was inspired by Rubens and Veronese; and yet, the lion at her side resembles a giant lap-dog compared with Rubens' virile beasts (see Chapter four). Watteau soon abandoned baroque monumentality for a lighter palette and more

2 Charles Cressent
French, 1685–1768
Writing Table (bureau plat)
*c.*1735/1745
veneered on oak and pine with kingwood, tulip-wood, purple-wood, boxwood, and ebony; mounted with gilt bronze
33 in x 76 3/8 in x 39 3/4 in
(83.8 cm x 1.94 m x 1.01 m)
Widener Collection
1942.9.423

2

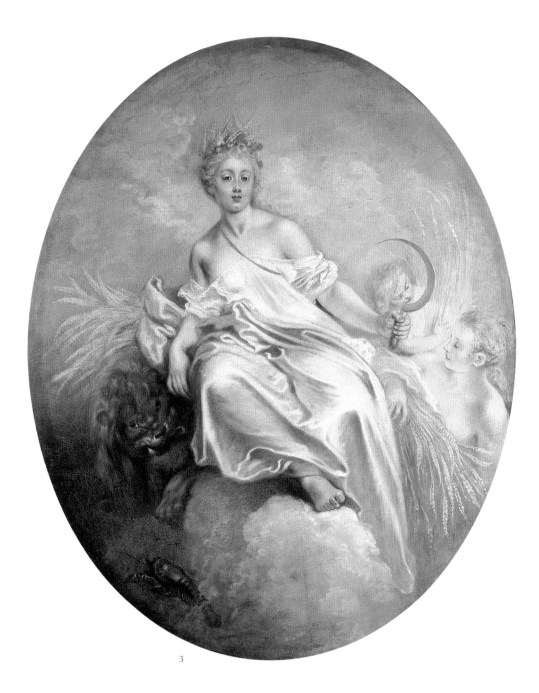

3

3 Antoine Watteau
French, 1684–1721
Ceres (Summer)
1715/1716
oil on canvas
oval, 55 3/4 in x 45 5/8 in (1.42 m x 1.16 m)
Samuel H. Kress Collection
1961.9.50

enigmatic, often amorous, subjects. His drawing, *Couple Seated on the Ground* [4], from around 1716, is in fact a composite of two separate studies of a man and woman, each drawn to a different scale. Watteau's line is a form of contrapuntal writing—a weaving together of three chalks that creates the impression of scintillating movement.

He developed an equally precise and graceful line in his painting. One of his most memorable characters is a popular character in eighteenth-century French theatre, Gilles. He appears at center-stage in Watteau's masterpiece *Italian Comedians*, thought to have been painted in 1720 [5]. Gilles is portrayed as a clownish figure in his ethereal white costume, with a garland of white roses strewn at his feet. Watteau avoids any narrative by choosing a moment between acts or even at curtain call. His focus rests on Gilles' insouciant expression.

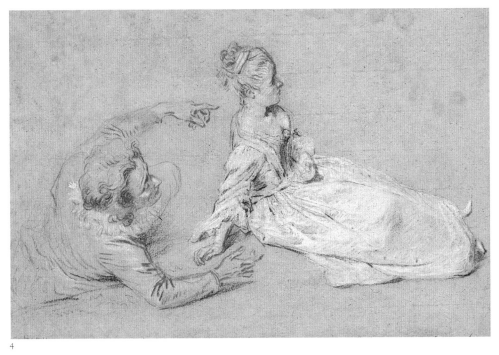

4 Antoine Watteau
French, 1684–1721
Couple Seated on the Ground
c.1716
red, black and white chalk on
brown laid paper
9 ½ in x 14 ⅛ in
(24.1 cm x 35.9 cm)
The Armand Hammer
Collection
1991.217.12

5 Antoine Watteau
French, 1684–1721
Italian Comedians
probably 1720
oil on canvas
25 ⅛ in x 30 in
(63.8 x 76.2 cm)
Samuel H. Kress Collection
1946.7.9

4

5

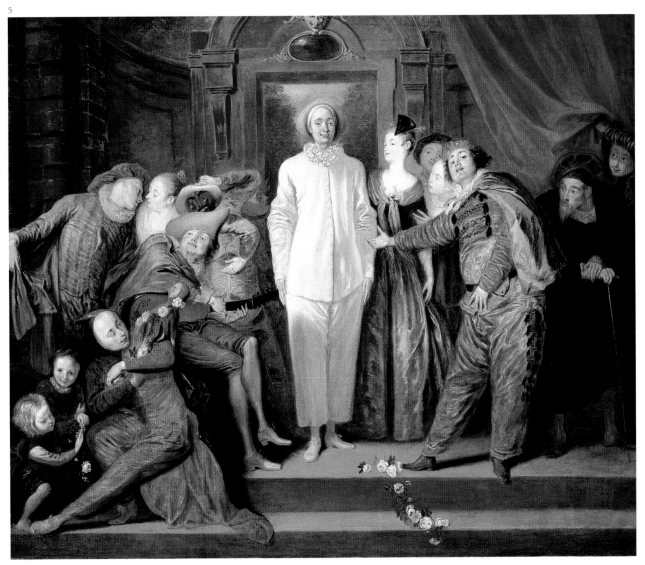

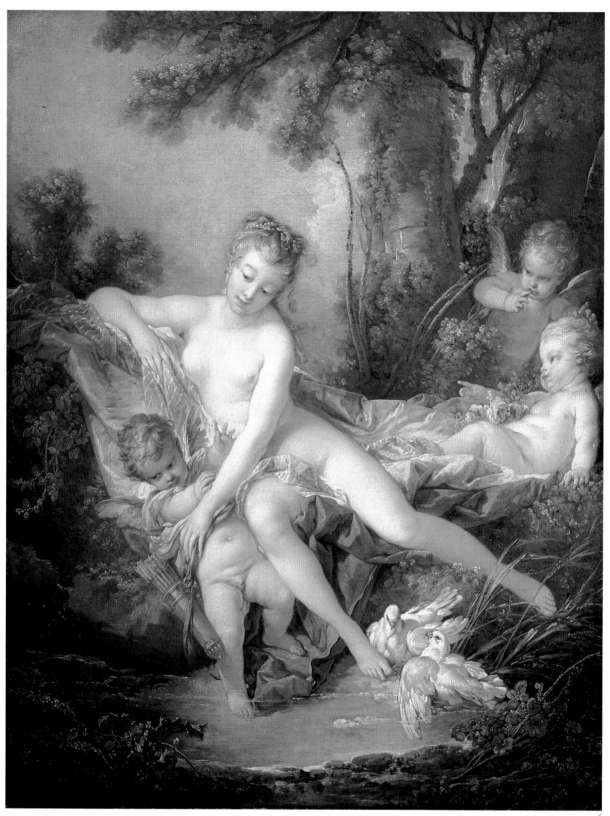

6 François Boucher
French, 1703–1770
Venus Consoling Love
1751
oil on canvas, 42 1/8 in x 33 3/8 in (1.07 m x 84.8 cm)
Chester Dale Collection
1943.7.2

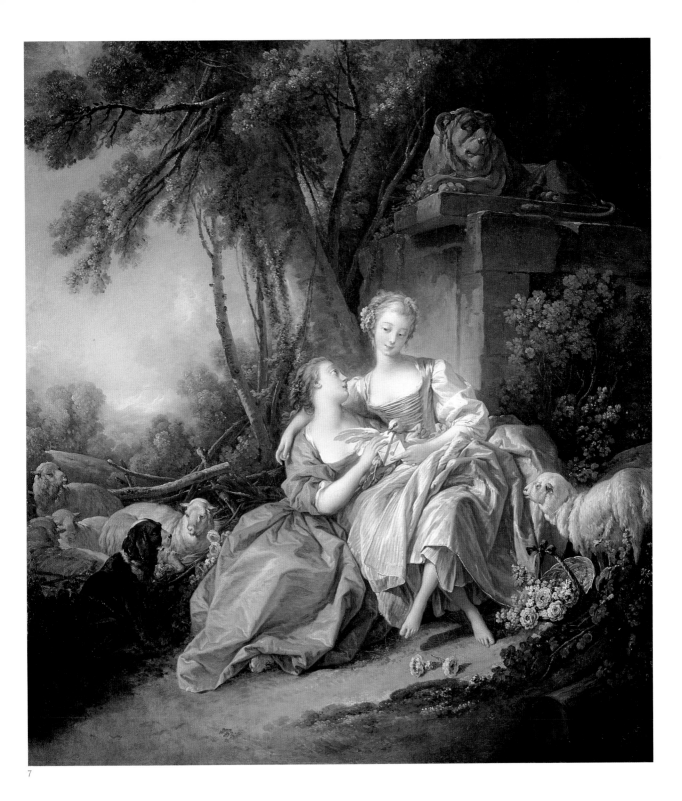

7

François Boucher, of the next generation, was less preoccupied with psychological depth than with erotic play. Born in Paris in 1703, he became the favorite painter of Louis XV's mistress, Madame de Pompadour. In *Venus Consoling Love* [6], from *c*.1751, the voluptuous figure of Venus was once believed to have been posed for by Mme de Pompadour herself. Boucher helped create a rococo ideal of feminine beauty; his women were invariably youthful, with skin of ivory and blushing cheeks, as in *The Love Letter* [7].

7 François Boucher
French, 1703–1770
The Love Letter
1750
oil on canvas mounted on wood
(fabric) 31 15/$_{16}$ in x 29 3/$_{16}$ in
(81.2 cm x 74.2 cm)
(panel) 32 1/$_{4}$ in x 29 5/$_{8}$ in (82 cm x 75.2 cm)
Timken Collection
1960.6.3

8

Nature in rococo painting was not only tamed, but artfully arranged. Boucher's most famous student, Jean-Honoré Fragonard, perfected an ideal rococo landscape—decorative, colorful, and whimsical. In his oval medallion commemorating love [8], the grass is every gardener's dream—no weeds, no fallen leaves, only a dewy lawn embroidered with flowers. Fragonard's trees, which would later inspire the British artist Thomas Gainsborough, are feathery and luxuriant, never having known a baroque storm. Rococo animals, too, are tamed. They are invariably docile companions, from the lion in Watteau's *Ceres (Summer)*, to the doves in Boucher's *Venus Consoling Love* and the dog and attentive sheep in Fragonard's *Diana and Endymion* [9], an early work close in style to Boucher.

In Fragonard's *The Swing* [10], the girl's ruffled skirts rise and fall to the delight of the peeping Tom below. The rococo artist's trees are light and airy, their movement synchronous with the pendulous rhythm of the girl on her swing—a rococo metaphor for sexuality. Besides providing an endless supply of

8 Jean-Honoré Fragonard
French, 1732–1806
Love as Folly
c.1775
oil on canvas
oval, 22 in x 18 1/4 in (55.9 cm x 46.4 cm)
In memory of Kate Seney Simpson
1947.2.1

9 Jean-Honoré Fragonard
French, 1732–1806
Diana and Endymion
c.1765
oil on canvas, 37 3/8 in x 53 7/8 in
(95 cm x 1.37 m)
Timken Collection
1960.6.2

10 Jean-Honoré Fragonard
French, 1732–1806
The Swing
probably c.1765
oil on canvas
85 in x 73 in (2.16 m x 1.86 m)
Samuel H. Kress Collection
1961.9.17

9

You must know the secret of the arts! It's to correct nature.
Voltaire (1694–1778)

10

Yet ah! Why should they know their fate?
Since sorrow never comes too late,
And happiness too swiftly flies.
Thought would destroy their paradise.
No more; where ignorance is bliss,
O! 'Tis folly to be wise.

THOMAS GRAY (1716–1771)
Ode on a Distant Prospect of Eton College

11 Jean-Honoré Fragonard
French, 1732–1806
A Game of Horse and Rider
1767/1773
oil on canvas
45 ³/₈ in x 34 ¹/₂ in (1.15 m x 87.5 cm)
Samuel H. Kress Collection
1946.7.5

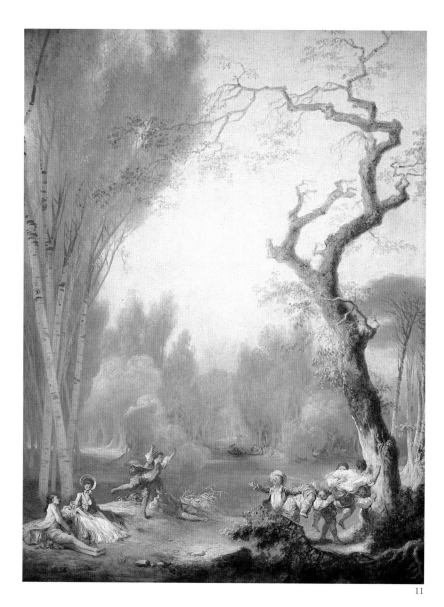

11

12 Jean Siméon Chardin
French, 1699–1779
The House of Cards
*c.*1735
oil on canvas
32 ³/₈ in x 26 in (82.2 cm x 66 cm)
Andrew W. Mellon Collection
1937.1.90

garlands for lovers, nature provides a theatrical setting for scenes of sexual play, as in Fragonard's mural-sized painting, *A Game of Horse and Rider* [11].

Although rococo was the most conspicuous style in France before the Revolution of 1789, the stillness and equilibrium of Jean-Siméon Chardin's compositions of the 1730s have more in common with the Dutch seventeenth-century master Vermeer (see Chapter 4) than with his French contemporaries Boucher or Fragonard. Chardin often portrayed children in a state of total absorption—whether blowing bubbles, learning to read, or playing cards. In Chardin's *The House of Cards* [12], painted around 1735, a boy, shown in luminous classical profile against a sober background, makes a delicately balanced semi-circle of cards—a diminutive classical architecture of its own.

12

13 Sir Joshua
Reynolds
British, 1723–1792
*Lady Elizabeth Delmé
and Her Children*
1777/1780
oil on canvas
94 in x 58 ⅛ in
(2.39 m x 1.48 m)
Andrew W. Mellon
Collection
1937.1.95

13

14

In England, the painter and arbiter of taste Sir Joshua Reynolds advocated a classical approach to painting. As the first President of the Royal Academy (1769–1789), he gave passionate lectures outlining his ideals in art, which were studied throughout England and America. "The Sublime in painting," he said, "as in poetry, [so] overpowers, and takes possession of the whole mind. . ." His aesthetic of the Sublime was rooted in his experience in Italy, where in 1750–1752 he studied classical art and architecture.

Reynolds' portraits reveal a certain sentimentality. In *Lady Elizabeth Delmé and Her Children*, from 1777–1780 [13], the artist presents the Delmé family as the model of domestic bliss. The theme of happy family life was also popular in the early 1780s in France, as in the work of Fragonard, whose paintings *The Happy Family* [14] and *The Visit to the Nursery* [15] resemble secular mangers.

14 Jean-Honoré Fragonard
French, 1732–1806
The Happy Family
after 1769
oil on canvas
oval, 21 1/4 in x 25 5/8 in (53.9 cm x 65.1 cm)
Timken Collection
1960.6.12

15

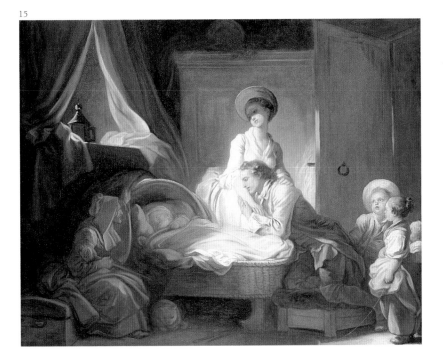

15 Jean-Honoré Fragonard
French, 1732–1806
The Visit to the Nursery
before 1784
oil on canvas
28 3/4 in x 36 1/4 in (73 cm x 92.1 cm)
Samuel H. Kress Collection
1946.7.7

16 Sir Joshua Reynolds
British, 1723–1792
Lady Caroline Howard
*c.*1778
oil on canvas
56 ¼ in x 44 ½ in (1.43 m x 1.13 m)
Andrew W. Mellon Collection
1937.1.106

17 Thomas Gainsborough
British, 1727–1788
Mrs. Richard Brinsley Sheridan,
probably 1785/1786
oil on canvas
86 ½ in x 60 ½ in (2.2 m x 1.54 m)
Andrew W. Mellon Collection
1937.1.92

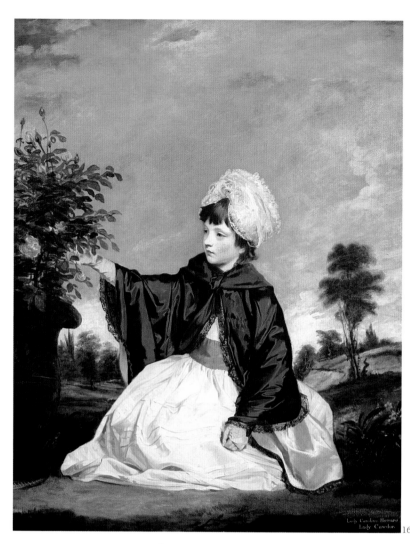

Here's to the maiden of bashful fifteen;
Here's to the widow of fifty;
Here's to the flaunting, extravagant quean,
And here's to the housewife that's thrifty.
RICHARD BRINSLEY SHERIDAN (1751–1816)
The School for Scandal

18 Detail of [17] showing brushstrokes on leaves of trees

Reynolds and his contemporaries, notably Thomas Gainsborough, idealized children of aristocratic families. One of the most popular prints of the time was Reynolds' *The Age of Innocence*, which portrayed children in an angelic guise. Reynolds' remarkably large portrait of *Lady Caroline Howard* [16] translates this young girl's life into a parable of innocence. She is shown kneeling in semi-profile, as if in prayer, with the soulful eyes and rosebud-lips the artist reserved for mothers and children.

Gainsborough's freely executed portrait of *Mrs. Richard Brinsley Sheridan* [17], the wife of the dramatist and politician, exemplifies his exceptional technique. His brushstroke [18, detail], particularly in the landscape in the background, was lighter and more energetic than Reynolds', whose paintings are more painstakingly conceived, in imitation of the Old Masters. Gainsborough's

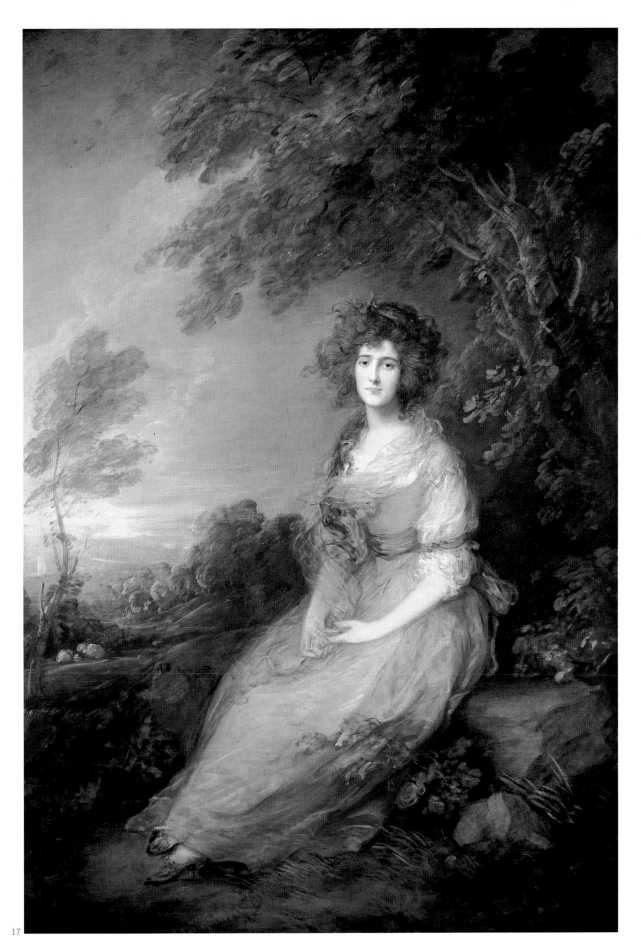

17

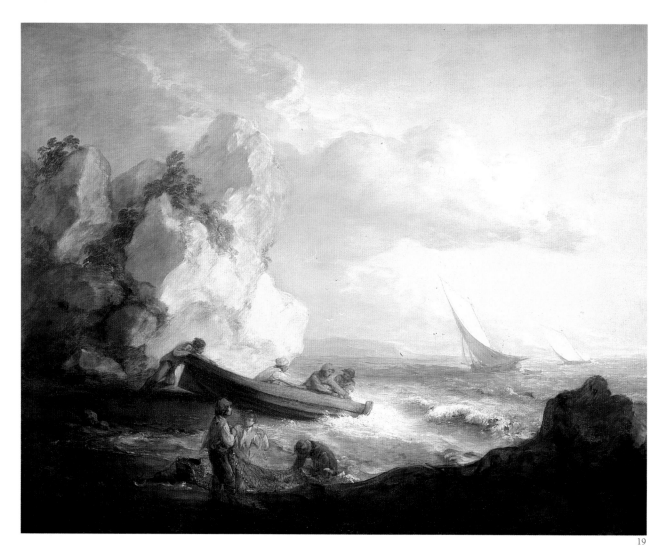

19 Thomas Gainsborough
British, 1727–1788
Seashore with Fishermen
*c.*1781/1782
oil on canvas
40¼ in x 50⅜ in (1.02 m x 1.28 m)
Ailsa Mellon Bruce Collection
1970.17.121

landscapes were more private than his portraits, which were his livelihood. *Seashore with Fishermen* [19] is one of the few coastal scenes by the artist, inspired in part by seventeenth-century Dutch marine painting. This work of 1781/1782 is partly based on sketches the artist made on a trip to the Devonshire coast three years earlier. In Gainsborough's painting, seven fishermen are shown pitted against the windy sea; the luminous clouds, full sails, white-caps, and sea-spray create a vivid sense of the stormy atmosphere.

Painters in America had not yet won the social status of their counterparts in England or France. As a young man, John Singleton Copley studied his stepfather's collection of prints by Raphael, Michelangelo, Poussin, and Rubens. Copley attained a clarity of form and composition, combining European influences and American subject-matter. In his portraits of colonial Americans, the artist was as exacting in his depiction of people as of objects. In *The Copley Family* [20], painted in 1776/1777, a still life appears in the lower left-hand corner that borders on *trompe l'oeil*, with a doll dressed in silk taffeta resting alongside an ostrich-feathered cap. Copley captures the texture and weight of things, from satin to brass upholstery tacks, with an equal measure of refinement and exactitude.

The ambitious scale and composition of Copley's family portrait, which he exhibited at the Royal Academy in London in 1777, emulates the "Grand Manner" of its director, Reynolds, while aspiring to Europe's great tradition of history portraits. And yet Copley's work also departs from that of Reynolds in its lack of sentimentality. Copley's children are earthy, not angelic. The young child seen perched in Copley's father-in-law's lap reaches playfully for his face as children do, impervious to his sober manner. A little girl lies on her stomach, nestled between her mother's lap and cushions. It is easy to imagine her a moment later hanging upside-down or tumbling to the ground in a fit of giggles.

20 John Singleton Copley
American, 1738–1815
The Copley Family
1776/1777
oil on canvas
72 ½ in x 90 ¼ in (1.84 m x 2.29 m)
Andrew W. Mellon Fund
1961.7.1

20

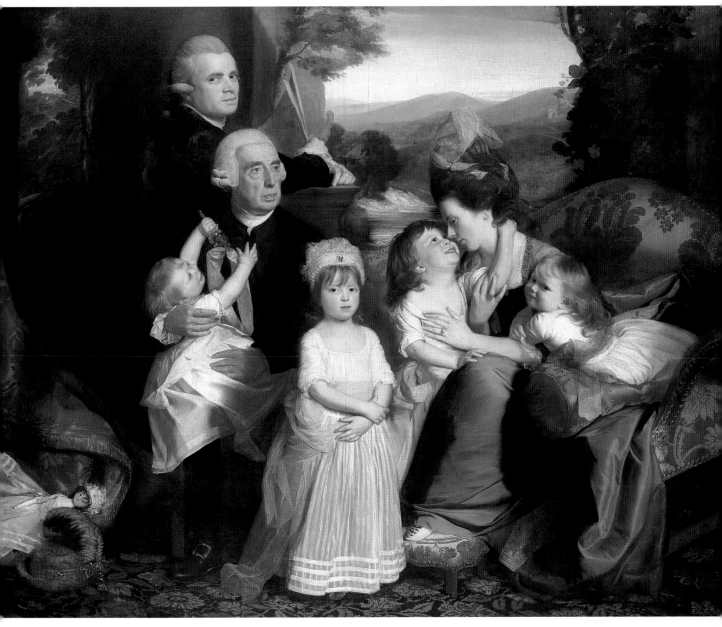

21 Benjamin West
American, 1738–1820
Colonel Guy Johnson
1776
oil on canvas
79 3/4 in x 54 1/2 in (2.03 m x 1.38 m)
Andrew W. Mellon Collection
1940.1.10

Benjamin West, the son of Quaker innkeepers in Swarthmore, Pennsylvania, attained international fame as America's first history painter. Born in 1738—the same year as Copley—West trained as a portraitist in Philadelphia. Determined to become a great painter, he left America for Italy in 1759, where he studied the Old Masters and ancient Roman sculpture, and met many neoclassical artists. He then settled in London, where he won commissions from

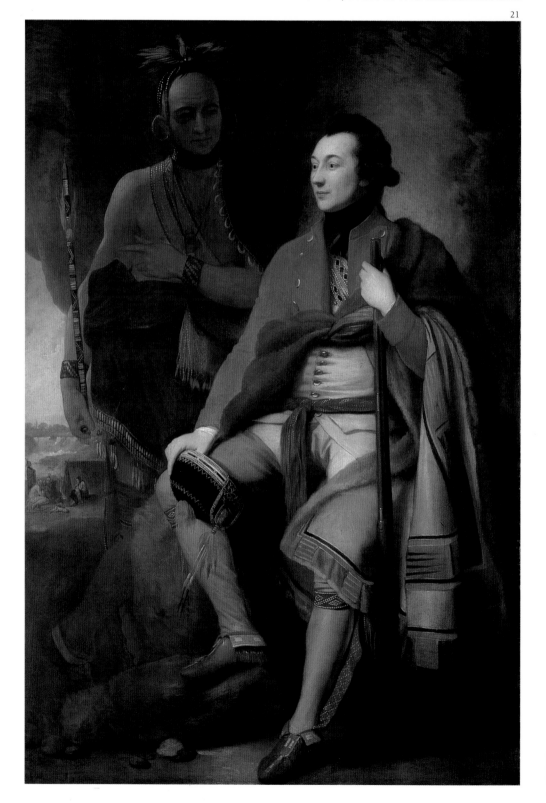

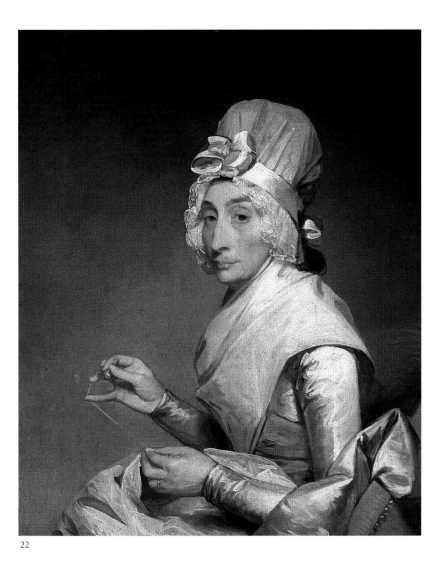

22

King George III. West documented contemporary American history with all the *gravitas* of neoclassical history painting, which traditionally portrayed a nation's past glories. His portrait, *Colonel Guy Johnson* [21], which depicted the English superintendent of Indian affairs in the American colonies with an Indian ally, was completed in the year of the American Revolution. Upon Reynolds' death in 1792, West became the first—and only—American president of the Royal Academy.

One of West's protégés in London was Gilbert Stuart, who, like many young American artists, had left for London at the time of the Revolution. Stuart served for five years as West's apprentice, and yet rejected West's formal, neoclassical portraiture. Stuart adopted a realist approach unfettered by classical allusion or by "Grand Manner" conventions. Shortly after he returned to America in 1793, he painted *Mrs. Richard Yates* [22]. Her dour expression has none of the charm or prettiness of the women of innumerable portraits by Gainsborough or Reynolds. She was the practical wife a New York merchant, and unlike the countesses and ladies of Europe, she *worked*. Her needlepoint, shown in sharp detail, exhibits a pride in handicraft that is essentially American.

22 Gilbert Stuart
American, 1755–1828
Mrs. Richard Yates
1793/1794
oil on canvas
30 in x 25 in (76.2 cm x 63.5 cm)
Andrew W. Mellon Collection
1940.1.4

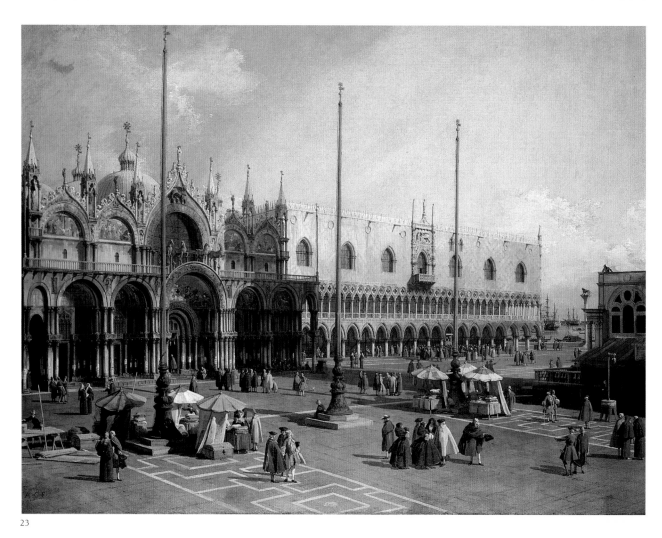

23

23 Canaletto
Italian (Venetian), 1697–1768
The Square of Saint Mark's
early 1730s
oil on canvas
45 in x 60¹⁄₂ in (1.15 m x 1.54 m)
Gift of Mrs. Barbara Hutton
1945.15.3

25 Etienne-Louis Boullée
French, 1728–1799
*Perspective View of the Interior
of a Metropolitan Church*
1780/1781
pen and gray ink with brown wash over
black chalk
23 ³⁄₈ in x 33 ¹⁄₁₆ in (59.4 cm x 83.9 cm)
Patrons' Permanent Fund
1991.185.1

25

In Italy, as in France, artistic styles ranged from the rococo to neoclassicism. As a young man, the Venetian painter Canaletto designed and painted sets for the theatre in Rome. After 1720, he devoted himself to the "townscapes" for which he is best known. His views of Venice were especially popular with the

24 Giovanni Paolo Panini
Italian (Roman), 1691 or 1692–1765
The Interior of the Pantheon
*c.*1740
oil on canvas
50½ in x 39 in (1.28 m x 99 cm)
Samuel H. Kress Collection
1939.1.24

24

English in the 1730s and 1740s, the age of the Grand Tour. *The Square of Saint Mark's* [23] demonstrates his style in its rigorous perspective, lucid forms, bright light, and smooth finish. His contemporary, the Roman artist Panini, also began his career as a stage-designer. Panini's *The Interior of the Pantheon* [24] has the choreographed quality of a theatrical production, with its rococo party gathered beneath the classical dome.

Panini's Pantheon is a diminutive painting compared with the monumental drawing of the enormous interior of a metropolitan church, based on the geometric principles of the Roman Pantheon, by the French neoclassical artist and visionary, Etienne-Louis Boullée [25]. The precise and measured style of his architectural designs was based on pure, abstract forms, like the sphere or cube, that he believed expressed the new ideals of the Enlightenment, the eighteenth-century philosophical movement that exalted reason and knowledge. None of his designs were executed.

26

Creeping along the sides of the walls, you perceived a staircase;
and upon it, groping his way upwards, was Piranesi himself … on the very brink of the abyss.

THOMAS DE QUINCEY (1785–1859), *The Confessions of an Opium Eater*

27

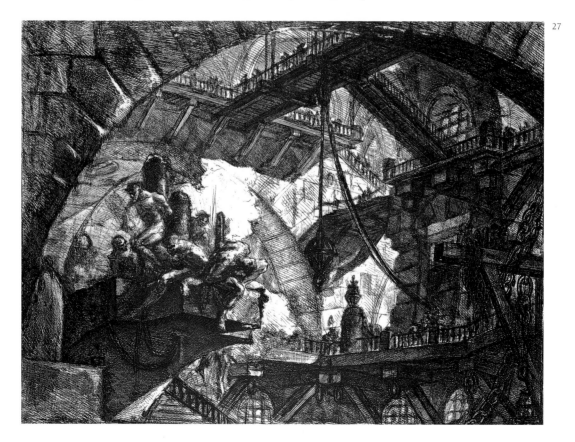

28

26 Giovanni Battista Piranesi
Italian, 1720–1778
Carceri
published 1761
The Arch with a Shell Ornament (Plate XI)
third state (second edition, first issue)
etching, engraving, scratching, sulphur tint
or open bite, and drypoint on laid paper
21 1/8 in x 30 1/4 in (53.6 cm x 76.7 cm)
Mark J. Millard Architectural Collection,
acquired with assistance from
The Morris and Gwendolyn Cafritz
Foundation
1983.118.12

27 Giovanni Battista Piranesi
Italian, 1720–1778
Carceri
published 1761
Prisoners on a Projecting Platform
second edition, first issue
etching, engraving, scratching, sulphur tint
or open bite, and burnishing on laid paper
21 1/8 in x 30 1/4 in (53.6 cm x 76.7cm)
Mark J. Millard Architectural Collection,
acquired with assistance from
The Morris and Gwendolyn Cafritz
Foundation
1983.118.11

28 Francisco de Goya
Spanish, 1746–1828
Los Caprichos
first edition, published 1799
The Sleep of Reason Produces Monsters,
plate 43, *c*.1794-1799
etching
plate: 8 1/2 in x 6 in (21.4 cm x 15.1 cm);
sheet: 12 in x 7 1/2 in (30.7 cm x 19.4 cm)
Rosenwald Collection
1943.3.4711

A nightmarish classical architecture, partly based on ancient Roman ruins and partly imaginary, formed the foundation of the prints of Giovanni Battista Piranesi. In his *Carceri* series [26, 27], he created illogical spaces with intersecting Roman arches and vaults, and ladders and staircases that stop short of the abyss. These are imaginary prisons, where human beings scamper from beam to beam.

By the end of this extraordinary period of revolution and enlightenment in Europe, no-one saw the inadequacies of man more clearly than the Spanish artist Francisco de Goya. His deafness in 1794, at the age of forty-eight, seemed to intensify his end-of-century pessimism. He doubted that man was any more capable of Liberty, Equality, or Fraternity than he was of Reason. The artist wrote that his series of prints, *Los Caprichos* (1794–1799), was intended "to banish harmful superstitions, and to promote … the solid testimony of truth." One of the most unforgettable of the series is *The Sleep of Reason Produces Monsters* [28], an etching Goya made in 1799. The bats and beasts that hover over the young man's crouched figure resemble gargoyles that have taken flight from the cathedrals of Europe. Nightmares have invaded the sweet dreams of Boucher and Fragonard.

Early 19th century

*Romanticism is precisely situated neither in choice of subject
nor in exact truth, but in a way of feeling.*

CHARLES BAUDELAIRE (1821–1867)
Salon of 1859

1 Jean-Auguste-Dominique Ingres
French, 1780–1867
Philippe Mengin de Bionval
1812
graphite on wove paper
10 ⅛ in x 7 ¾ in (25.6 cm x 19.6 cm)
Woodner Collection
1991.182.21

1

ugène Delacroix was the leading romantic painter of early nineteenth-century France. Championed by the poet Charles Baudelaire, who in his poetry and writings on art, celebrated the irrational and the artist's *imagination,* Delacroix passionately believed in the use of vibrant color. The romantic painter's expressive style was opposed by Jacques-Louis David, the aging leader of the neoclassical school, and his disciple, Jean-Auguste-Dominique Ingres. Through- out his career as artist and academician, Ingres espoused the neoclassical ideals of precision of form and fine line, as expressed by the French academic term *dessin,* encompassing draftmanship, design, and a sense of measure of composition. This divide between the romantics, led by Delacroix, and the neoclassical school, with Ingres as its standard-bearer, was one of the defining controversies of the period.

Ingres had studied in Jacques-Louis David's Paris studio, and in 1801, won the Prix de Rome, the first of the many academic honors of his career. He lived in Rome for fourteen years, from 1806 to 1820, where he painted mythological

PREVIOUS PAGES
Eugène Delacroix
Tiger [2]

108

and historical subjects, as well as portraits. His graphite drawing of an elegant young gentleman, *Philippe Mengin de Bionval* [1], inscribed at the lower right, "Ingres a Rome/1812," belongs to an eighteenth-century tradition of medallion portraits, inspired by the profile-heads of antique medals and coins. Ingres' line was often poetic and graceful, the contours of his figures breaking David's classical rules of proportion. In this early drawing, his sensitivity of line is apparent in the intricate shading around the eye, nose, and mouth, the hatchings of the hair, and the freer lines across the sleeve.

Partly due to Ingres' academic success and influence, the controversy of line versus color somewhat unfairly pitted Delacroix against Ingres as part of a romantic rebellion against academic rule. The romantics challenged academic authority by overturning the traditional hierarchy of painting that regarded grand-scale history and religious subjects as the pinnacle of art. It was the more humble forms—the most intimate of sketches, landscape painting, and scenes of contemporary life—that grew in scale and importance.

Romanticism is best defined by example. Even the poet Baudelaire struggled with its precise definition, calling it "a way of feeling." Delacroix's *Tiger* [2] exemplifies the romantic ideals of the irrational and exotic. For his studies of lions and tigers, the artist often visited the Jardin des Plantes, the Paris zoo.

2 Eugène Delacroix
French, 1798–1863
Tiger
c.1830
watercolor
5 9/16 in x 9 15/16 in (14.1 cm x 25.1 cm)
Rosenwald Collection
1943.3.3375

2

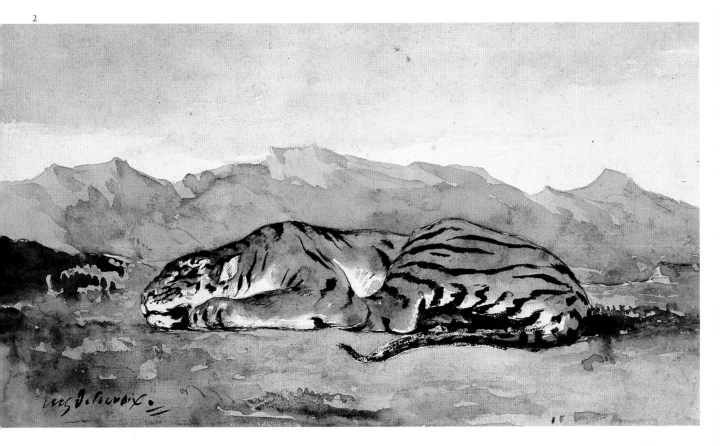

3 Antoine-Louis Barye
French, 1796–1875
Tiger Seizing a Gazelle
1834
bronze
13 3/4 in x 21 3/4 in x 9 in
(34.9 cm x 55.3 cm x 22.9 cm)
Gift of Eugene and Agnes E. Meyer
1967.13.2

4 Eugène Delacroix
French, 1798–1863
Arabs Skirmishing in the Mountains
1863
oil on canvas
36 3/8 in x 29 3/8 in (92.5 cm x 74.6 cm)
Chester Dale Fund
1966.12.1

He was renowned for his expressive use of color, and chose bright cadmium red to capture the fiery mood of his *Tiger*, which in reality could only have been a beige dulled by captivity. Delacroix painted *Tiger* two years before his first visit to North Africa in 1832. He later painted from memory and imagination many lion and tiger hunts, as well as such dramatic scenes as *Arabs Skirmishing in the Mountains* [4].

The ferocity of wild animals also captured the romantic imagination of the sculptor Antoine-Louis Barye. In *Tiger Seizing a Gazelle* [3] of 1834, the artist accentuates the taut muscles and unbridled ferocity of the massive tiger as it seizes a terrified gazelle by the neck. Bayre's sculptures of wild animals often suggest sexual encounters. To the romantics, animals embodied human passion.

3

4

5 William Blake
British, 1757–1827
The Great Red Dragon and the
Woman Clothed with the Sun
*c.*1805
pen and ink with watercolor over graphite
16¹/₁₆ in x 13¼ in
(40.8 cm x 33.7 cm)
Rosenwald Collection
1943.3.8999

The ultimate romantic in England was both a poet and a painter. The hermetic Londoner William Blake created an imaginary world in his watercolors, peopled by angels and mythic and biblical figures. *The Great Red Dragon and the Woman Clothed with the Sun* [5] represents a personal iconography—a system of signs and symbols—that revolved around themes of death and rebirth. In this pen and ink drawing with watercolor, the artist conjures a frightening image of a dragon, its devilish form hovering over an angelic figure, who appears fearless and immune. Blake's evangelical vision was grounded by a social conscience, for he was an advocate for children and the poor. His vision of Heaven was the place where they would be safe.

6

Beneath them sit the aged men,
wise guardians of the poor;
then cherish pity, lest you drive
an angel from your door

WILLIAM BLAKE
(1757–1827)

For John Constable, the English countryside was, as one romantic poet remarked, "a place to make a man forget that there was any necessity for treason." Constable's *Wivenhoe Park, Essex,* 1816 [7] could not have been more distant from London's slums, nor from industrial progress. Born the son of a miller in rural Suffolk, Constable's affection for the English countryside—its distinct sloping zig-zag formations, its subtle greens—is manifest in every detail. From the dewy grass and rippling waters to each swan and cow [6, detail], Constable creates "a pure and unaffected" vista, as if seen from an English cottage window.

6 Detail of [7]

7 John Constable
British, 1776–1837
Wivenhoe Park, Essex
1816
oil on canvas
22 1/8 in x 39 7/8 in (56.1 cm x 1.01 m)
Widener Collection
1942.9.10

7

8 John Constable
British, 1776–1837
A Great Oak Tree
1801
black chalk with gray wash
21 1/4 in x 17 1/2 in (54 cm x 44.4 cm)
Gift of Paul Mellon
1985.9.1

9 Joseph Mallord William Turner
British, 1775–1851
Venice: Dogana and San Giorgio Maggiore
probably 1834
oil on canvas
36 in x 48 in (91.5 cm x 1.22 m)
Widener Collection
1942.9.85

8

9

Constable based his final compositions on open-air oil sketches, whose freedom of execution looks forward to the impressionists. Sketches were crucial to the romantics because they were seen as the direct expression of the artist. "Painting," Constable famously said, "is but another word for feeling." Yet his sketches were observed assiduously. In his cloud studies, sketchbooks, and other nature studies [8], he frequently recorded the exact time and date with the precision of a meteorologist.

The landscape painter J. M. W. Turner, Constable's nearly exact contemporary, was equally fascinated by English weather. Atmospheric effects are central to his work, from the shimmering sunlight inherited from Claude and Canaletto [9] to more turbulent skies that dominate the compositions of the mid-1840s associated with his romantic period, such as *Rain, Steam and Speed—The Great Western Railway* (London) and *Snowstorm at Sea* (London). His last works, inspired by the German romantic philosopher and poet Goethe's theories of color, veered toward abstraction. In his painting of 1835, *Keelmen Heaving in Coals by Moonlight* [10], Turner creates a sense of atmosphere with an arc of open brushwork, radiating color and light. Reflected on the rippling waters, the light creates an oval, swirling vortex that pulls the viewer into the painting.

10 Joseph Mallord William Turner
British, 1775–1851
Keelmen Heaving in Coals by Moonlight
probably 1835
oil on canvas
36¼ in x 48¼ in (92.3 cm x 1.23 m)
Widener Collection
1942.9.86

10

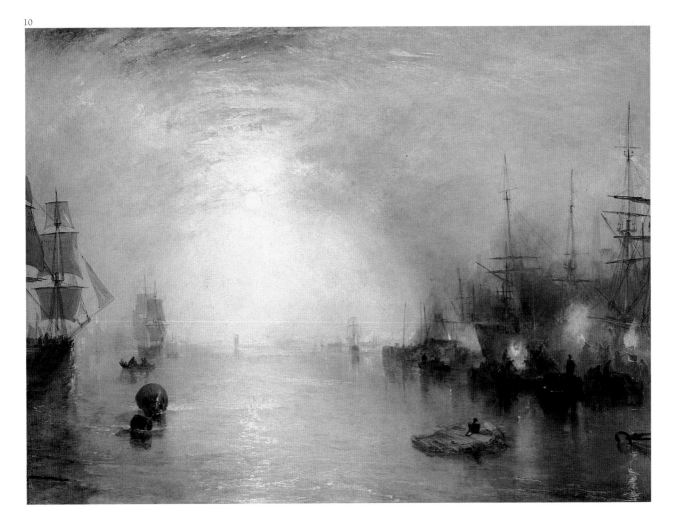

11 Thomas Cole
American, 1801–1848
*A View of the Mountain Pass Called the
Notch of the White Mountains (Crawford Notch)*
1839
oil on canvas
40 3/16 in x 61 5/16 in (1.02 m x 1.56 m)
Andrew W. Mellon Fund
1967.8.1

12 Thomas Cole
American, 1801–1848
The Voyage of Life: Childhood
1842
oil on canvas
52 7/8 in x 76 7/8 in (1.34 m x 1.95 m)
Ailsa Mellon Bruce Fund
1971.16.1

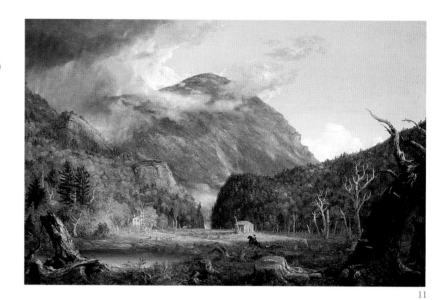

11

*In the woods, we return to reason and faith . . . all mean egotism vanishes.
I become a transparent eye-ball; I am nothing; I see all; the currents of the
Universal Being circulate through me; I am part or particle of God.*

RALPH WALDO EMERSON (1803–1882)
Nature, 1836

12

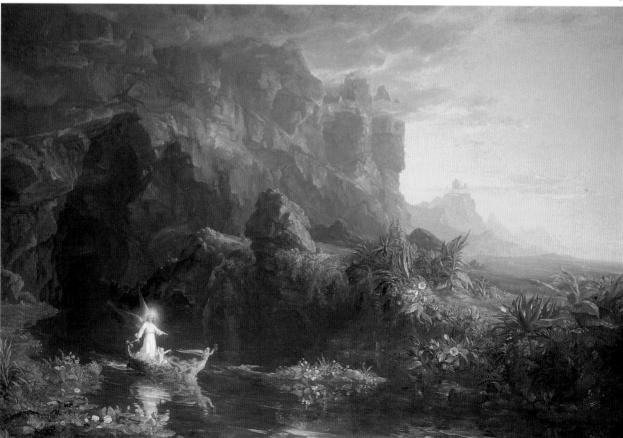

In America, romantic landscape painting represented God's country, and God was in every detail. Thomas Cole's vision of American wilderness, leaf by leaf, was one of a New Eden. Many Europeans did not share his view; one early traveler from London, accustomed to Hampstead Heath, found the "eternal forests" of America "detestable." After recovering from a walk in the woods outside Cincinnati, she wrote: "A cloud of mosquitoes gathered round, and while each sharp proboscis sucked our blood...[we] resolved never to try the *al fresco* joys of an American forest again." It was precisely this uncultivated quality that inspired Cole: "All nature here is new to art," he said.

In his paintings of distinctly American scenery, Cole was apt to use titles worthy of a land surveyor—*A View of the Mountain Pass Called the Notch of the White Mountains (Crawford Notch)* [11]. The artist had made his first sketching trip to the White Mountains, New Hampshire, in the late 1820s; in this work, painted over a decade later, in 1839, he records the evidence of logging, as seen in the tree stumps in the foreground. Moral themes became central to Cole's landscape painting: in the following year, in New York, he painted the first of two four-picture series, called *The Voyage of Life*; two years later, in 1842, he completed the second set in Rome. These imaginary landscapes chart the spiritual progress of man from childhood [12] to old age [13], combining open-air preparatory studies with a spiritualist vision, investing landscape painting with allegorical meaning and the solemnity of religious art.

13 Thomas Cole
American, 1801–1848
The Voyage of Life: Old Age
1842
oil on canvas
52 1/2 in x 77 1/4 in (1.33 m x 1.96 m)
Ailsa Mellon Bruce Fund
1971.16.4

13

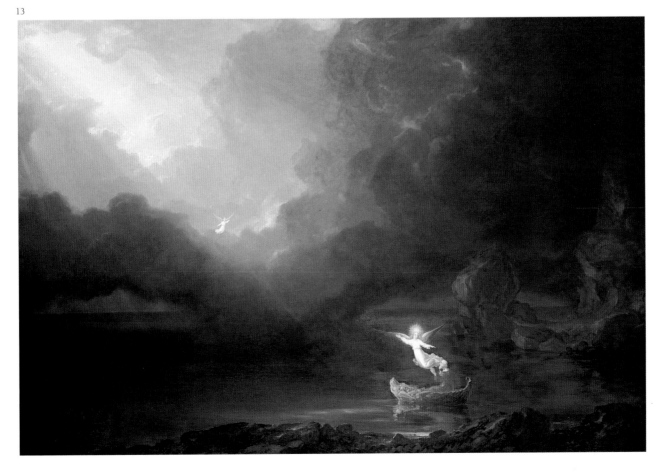

Like romanticism, realism was a preoccupation in nineteenth-century art and literature, rather than a movement or school. In the role of artist-reporter, realists were more concerned with plain truths than with aesthetic ideals of beauty and exotica, which preoccupied the romantics. The French realists, led by Gustave Courbet, challenged the authority of the Academy, the arbiters of taste in French art since the seventeenth century. They stripped away the veils of ancient history and myth inherited from neoclassicism, and laid bare the *truth*, as they saw it.

It is often said that realism began with Goya. This is remarkable when one considers his work before the French Revolution of 1789, from his earliest

14 15

rococo tapestry cartoons to his portraits of the late eighteenth-century Spanish royals and their fashionable dogs [14, detail and 15, detail], which are remarkable for their candor and lack of flattery. His style was transformed by the atrocities he witnessed during Napoleon's occupation of Spain (1808–1814). *The Disasters of War*, his series of eighty-three etchings, was not to be published until 1863, thirty-five years after his death. It was as if Goya understood that such extreme human cruelty was beyond comprehension, and needed constant reinstatement. *"I saw it,"* one caption reads. In Plate 39, *Wonderful heroism! Against dead men!* [16], dismembered corpses are skewered by the branches of a tree. The final print of the series is called, simply, *This is the Truth* [17].

14 *Detail of Shih Tzu,* from
Francisco de Goya
Spanish, 1746–1828
Condesa de Chinchon
1783
oil on canvas
53 in x 46¼ in (1.35 m x 1.17 m)
Ailsa Mellon Bruce Collection
1970.17.123

15 *Detail of Pug,* from
Francisco de Goya
Spanish, 1746–1828
The Marquesa de Pontejos
probably 1786
oil on canvas
83 in x 49¾ in (2.11 m x 1.26 m)
Andrew W. Mellon Collection
1937.1.85

16 Francisco de Goya
Spanish, 1746–1828
The Disasters of War, 1812–1815
first edition, 1863
Wonderful heroism! Against dead men!
(Plate 39)
etching, lavis, drypoint, and burin
plate: 6 in x 7¾ in (15.5 cm x 19.7 cm);
sheet: 9½ in x 13 in (24.1 cm x 32.9 cm)
Rosenwald Collection
1943.3.4716

17 Francisco de Goya
Spanish, 1746–1828
The Disasters of War, 1812–1815
first edition, 1863
This is the Truth (Plate 82)
etching, aquatint, drypoint, burin, and
burnisher in umber on laid paper
(trial proof/posthumous)
7 in x 8½ in (18.1 cm x 21.9 cm);
sheet: 9 in x 12¼ in (22.6 cm x 31.4 cm)
Rosenwald Collection
1951.10.62

War always weakens and often completely shatters the crust
of customary decency which constitutes a civilization.
It is a thin crust at the best of times, and beneath it lies—what?
Look through Goya's Desastres and find out.
ALDOUS HUXLEY (1894–1963)
The Complete Etchings of Goya, 1943

16

17

18

18 Jacques-Louis David
French, 1748–1825
Napoleon in His Study
1812
oil on canvas
80 ¼ in x 49 ¼ in (2.04 m x 1.25 m)
Samuel H. Kress Collection
1961.9.15

In 1812, the same year that Goya, his almost exact contemporary, began *The Disasters of War*, the French artist Jacques-Louis David painted his official portrait, *Napoleon in His Study* [18]. In contrast with Goya's indictment of the Napoleonic army, David, a leader of the neoclassical school, portrays the Emperor in a regal pose, standing between his desk and chair, as if his work had just been interrupted. It is precisely 4:13 a.m, indicated by the clock and candles burning low. The manuscript of the Napoleonic Code lies on his desk.

The sheer pace of political change in early nineteenth-century France, from the time of David's portrait of the French Emperor to the restoration of the Bourbon monarchy and the Revolution of 1830, demanded a new form of image-making. The artist Honoré Daumier, the son of a glazier from a working-class district ofMarseilles, used the new printing technique of lithography as a formidable instrument of satire.

The lithographic process required no painstaking cutting or engraving, and enabled Daumier to draw his compositions directly with a greasy crayon on to limestone slabs. The stone is wetted and then coated with greasy ink, which clings to the design and is repelled by the wet areas. Lithography was a distinct advantage for an artist of Daumier's wit. It afforded cheap and fast reproduction, through which he produced thousands of caricatures for newspapers and magazines. Censorship was the bane of his existence: he was sent to prison for six months in 1832 for a grotesque portrait of Louis-Philippe. *Le Ventre Législatif* [19] of 1834 caricatures each member of French government (the title translates as "the legislative belly," not "body"), which he also modeled in clay and cast in bronze [20].

19 Honoré Daumier
French, 1808–1879
Le Ventre Législatif (The Legislative Belly)
1834
lithograph on wove paper
image: 11 in x 17 in (28 cm x 43.4 cm)
sheet: 13½ in x 20¾ in (34.6 cm x 52.7 cm)
Gift of Lloyd Cutler and Polly Kraft, in Honor
of the 50th Anniversary of the National Gallery of Art
1991.229.1

20

20 Honoré Daumier
French, 1808–1879
Le Ventre Législatif
1832/1835
bronze (installation view)
Rosenwald Collection

21 Honoré Daumier
French, 1808–1879
Rue Transnonain, le 15 avril 1834
1834
lithograph
image: 11¼ in x 17⅓ in (28.5 cm x 44.1 cm);
sheet: 14⅓ in x 21½ in (36.6 cm x 55 cm)
Rosenwald Collection
1943.3.2957

22 Honoré Daumier
French, 1808–1879
Wandering Saltimbanques
c.1847/1850
oil on wood
41⅜ in x 30¼ in (1.05 m x 77 cm)
Chester Dale Collection
1963.10.14

As an artist-reporter, Daumier's most poignant image of social injustice was the lithograph *Rue Transnonain* [21]. Its realism was unsparing. The full title refers to the precise date and place—the 15th of April, 1834—when French police raided a housing project in a working-class district of Paris, in retaliation for a riot, and shot all its occupants. Daumier focuses on one victim, still in his nightclothes and slumped by the side of his bed.

By the time of the next revolution in France, the tone of Daumier's work was growing more sombre and cynical. Among the rebels of June 1848 were "social outcasts of all kinds," according to a social historian who witnessed the revolution. There were, he wrote, "tramps, street-porters, organ-grinders, ragpickers, knife-grinders, tinkers, errand-boys, all those who lived by the thousand little occupations of the streets of Paris, and also that confused, drifting mass known as *La Bohème*."

Daumier portrayed many of these disenfranchised people in his paintings and prints, including *Wandering Saltimbanques* [22]. These traveling street-performers lived on the fringes of society; Daumier gave them not only an aura of sadness, but also a sense of dignity.

21

Chapter seven
Mid-19th century

I have, as it were, my own sun and moon and stars,
and a little world all to myself.

HENRY DAVID THOREAU (1817–1862)

"Solitude", from *Walden*, 1854

In the nineteenth century, the American wilderness represented the promise of the New World. The most visionary of American landscape painters saw their native land as the New Eden. Both poets and painters glorified the monuments of natural history, from Niagara Falls to the Precambrian bedrock of the Hudson River. The forests of the East Coast acquired mystical stature, and later, the Great Plains and spectacular scenery of the American West rivaled the monuments of ancient history.

Jasper Francis Cropsey was best known for capturing the extraordinary variety of hues and textures seen in *Autumn—On the Hudson River* [1], painted in London in 1860. It is said that when Cropsey exhibited the painting at the Great London International Exhibition of 1862, the artist displayed a few autumn leaves from home as proof of the authenticity of the splendid amber scene. The American wilderness, devoid of gods and goddesses, classical temples, or even picturesque villages, was foreign to the European eye. As Henry James wrote, "The apple of America is a totally different apple."

2

Across the Atlantic, Constable's English countryside was hedged and manicured; in America, Cropsey's panoramic view reflected the poet Thoreau's ideal of "unfenced nature."

A transcendental, spiritual light graced the atmosphere of American landscape painting of the nineteenth century. This is often associated with luminism, a term that best describes a mode of painting, rather than a distinct syle or school. Fitz Hugh Lane, born in Gloucester, Massachussetts, painted many views of his native New England coast, depicting extraordinarily placid and reflective waters, and an uninterrupted, nearly flat horizon, as seen in *Lumber Schooners at Evening on Penobscot Bay* [2]. The luminous quality of the light contributes to a sense of balance and stillness within this horizontal composition. The lucid detail of the schooner's rigging is comparable to the precise forms seen in John Frederick Kensett's *Beacon Rock, Newport Harbor* of 1857 [3], from the individual waves in the foreground to the surface of the distant, rugged Beacon Rock.

3 John Frederick Kensett
American, 1816–1872
Beacon Rock, Newport Harbor
1857
oil on canvas
22 ½ in x 36 in (57.2 cm x 91.4 cm)
Gift of Frederick Sturges, Jr.
1953.1.1

3

4

4 Martin Johnson Heade
American, 1819–1904
Rio de Janeiro Bay, 1864
oil on canvas
17 15/16 in x 35 7/8 in (45.5 cm x 91.1 cm)
Gift of the Avalon Foundation
1965.2.1

Cropsey's contemporary, Martin Johnson Heade, recreated the flat expanses of the salt marshes of Massachussetts, Rhode Island, Connecticut, and New Jersey, punctuated by haystacks more solid than those of the French impressionist Claude Monet. Heade was also captivated by tropical nature. He was one of many American artists and naturalists who traveled to South America in the mid-nineteenth century. His *Rio de Janeiro Bay* of 1864 [4] reflects a luminist lucidity and precision. One of his favorite subjects was the hummingbird, appearing gem-like among the glassy flowers in *Cattelya Orchid and Three Brazilian Hummingbirds* [5], painted seven years after the artist's trip to Brazil. He continued to paint hummingbirds for decades afterward, suggesting that he relied on memory as well as nature studies for his tropical landscapes.

5

In the midst of the foliage [the hummingbird] appeared like a piece
of lapis lazuli surrounded by emeralds; for her back was of the deepest
blue. Everywhere throughout Brazil this little winged gem abounds …

REV. JAMES C. FLETCHER
Brazil and the Brazilians, 1857

6

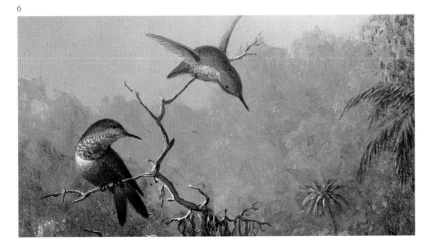

5 Martin Johnson Heade
American, 1819–1904
*Cattelya Orchid and Three Brazilian
Hummingbirds*
1871
oil on wood
13 11/16 in x 17 15/16 in (34.8 cm x 45.6 cm)
Gift of the Morris and Gwendolyn Cafritz
Foundation
1982.73.1

6 Detail of [5]

7 Winslow Homer
American, 1836–1910
The Dinner Horn (Blowing the Horn at Seaside)
1870
oil on canvas
19 ¼ in x 13 ¾ in (48.9 cm x 34.9 cm)
Collection of Mr. and Mrs. Paul Mellon
1994.59.2

8 Winslow Homer
American, 1836–1910
Autumn
1877
oil on canvas
38 ¼ in x 23 ³/₁₆ in (97.1 cm x 58.9 cm)
Collection of Mr. and Mrs. Paul Mellon
1985.64.22

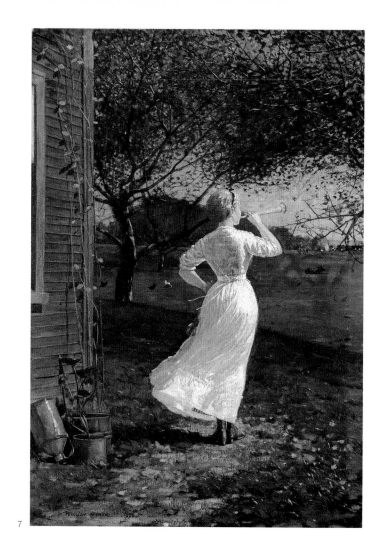

7

Winslow Homer was born in Boston in 1836, where he served his apprenticeship as a lithographer, studying painting only briefly. After the Civil War ended in 1866, he turned away from magazine illustration, which had been his main source of income, and Civil War subjects, to paint a peaceful, rural America. *The Dinner Horn (Blowing the Horn at the Seaside)* of 1870 [7] is the first of a series of works depicting the trumpeting figure of a woman in a similar pose. Her windswept dress accentuates her feminine form, lifting her skirts slightly to reveal her petticoat and ankles. The overturned milk can, to the far left, is a variation on a traditional erotic symbol of the broken milk pitcher.

In *Autumn* [8], painted in 1877, Homer portrays another anonymous, solitary woman, surrounded by woods, in one of many autumnal scenes the artist painted in the Adirondacks in upstate New York. She stands on a slope, holding a spray of autumn leaves in one hand, and her long skirt in the other. Here, too, her petticoats are revealed, but unlike the trumpeting figure in *The Dinner Horn*, whose face is hidden, the woman in *Autumn* confronts the viewer. The all-engulfing, horizonless landscape suggests an insular Nature that guards her solitude. Unlike Cropsey's autumnal scene, which concentrates on physical appearances, Homer's painting is a psychological portrait.

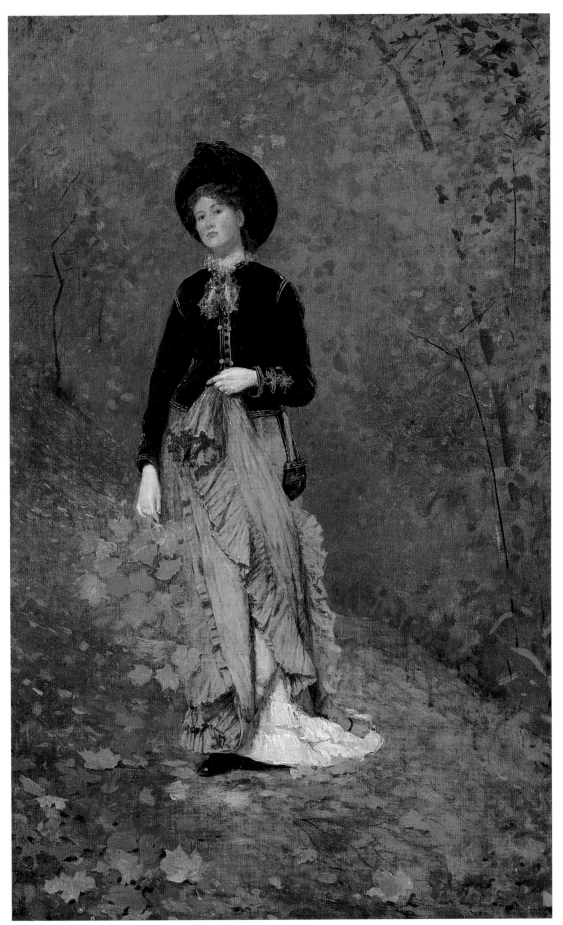

9 Gustave Courbet
French, 1819–1877
The Stream
(Le ruisseau du Puit-noir, vallée de la Loue)
1855
oil on canvas
41 in x 54 in (1.04 m x 1.37 m)
Gift of Mr. and Mrs. P.H.B. Frelinghuysen
in memory of her father and mother,
Mr. and Mrs. H.O. Havemeyer
1943.15.2

In mid-century France, the realist painter Gustave Courbet stressed a tactile nature rather than a poetic one, which he associated with the romantics. "Show me an angel and I'll paint one," he is reported to have said. In *The Stream* [9], rocks and undergrowth obscure the horizon. Compared with the smooth surfaces typical of academic painting of the time, his brushwork was at times as roughly hewn as the surfaces of the rocks he painted.

Courbet's *The Stream* was blatantly unpicturesque, especially when compared with the landscapes of his contemporaries, such as Jean-Baptiste Corot's painting, *Forest of Fontainebleau* [11]. As a realist, Courbet resolved to banish all "romantic trappings" from his painting, and so there are no river gods, nymphs, or muses in *his* forest. The site of Courbet's painting is specific—its full title is *Le ruisseau du Puits-noir, vallée de la Loue.* This is near Courbet's birthplace, Ornans, the subject of many other important realist works by the artist. Corot's landscape painting lies between romanticism and realism. While the

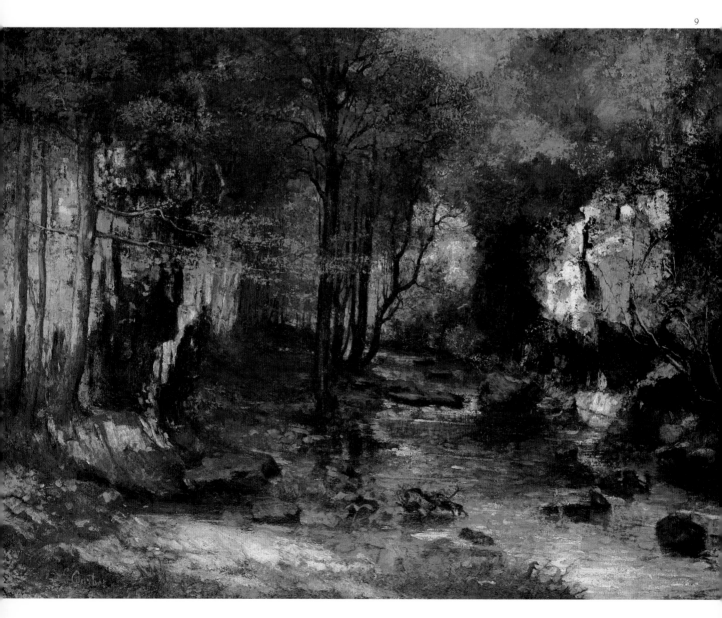

10

10 Detail of [11]

11 Jean-Baptiste Corot
French, 1796–1875
Forest of Fontainebleau
*c.*1830
oil on canvas
69 ⅛ in x 95 ½ in (1.76 m x 2.43 m)
Chester Dale Collection
1963.10.109

rocky river bed and trees of the Forest of Fontainebleau, south of Paris, are closely observed, he also includes the romantic figure of a young girl dressed in a rustic Italian costume, shown reading, who appears like a muse in many of Corot's paintings.

11

12 Gustave Courbet
French, 1819–1877
A Young Woman Reading
1866/1868
oil on canvas
23 ⁵⁄₈ in x 29 ³⁄₄ in (60 cm x 73 cm)
Chester Dale Collection
1963.10.114

The realists often portrayed their contemporaries, both known and unknown. Courbet's portraits ranged from the great writers, poets, and politicians of his day to more personal choices, such as *A Young Woman Reading* [12], painted in the late 1860s. The younger artist Edouard Manet, like Daumier before him, portrayed the itinerants of Paris, but with greater specificity and on a monumental scale. Manet's *The Old Musician* [14], painted in 1862, appears at first glance to be a haphazard group of figures in a nondescript landscape outside Paris; the old musician, drunkard, gypsy-girl, and street-beggars were among those dispossessed by Baron Haussmann's renovation of Paris in the early 1860s, which razed the slums to make way for the city's new grand boulevards. But on closer examination it is not a social-realist documentary, but a collage of artistic influences, juxtaposing familiar figures from his earlier works, such as the drunkard, with images gleaned from the Old Masters. The psychological insight into the character of the old musician is contained within his enigmatic gaze [13, detail], a hallmark of Manet's portraiture.

13

14

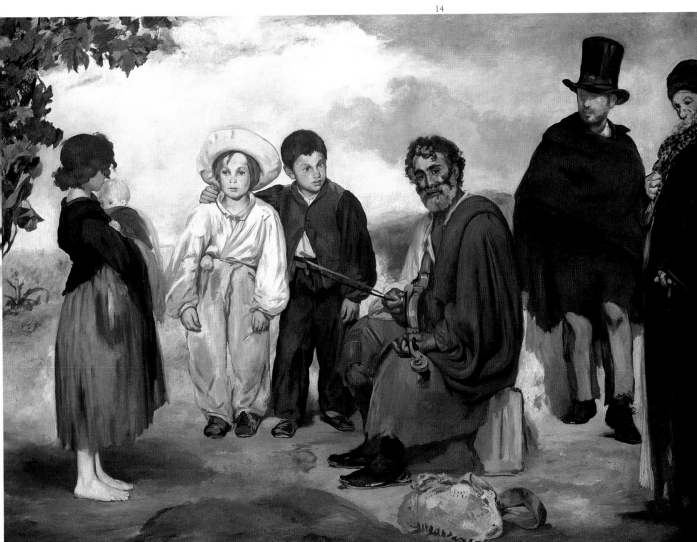

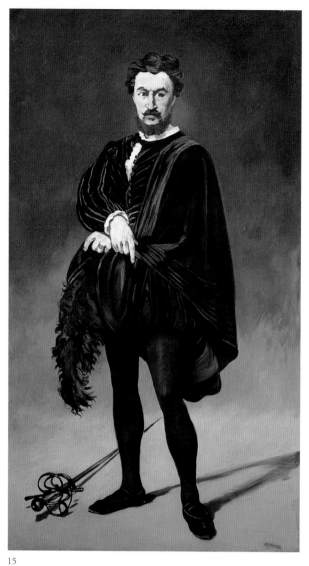

Manet's extraordinary range of black hues rivaled that of one of his favorite painters, the Spanish baroque master Velázquez. The blacks intensified such theatrical images as *The Dead Toreador* [16], probably painted in 1864, and *The Tragic Actor (Rouvière as Hamlet)* [15]. *The Dead Toreador* represents only the lower section of the original composition that featured an array of spectators inspired by the bullfight scenes of the Spanish master Goya. The tall, elongated figure of Rouvière, dressed in black against a neutral background, is in part Manet's tribute to the seventeenth-century masters Van Dyck and Velázquez, whose artful portraits transformed many ungainly aristocrats into elegant figures in black.

The American expatriate James Abbott McNeill Whistler was Manet's almost exact contemporary, and yet their visions of contemporary society were worlds apart. In the same year that Manet painted *The Old Musician*, Whistler painted *The White Girl* [17]. Whistler, born in Lowell, Massachussetts, in 1834, left for France at twenty-four. He found Courbet's realism and Delacroix's romanticism equally compelling; like Manet's, Whistler's style was formed from a hybrid of influences.

He settled permanently in London in 1863, where he painted *The White Girl*. The density of paint and sculpted shadows of the young girl's head reflect Courbet's tactile application of his oils. Whistler presents a new standard

15

16

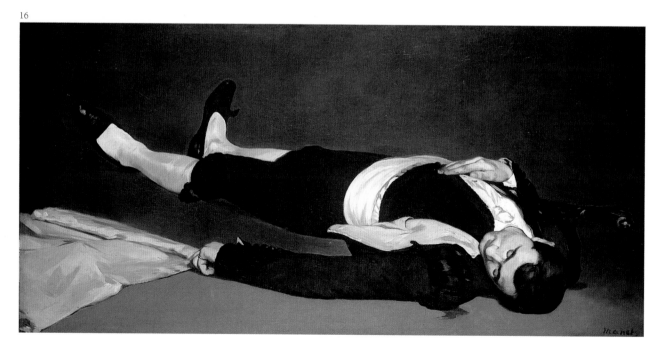

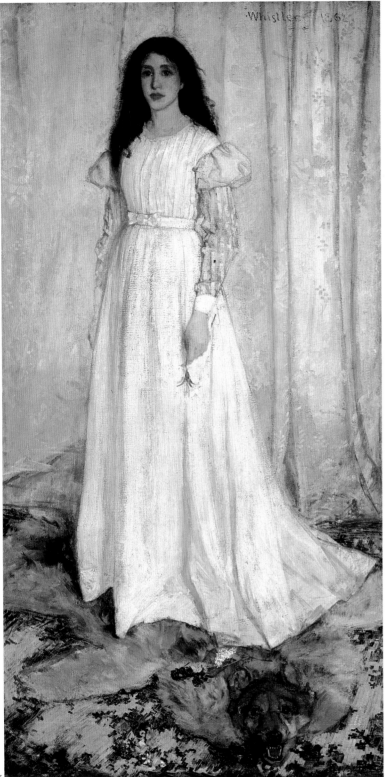

17

15 Edouard Manet
French, 1832–1883
The Tragic Actor (Rouvière as Hamlet)
1866
oil on canvas
73 ³/₄ in x 42 ¹/₂ in (1.87 m x 1.08 m)
Gift of Edith Stuyvesant Gerry
1959.3.1

16 Edouard Manet
French, 1832–1883
The Dead Toreador
probably 1864
oil on canvas
29 ⁷/₈ in x 60 ³/₈ in (75.9 cm x 1.53 m)
Widener Collection
1942.9.40

17 James McNeill Whistler
American, 1834–1903
The White Girl (Symphony in White)
1862
oil on canvas
84 ¹/₂ in x 42 ¹/₂ in (2.15 m x 1.08 m)
Harris Whittemore Collection
1943.6.2

of red-haired, Roman-nosed beauty that was associated with the English
Pre-Raphaelite painters. Her ethereal white dress later inspired the artist to add
the subtitle: "Symphony in White, No.1." The floral design of the carpet and the
bearskin under her feet reflect the artist's taste for exotic textiles, furnishings,
and designs from the East that were fashionable in Victorian London.

18 Detail of [19]

19 Paul Cézanne
French, 1839–1906
The Artist's Father
1866
oil on canvas
78 ⅛ in x 47 in (1.98 m x 1.19 m)
Collection of Mr. and Mrs. Paul Mellon
1970.5.1

The brutal realism of Paul Cézanne's portrait of his father from 1866 [19] reveals a darkly psychological perspective. Cézanne, indifferent to fashion, exposes the core of his subjects. He shows his father seated precariously on the edge of an armchair, its back resembling a weathered tombstone. The slope of the floor tilts the scene toward the viewer, making the exaggerated scale of the father doubly oppressive. Cézanne's brooding hues—ranging from mustard-ochres and stone-grays to deep brown shadows—underscore his subject's furrowed brow.

Cézanne's father allegedly disdained his son's painting, but supported him financially. Although he was a conservative banker, he is shown reading the left-wing newspaper, *L'Indépendent*, which had a personal significance for the painter. Cézanne's childhood companion and early champion, the realist novelist Emile Zola, had just become the paper's art critic. The painting on the wall is one of Cézanne's own still lifes [18, detail]. It is impossible to determine whether such personal details are signs of the twenty-seven-year-old artist's desire for his father's support of his work, or sardonic reminders of their insurmountable differences.

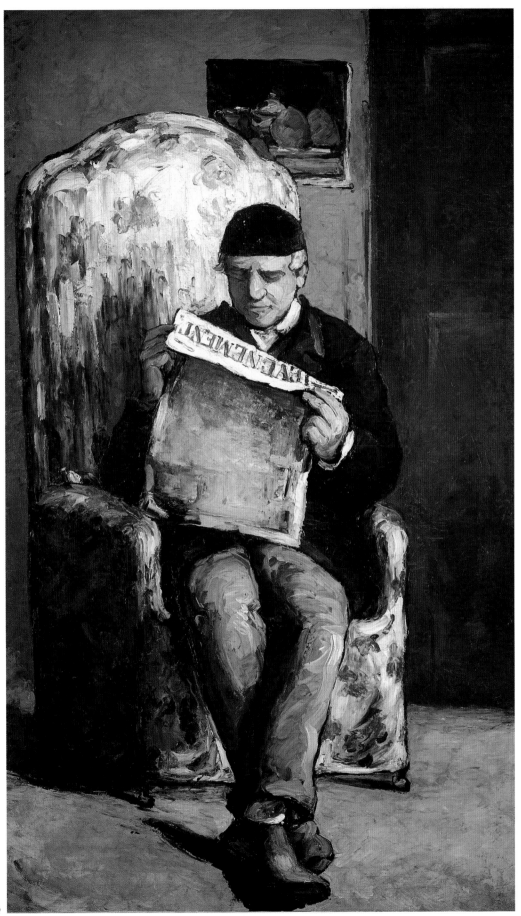

20 Berthe Morisot
French, 1841–1895
The Harbor at Lorient
1869
oil on canvas
17 ⅛ in x 28 ¾ in (43.5 cm x 73 cm)
Ailsa Mellon Bruce Fund
1970.17.48

By the mid-nineteeenth century, scenes of domestic life, together with land-scape paintings and still lifes, had grown in importance, establishing themselves alongside history and religious painting in scale and ambition. Among the impressionists painting domesticity were two women, Berthe Morisot and Mary Cassatt. Morisot's *The Artist's Sister at a Window* of 1869 [22], and the early impressionist masterpiece of the same year, *The Harbor at Lorient* [20], are intimate portraits of women she knew. She also painted her sister's children with a tenderness mingled with objectivity. Like her other work, *The Mother and Sister of the Artist* [21] is devoid of the comical, sentimental, or moralizing themes that characterized the portrayal of women in French painting since the late eighteenth century.

In this work of 1869/1870, Morisot dispenses with the rapidly disappearing formal conventions of portraiture. The sitter no longer had to be titled, formally dressed, or theatrically posed. Morisot's mother is shown simply reading, while the artist's sister stares ahead without engaging the viewer's gaze. The artist's sister, who was pregnant at the time, is dressed in a morning-robe. Both women are shown in a state of complete absorption, as in the portraits of women by Corot and Courbet. Compared with the enthralling gaze of Manet's old musician or of the actor Rouvière, Morisot's portraits are decidedly untheatrical.

Color unifies the composition—from the purple flowers on the table, to the red cushions on the couch, to the sister's bright blue bow, to the yellow pages of

21

22

the mother's book—in a medley of freshly applied primary and more subtle hues. Morisot's vivid use of color and light would become the hallmark of the new impressionist style. One has only to look back at the contemporary work of the American painter Martin Johnson Heade, *Cattelya Orchid and Three Brazilian Hummingbirds* [5], to see how comparatively evanescent and freely painted Morisot's forms are. Morisot's *The Mother and Sister of the Artist* was to appear in the first impressionist exhibition in Paris in 1874, where her fellow artists Monet, Renoir, Pissarro, Degas, and Sisley were to open a new chapter in the history of nineteenth-century painting.

I am not for any school, because I am for human truth ... The word art displeases me. It holds who-knows-what ideas of necessary arrangements, of absolute ideals ... I want artists to make life.

EMILE ZOLA (1840–1902)
Mes haines (My hatreds), Paris, 1866

21 Berthe Morisot
French, 1841–1895
The Mother and Sister of the Artist
1869/1870
oil on canvas
39 ½ in x 32 ¼ in (1.01 m x 81.8 cm)
Chester Dale Collection
1963.10.186

22 Berthe Morisot
French, 1841–1895
The Artist's Sister at a Window
1869
oil on canvas
21 ⅝ in x 18 ¼ in (54.8 cm x 46.3 cm)
Ailsa Mellon Bruce Collection
1970.17.47

Chapter eight
Late 19th century

*Our artists must discover the poetry of
railway stations,
as their fathers found that of forests
and rivers.*

EMILE ZOLA (1840–1902)
*The Impressionist Painters
of 1877*

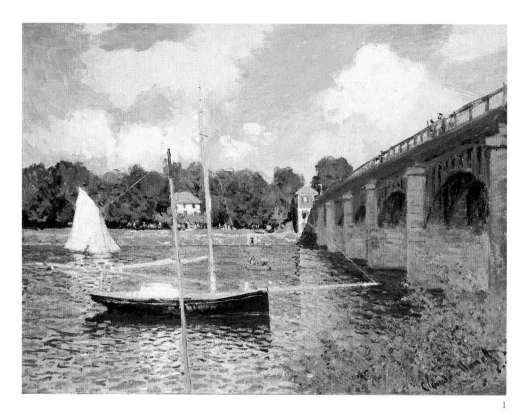

1

1 Claude Monet
French, 1840–1926
The Bridge at Argenteuil
1874
oil on canvas
23⅝ in x 31⅜ in (60 cm x 79.7 cm)
Collection of Mr. and Mrs. Paul Mellon
1983.1.24

2 Detail of [1]

3 Claude Monet
French, 1840–1926
*Woman with a Parasol—
Madame Monet and Her Son*
1875
oil on canvas
39⅜ in x 31⅞ in (1 m x 81 cm)
Collection of Mr. and Mrs. Paul Mellon
1983.1.293

2

Today, impressionist painting is not only enormously popular, but also famous for its astronomical prices at auction. Yet when it first appeared in Paris just over a century earlier, it was ridiculed. The term "impressionist" was a critic's disdainful twist on Claude Monet's title, *Impression—Sunrise*, one of the works shown at the first impressionist exhibition in 1874. To those accustomed to the lucid forms and smooth finish of academic painting—art sanctioned by the jurors of the French Academy —the impressionist style was difficult to "read." Monet's visible brushstroke and emphasis on the effects of light, air, fog, and steam blurred the distinction between solid objects and atmosphere. He veiled the masts and factory chimneys of the commercial port of Le Havre in lavender mists, and made the focus of the painting the rising sun—a disk of swirled orange paint, thickly applied—and the source of impressionist color and light.

Monet's *The Bridge at Argenteuil* [1], painted in 1874, typifies the breezy, sunlit atmosphere of the artist's impressionist style. His *impasto* technique of painting with a brush laden with pigment [2, detail] is characteristic of the impressionists and was vital to their interpretation of nature. For added luminosity, they painted over a primed white canvas, rather than the traditional beige or brown.

Monet's *Woman with a Parasol—Madame Monet and Her Son* [3], painted in 1875, reflects the artist's desire to arrest the fleeting nature of all things. His wife, Camille, was to die four years later, after a long illness. It is as if the artist anticipated losing her, as she recedes over the high horizon in his painting, her features beckoning, looking back, her face veiled.

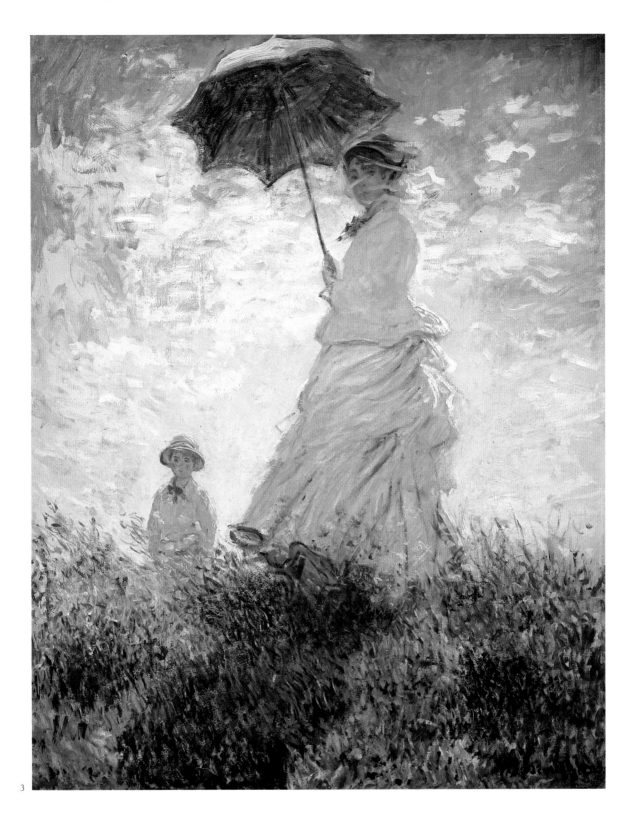

3

Try to forget what object you have before you—
a tree, a house, a field, or whatever.
Merely think, here is a little square of blue,
here an oblong of pink, here a streak of yellow...

CLAUDE MONET
advice to an American painter

145

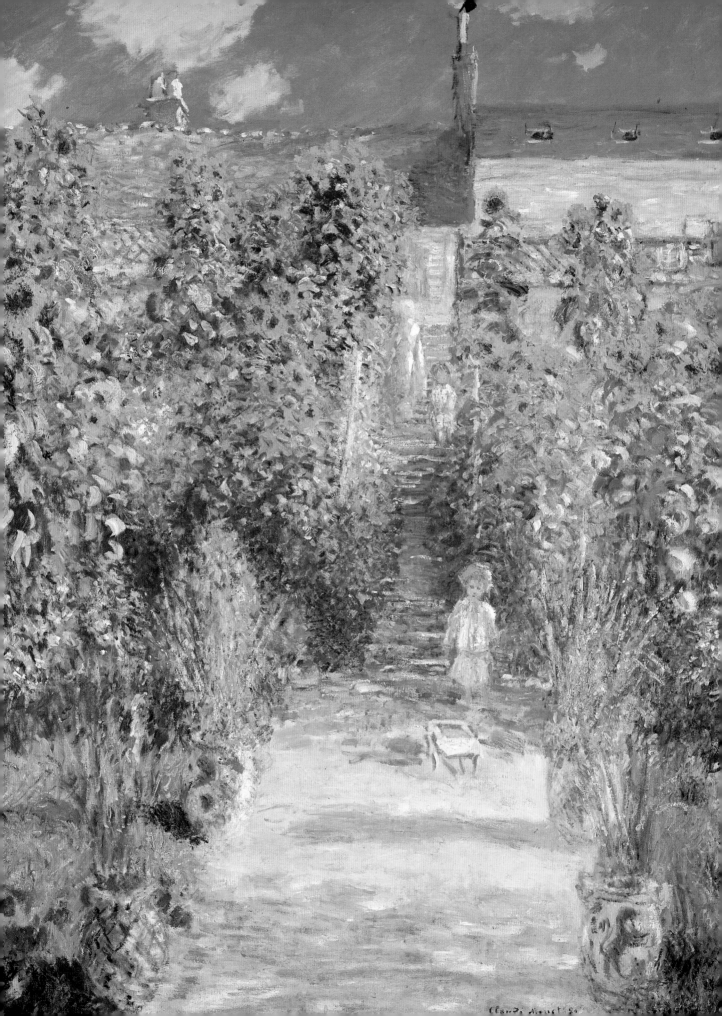

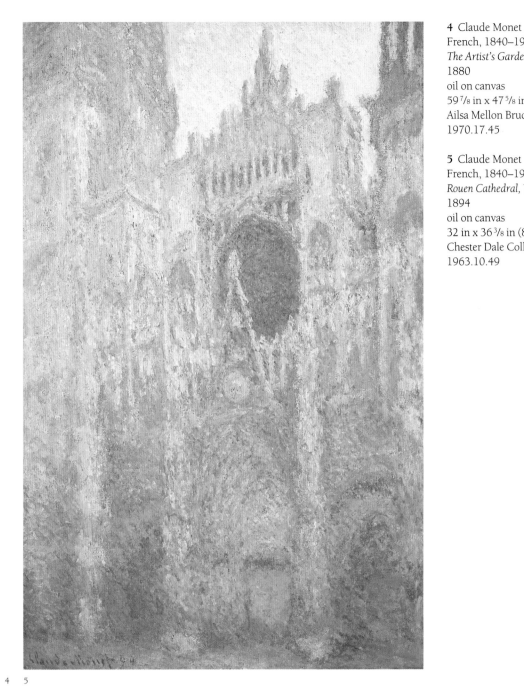

4 Claude Monet
French, 1840–1926
The Artist's Garden at Vétheuil
1880
oil on canvas
59 7/8 in x 47 5/8 in (1.51 m x 1.21 m)
Ailsa Mellon Bruce Collection
1970.17.45

5 Claude Monet
French, 1840–1926
Rouen Cathedral, West Façade
1894
oil on canvas
32 in x 36 3/8 in (81.3 cm x 92.5 cm)
Chester Dale Collection
1963.10.49

Camille died in 1879 at their home in Vétheuil, on the banks of the Seine. In *The Artist's Garden at Vétheuil* [4], painted in 1880, the colorful and free brushwork signals a new direction for Monet. The image presses against the picture plane, creating an impression of flatness. The high horizon and tall sunflowers form a steep, shallow space, where the garden path and steps ascend towards the house. The light appears to dissolve the edges of the solitary figure of the child and his diminutive cart in the foreground, and of the still smaller and more abstract figures in the background. Monet's later paintings dissolved entire cathedrals [5] into flecks of color and light.

6 Auguste Renoir
Woman with a Cat
c.1875
French, 1841–1919
oil on canvas
22 in x 18¼ in
(56 cm x 46.4 cm)
Gift of Mr. and Mrs.
Benjamin E. Levy
1950.12.1

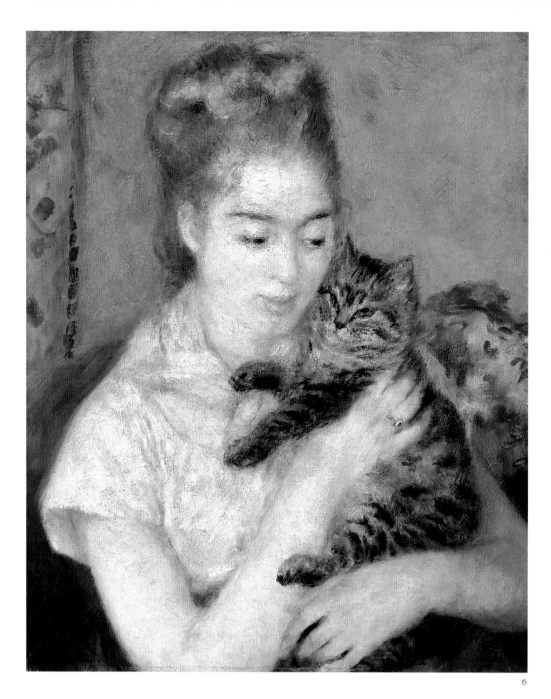

6

7 Auguste Renoir
French, 1841–1919
The Dancer
1874
oil on canvas
56⅛ in x 37⅛ in (1.43 m x 94.5 cm)
Widener Collection
1942.9.72

The impressionist Pierre Auguste Renoir was born in Limoges, renowned for its porcelain. He began his career in Paris painting porcelains, coats-of-arms, ladies' fans, blinds, and awnings. With the money he saved, he enrolled at the Académie Gléyre in Paris, where he met Bazille, Monet, and Sisley. He established his mature, impressionist style with the large canvas, *The Dancer* [7], which appeared at the 1874 impressionist exhibition. Throughout his life, he continued to explore variations on the female form, while other impressionists devoted themselves to landscape. He worked in pastels or oils, portraying sensual female dancers, bathers, and nudes in pastel hues with silken brushwork. His later paintings were often playful and intimate, as in *Woman with a Cat* [6], in which he captures the downy texture of the cat's fur.

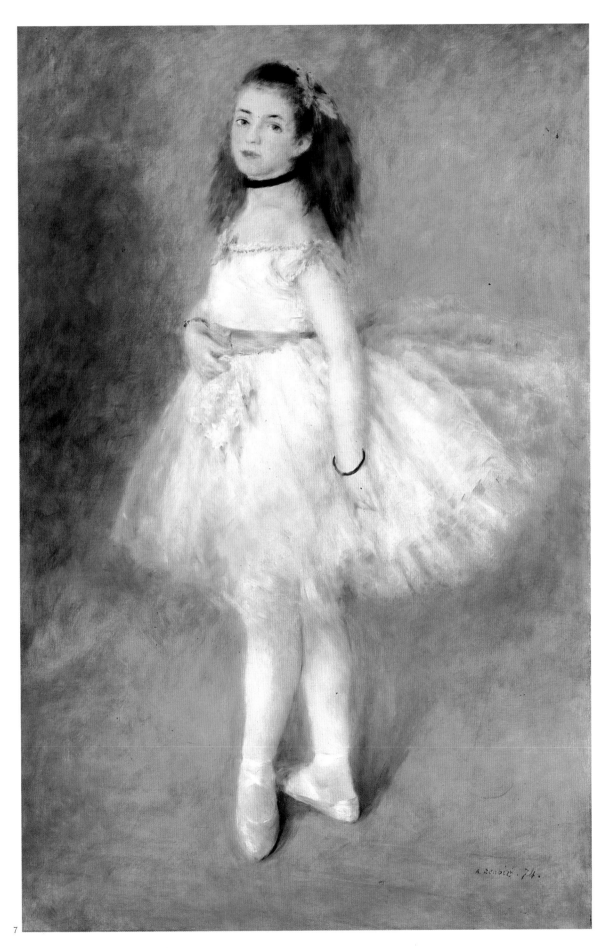

7

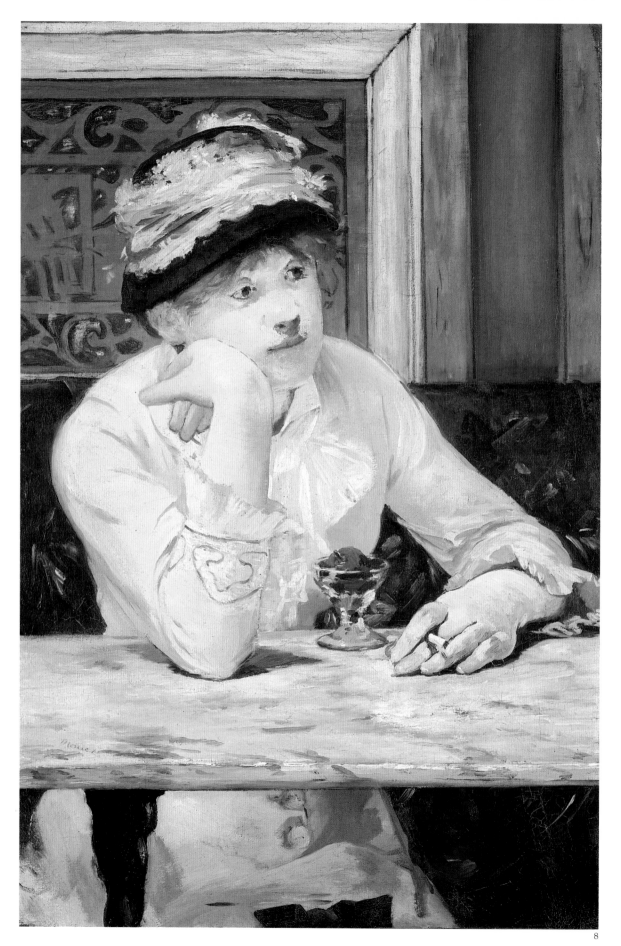

Although Edouard Manet and Edgar Degas exhibited with the impressionists, their style and subject-matter are often associated with realism. Victorine Meurent, the central figure in Manet's *Gare Saint-Lazare*, 1873 [9], was a professional model (and later a painter) who posed for Manet's most famous works, *Déjeuner sur l'Herbe* and *Olympia*. Victorine is accompanied by a young girl, seen from behind, who grasps the wrought-iron railings to see the trains below, blanketed in steam. Victorine glances up from her book, holding her place with her finger, a puppy asleep in her lap. Manet's *The Plum* [8] is an equally tantalizing portrait of a young woman in fashionable dress. She sits alone in a café, absorbed in her own thoughts, with her head resting on one hand, a cigarette in the other. A single glass dish containing an untouched plum is set before her. Both portraits capture the sense of intimacy and anonymity of the chance-encounters of city life.

8 Edouard Manet
French, 1827–1875
The Plum
c.1877
oil on canvas
29 in x 19 3/4 in (73.6 cm x 50.2 cm)
Collection of Mr. and Mrs. Paul Mellon
1971.85.1

9 Edouard Manet
French, 1832–1883
Gare Saint-Lazare
1873
oil on canvas
36 3/4 in x 45 1/8 in (93.3 cm x 1.16 m)
Gift of Horace Havemeyer in memory
of his mother, Louisine W. Havemeyer
1956.10.1

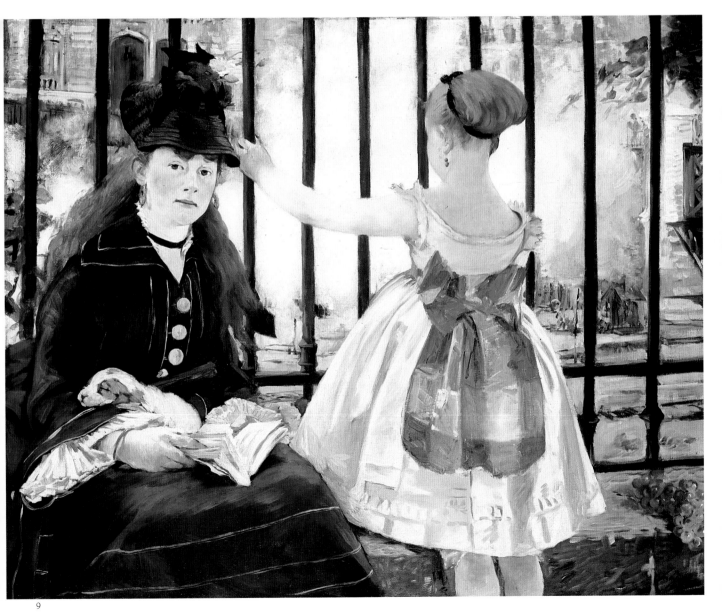

9

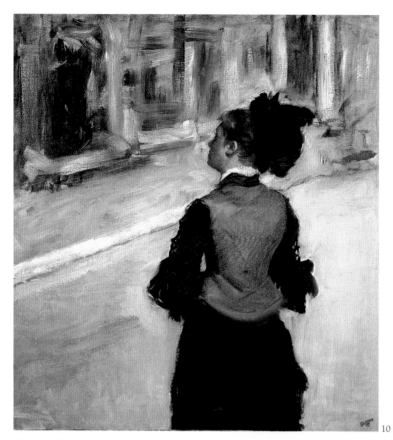

It is the movement of people and things that distracts and even consoles...

EDGAR DEGAS

10 Edgar Degas
French, 1834–1917
Woman Viewed from Behind
n.d.
oil on canvas
32 in x 29 ³/₄ in (81.3 cm x 75.6 cm)
Collection of Mr. and Mrs. Paul Mellon
1985.64.11

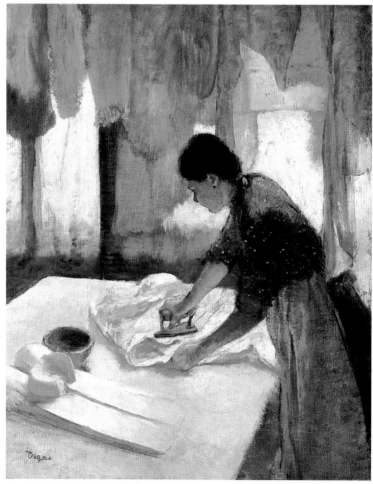

11 Edgar Degas
French, 1834–1917
Woman Ironing
begun *c.*1876, completed *c.*1887
oil on canvas
32 in x 26 in (81.3 cm x 66 cm)
Collection of Mr. and Mrs. Paul Mellon
1972.74.1

152

Degas shared Manet's fascination for the modern urban woman. His painting *Woman Viewed from Behind* [10] records the body language of an unaccompanied woman pausing to look at a picture at the Louvre. The realists—from Daumier to Degas— frequently portrayed the women workers of Paris, including shop assistants, milliners, and laundresses. Degas' *Woman Ironing* [11], completed around 1887, is a study of a working woman's body distorted by physical strain.

Degas perceived ballet dancers as working bodies in motion, with the same fascination for movement that he brought to his study of racehorses. The artist often portrayed unconventional poses, as in *Four Dancers* [12], where women are shown fastening the ribbons on their costumes in a rhythmic pattern of elbows. His realism could be cruel in his studies of movement, showing women stretching, scratching, and bathing themselves. Degas translated these postures and gestures into figurines, made of wax, cork, wire, and other materials. He reworked these malleable wax figurines throughout his career, but never committed a single one to bronze—"that material for eternity," as he said.

12 Edgar Degas
French, 1834–1917
Four Dancers
*c.*1899
oil on canvas
59 ½ in x 71 in (1.51 m x 1.80 m)
Chester Dale Collection
1963.10.122

12

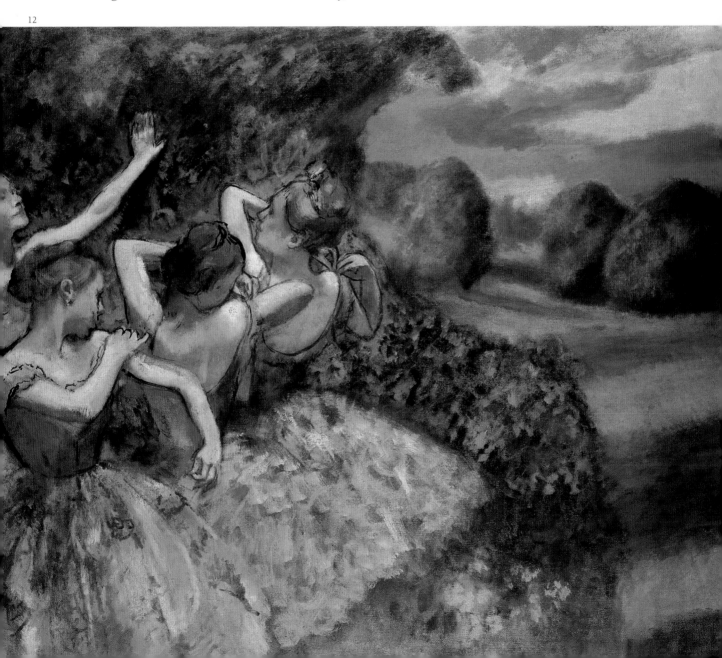

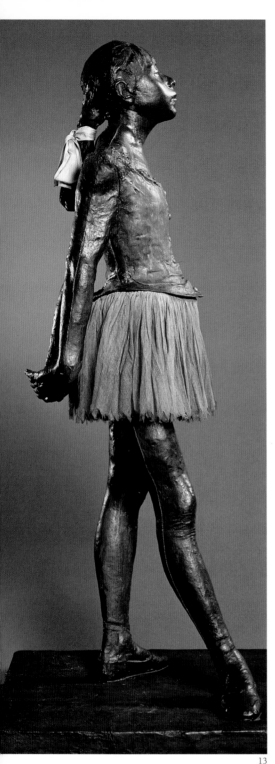

More than 150 wax statuettes, many of them incorporating cork, clay, wood splinters, and other materials, were found in the artist's studio after his death in 1917. In 1919, bronze casting began at a foundry in Paris, but many of the wax sculptures had begun to disintegrate: *The Tub* of 1889 [14] is one of the seventy surviving wax figurines (including one in plaster). Degas' *Little Dancer—Fourteen Years Old* [13] is a plaster version cast from the wax figure model that was exhibited at the Sixth Impressionist Exhibition in 1881. Considerably larger than his wax statuettes, *Little Dancer* was the only sculpture Degas exhibited in his lifetime. It was startling in its realism, not least because he dressed the figure in a real tutu and ribbon. Those critics accustomed to the smooth finish of academic sculpture of female nudes—often classically inspired—found *Little Dancer's* realism to be grotesque. The writer and art critic J. K. Huysmans felt otherwise: "The fact is that in one blow, M. Degas has overthrown the traditions of sculpture."

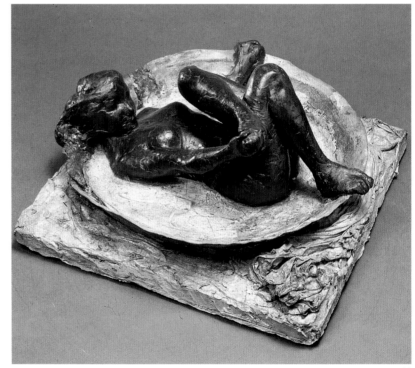

13

13 Edgar Degas
French, 1834–1917
Little Dancer—Fourteen Years Old,
1880/1881,
cast *c.*1920–1923
plaster cast
height: 39 ½ in (1 m)
Collection of Mr. and Mrs. Paul Mellon
1985.64.62

14

14 Edgar Degas
French, 1834–1917
The Tub
1889
brownish red wax, lead, plaster of Paris, cloth
diameter: 18 ½ in (47 cm)
Collection of Mr. and Mrs. Paul Mellon
1985.64.48

Mary Cassatt first exhibited with the impressionists in 1879, at Degas' invitation. The daughter of a Pennsylvania broker, she had settled in Paris in 1866, after extensive trips to Europe and years of study in Philadelphia. She cast away many of the academic rules of Renaissance perspective and precision of form after studying with Degas in the 1870s. She painted young girls and women with an uncompromising, realistic rigor. The bright blues, dense brushwork, and tilted perspective of her large canvas were typical of her mature style. In *Little Girl in a Blue Armchair* of 1878 [15], Cassatt portrayed the child slumped in her chair, practically sliding off in her restlessness. The intense blue of the chair, combined with the absence of a horizon, flattens the three-dimensional environment into a single, unified composition. Subtract the girl, and the composition borders on abstraction.

15 Mary Cassatt
American, 1844–1926
Little Girl in a Blue Armchair
1878
oil on canvas
35 ½ in x 51 ⅛ in (89.5 cm x 1.3 m)
Collection of Mr. and Mrs. Paul Mellon
1983.1.18

15

16

16 James McNeill Whistler
American, 1834–1903
Chelsea Wharf: Gray and Silver
c.1875
oil on canvas
24 ¼ in x 18 ⅛ in (61.5 cm x 46 cm)
Widener Collection
1942.9.99

As we have seen, the American expatriate artist James Abbott McNeill Whistler began his career as a painter in Paris, immersing himself in French art and culture. He studied at the Ecole des Beaux Arts and later met regularly with Courbet's group of realist artists, politicians, and writers at the Brasserie Hautefeuille. After being refused by the Salon of 1859—the official exhibition of the French Academy— Whistler exhibited at the Royal Academy, marking the beginning of his English career.

His landscape paintings made in England in the 1870s were often nocturnal, unlike the sunlit atmospheres of French impressionism. He studied the effects of artificial light, especially the reflections of city lights, welding sparks, and fireworks on the Thames. *Chelsea Wharf: Gray and Silver* [16] was painted in London within a year of the first impressionist exhibition in Paris. The radically abstract treatment of fireworks at night in Whistler's painting, *The Falling Rocket*, provoked the critic John Ruskin to accuse the artist of "flinging a pot of paint in the public's face." This remark incited the artist to sue the critic for libel, leading to a legal action in 1878 that left Whistler penniless. "As to what the picture represents," the defiant Whistler said, "that depends upon who looks at it."

The style of the French sculptor Auguste Rodin was profoundly influenced by his teacher, the romantic artist Barye (Chapter six), whose sculptures of wild animals inspired the young sculptor to explore the primitive nature of man. Rodin emulated the expressive male nudes of the Renaissance master Michelangelo. After a trip to Italy in 1875, Rodin wrote, "Michelangelo freed me from academicism." Nevertheless, monumental bronze casts of *The Thinker* of 1880 [17] are often seen at university campuses.

17 Auguste Rodin
French, 1840–1917
The Thinker
1880
bronze
28 1/8 in x 14 3/8 in x 23 1/2 in
(71.5 cm x 36.4 cm x 59.5 cm)
Gift of Mrs. John W. Simpson
1942.5.12

17

House of Père Lacroix [18] is from Paul Cézanne's impressionist period. It was painted in the town of Auvers-sur-Oise, northwest of Paris, where the 34-year-old artist moved in 1873 to be close to his friend and mentor, Camille Pissarro. The carefully applied broken brushwork reveals Pissarro's influence. Yet the layers of pigment and obvious signs of reworking show how Cézanne struggled with the impressionist technique.

Within a few years Cézanne grew impatient with impressionism and he reached instead for a more formal, structured style. An emotional man, he perceived instability and anxiety even in nature. He became obsessed with how to fix the solidity of things—rocks, mountains, houses, even his father—on the flat surface of the painting. In the small but intense work *The Battle of Love* of around 1880 [19], the swirling clouds and lance-like trees accentuate the psychological struggle of the naked male and female figures. .

18 Paul Cézanne
French, 1839–1906
House of Père Lacroix
1873
oil on canvas
24 1/8 in x 20 in (61.3 cm x 50.6 cm)
Chester Dale Collection
1963.10.102

19 Paul Cézanne
French, 1839–1906
The Battle of Love
c.1880
oil on linen
14 7/8 in x 18 1/4 in (37.8 cm x 46.2 cm)
Gift of the W. Averell Harriman Foundation
in memory of Marie N. Harriman
1972.9.2

18 19

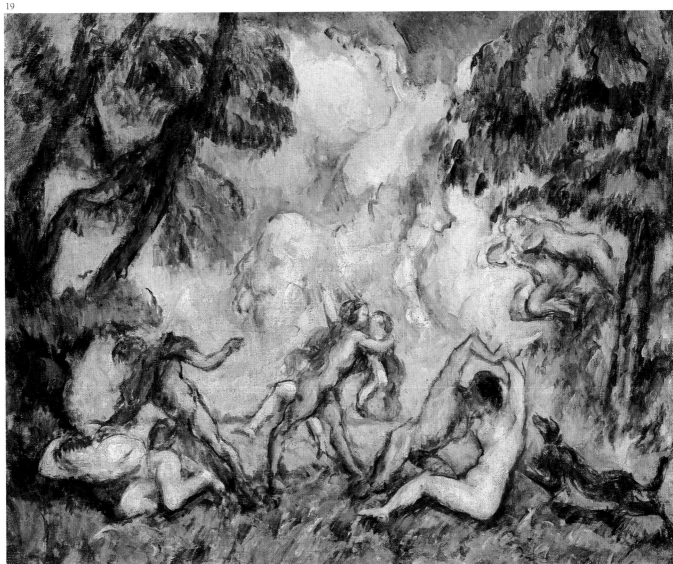

20 Paul Cézanne
French, 1839–1906
Still Life with Peppermint Bottle
*c.*1894
oil on canvas
26 in x 32 ³/₈ in
(65.9 cm x 82.1 cm)
Chester Dale Collection
1963.10.104

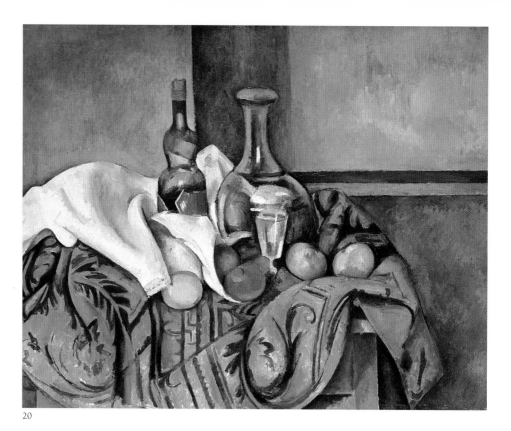

20

21

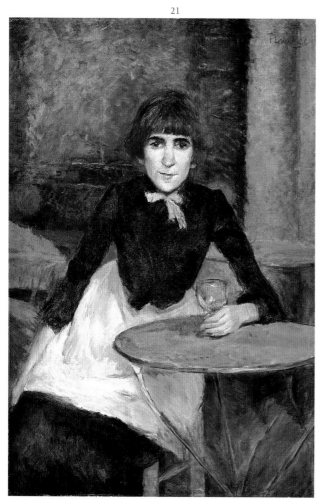

Whether he was painting female nudes, apples, or peaches, the artist's battle was with a reality that was constantly shifting and changing. In 1886, after the death of his father, Cézanne settled in his native Aix-en-Provence. The still lifes he painted in his fifties, included works of imposing form and vibrant color, and even sumptuous textures. His monumental *Still Life with Peppermint Bottle* of around 1894 [20] reflects his mature artistry.

Like Cézanne, the new generation of postimpressionists created many of their principal works in the 1880s and 1890s. Henri de Toulouse-Lautrec was ten years old when Monet's *Impression— Sunrise* was first exhibited. As a young man, he learned from his aristocratic uncle to paint sporting pictures. But his early sketchbooks revealed one of his great talents—caricature. Among his sketches were self-parodies; he was a diminutive figure whose legs had failed to develop as the result of a childhood bone disease. He soon eschewed

21 Henri de Toulouse-Lautrec
French, 1864–1901
Carmen Gaudin
1885
oil on wood
9 ³/₈ in x 5 ⁷/₈ in (23.8 cm x 14.9 cm)
Ailsa Mellon Bruce Collection
1970.17.85

his aristocratic background and became a regular at the music halls and night-cafés of Montmartre, a *demi-monde* that he often portrayed in paintings and prints with a harsh objectivity. A portrait of his friend Carmen Gaudin of 1885 [21] reveals the artist at his most compassionate. Her sharp features and penetrating deep brown eyes radiate intelligence and humor. *A Corner of the Moulin de la Galette* of 1892 [22] exemplifies his mature style and captures the lively decadence of *fin-de-siècle* Paris.

22 Henri de Toulouse-Lautrec
French, 1864–1901
A Corner of the Moulin de la Galette
1892
oil on cardboard
39 ³/₈ in x 35 ¹/₈ in (1 m x 89.2 cm)
Chester Dale Collection
1963.10.67

22

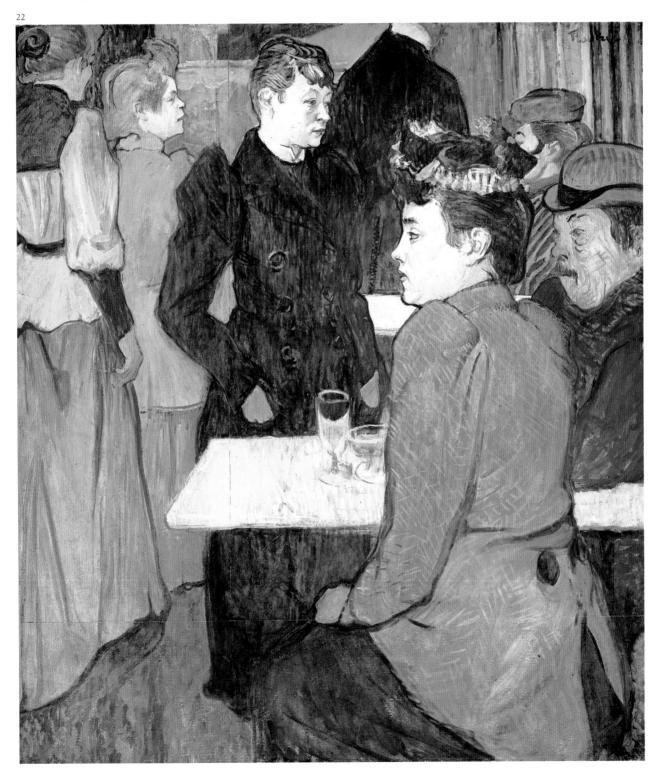

23 Georges Seurat
French, 1859–1891
Seascape at Port-en-Bessin, Normandy
1888
oil on canvas
25 ⅝ in x 31 ⅞ in (65.1 cm x 80.9 cm)
Gift of the W. Averell Harriman Foundation
in memory of Marie N. Harriman
1972.9.21

Another postimpressionist, Georges Seurat, forged a new theory of painting in the mid-1880s based on the impressionist principles of color and light. Fascinated by scientific theories of color and optics, the artist developed his own "formula for optical painting" using simplified forms and individual "points" of primary (unmixed) colors, a technique known as neo-impressionism or divisionism. It was in 1886, after two years of experiment and a decade of study, that Seurat exhibited the monumental divisionist work *Sunday Afternoon on the Island of the Grand Jatte* (Chicago), a scene of hieratic stillness showing Parisians at rest on the banks of the Seine. As seen in his later work, *Seascape at Port-en-Bessin, Normandy*, of 1888 [23], Seurat divides each simplified shape into a field of color and light composed of "dots" that coalesce only when the viewer steps back from the painting. A halo around the image forms a border, or frame, which further illuminates the central composition.

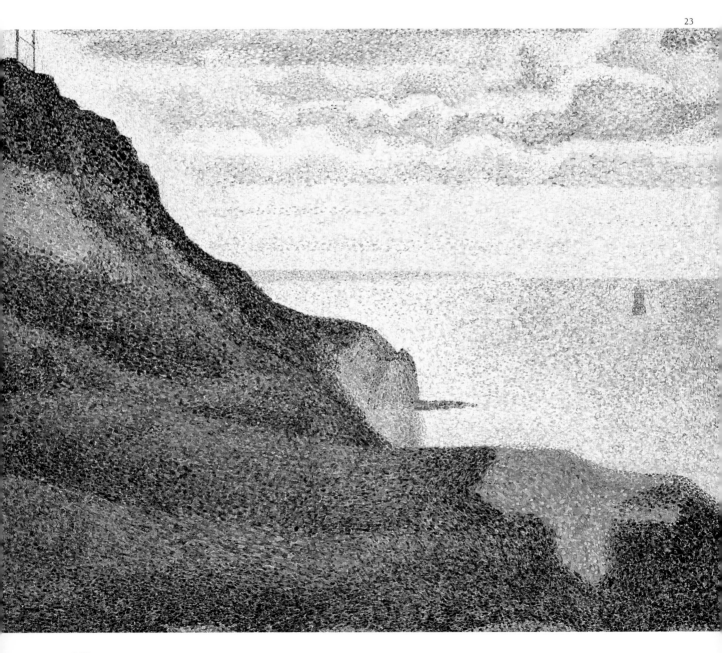

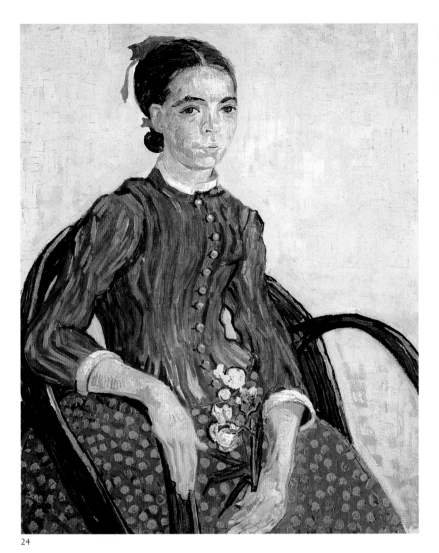

24

24 Vincent Van Gogh
Dutch, 1853–1890
La Mousmé
1888
oil on canvas
28 7/8 in x 23 3/4 in (73.3 cm x 60.3 cm)
Chester Dale Collection
1963.10.151

Instead of trying to reproduce exactly what I have before my eyes,
I use color more arbitrarily so as to express myself forcibly.

Vincent van Gogh

Vincent van Gogh did not share Seurat's rational approach. The son of a Dutch Protestant pastor, Van Gogh had hoped to become a priest, but such was his ascetic zeal that he was rejected from the ministry. In 1881, he resolved to become a painter, to express "the terrible passions of humanity." For the remainder of his brief life— he committed suicide in 1890, at the age of forty-seven—he created a claustrophobic universe of electric hues and anxious perspectives. His use of arbitrary color, applied with a heavily laden brush, was vital to his expressive style. He often chose lemon-yellow and acidic green for his backgrounds, as in *La Mousmé* of 1888 [24].

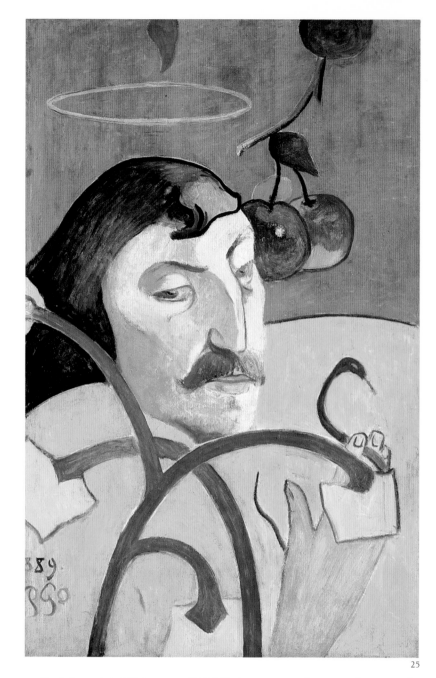

25

25 Paul Gauguin
French, 1848–1903
Self-Portrait
1889
oil on wood
31 ¼ in x 20 ¼ in (79.2 cm x 51.3 cm)
Chester Dale Collection
1963.10.150

26 Paul Gauguin
French, 1848–1903
Parau na te Varua ino (Words of the Devil)
1892
oil on canvas
36 ⅛ in x 27 in (91.7 cm x 68.5 cm)
Gift of the W. Averell Harriman Foundation
in memory of Marie N. Harriman
1972.9.12

Paul Gauguin's *Self-Portrait* of 1889 [25] accentuates his exotic features—he was proud of his mother's Peruvian roots—and includes a halo and a snake, cultish symbols of a brotherhood of painters known as the Nabis (Hebrew for "Prophets"). It was a short-lived phase and Gauguin left France in 1891 for Tahiti. He was turning his back on Paris—"the disease of civilization"—and on the impressionists and postimpressionists who, in his words, "heed only the eye and neglect the mysterious centers of thought, so falling into merely scientific reasoning." In his Tahitian paintings, including *Words of the Devil* [26], he interpreted images of Polynesian religion and folklore, and invested them with his own mysticism. He died in Tahiti in 1903 of malnutrition and disease, leaving behind his end-of-century work *Where Do We Come From? Who Are We? Where Are We Going?* (Boston).

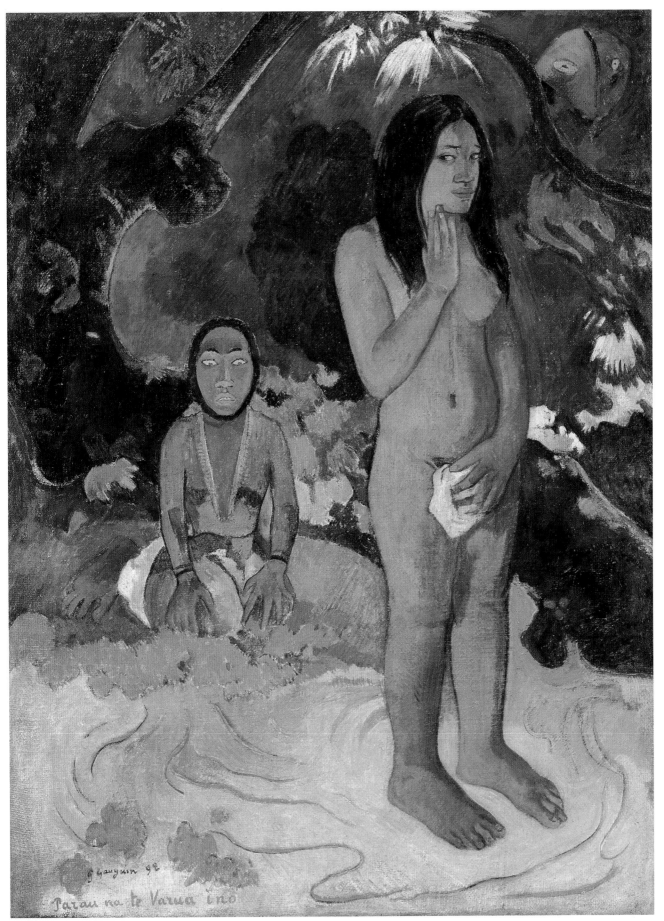

26

Early 20th century

*What is real is not the external form,
but the essence of things. . .
it is impossible for anyone to express
anything essentially real by
imitating its exterior surface.*

<small>Constantin Brancusi (1876–1957)</small>
In an interview with Paul Morand, 1926

Wassily Kandinsky
Improvisation 31, Sea Battle
[11, detail]

1 Paul Cézanne
French, 1839–1906
Still Life with Apples and Peaches
*c.*1905
oil on canvas
31 ⁷/₈ in x 39 ⁹/₁₆ in
(81 cm x 1 m)
Gift of Eugene and
Agnes E. Meyer
1959.15.1

2 Claude Monet
French, 1840–1926
Waterloo Bridge, Gray Day
1903
oil on canvas
25 ³/₈ in x 39 ³/₈ in
(65.1 cm x 1 m)
Chester Dale Collection
1963.10.183

1

2

3

3 Pablo Picasso
Spanish, 1881–1973
Le Gourmet
1901
oil on canvas
31 3/8 in x 23 5/8 in (79.7 cm x 60 cm)
Collection of Mr. and Mrs. Paul Mellon
1963.10.52

*Of course the conviction of "the truth"
of geometrical propositions . . .
is founded exclusively on rather
incomplete experience. At a later
stage . . . we shall see that this "truth"
is limited.*

ALBERT EINSTEIN (1879–1955)
Special Theory of Relativity, 1905

By the early twentieth century, Claude Monet and Paul Cézanne were in their sixties, but still producing revolutionary work bordering on abstraction. In Monet's *Waterloo Bridge, Gray Day*, 1903 [2], the solid form of the bridge virtually dissolves into London's wintry fog. Cézanne's *Still Life with Apples and Peaches* [1], painted during the year before he died in 1906, displays an increasingly precipitous perspective—in retrospect, a dam of forms that broke with cubism. "Around 1906," the Spaniard Pablo Picasso, a pioneer of cubist technique, would later say, "Cezanne's influence gradually flooded everything."

Picasso's Blue Period paintings created a unifying vision of melancholy color and attenuated forms, partly inspired by El Greco (Chapter four). Picasso, born in 1881 in Malagá, spent his late teens working in the long shadow of *fin-de-siècle* Barcelona, where artists and poets were steeped in late nineteenth-century symbolism and Catalan mysticism. *Le Gourmet* of 1901 [3] portrays a little girl standing in a shallow, shrouded space, reminiscent of Cezanne's distorted perspectives. The table is tipped toward the viewer, revealing nothing but an empty bowl, cup, and crust of bread.

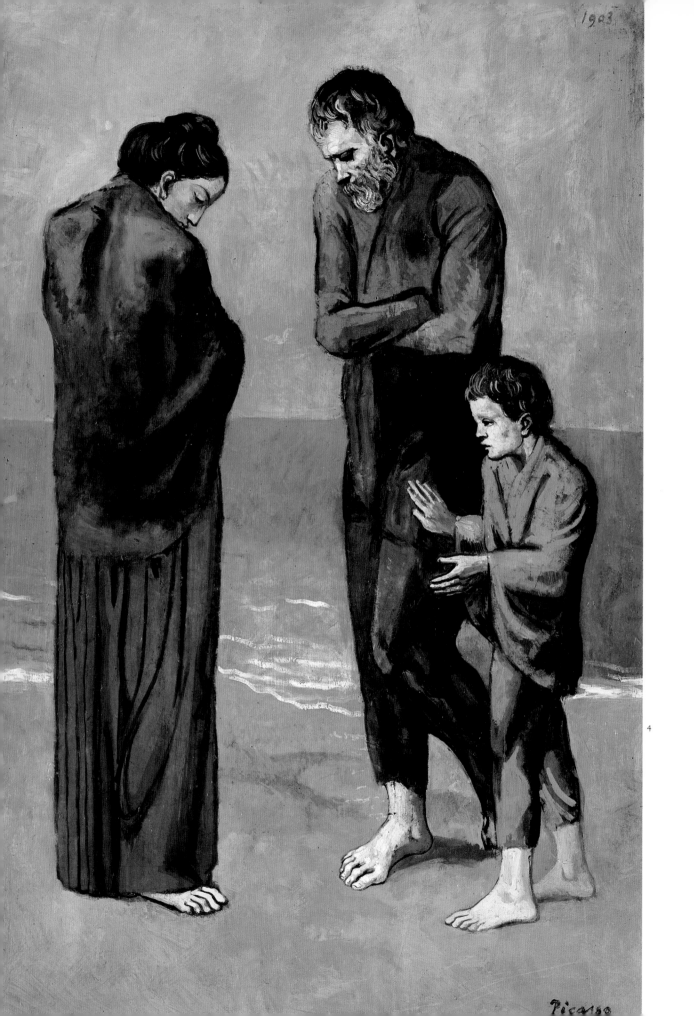

5

4 Pablo Picasso
Spanish, 1881–1973
The Tragedy
1903
oil on canvas
39 3/8 in x 31 7/8 in
(1 m x 81 cm)
Collection of
Mr. and Mrs. Paul
Mellon
1963.10.196

5 Pablo Picasso
Spanish, 1881–1973
Lady with a Fan
1905
oil on canvas
39 1/2 in x 32 in
(1 m x 81.2 cm)
Gift of the
W. Averell Harriman
Foundation
in memory of
Marie N. Harriman
1972.9.19

Picasso's *The Tragedy*, a Blue Period work painted in 1903 [4], portrays three ascetic figures—a man, a woman, and a young boy— standing together on the seashore. The entire scene is suffused with blue. The gaunt, bearded figure of the man, who faces the cloaked woman but does not look at her, braces himself against the chill of loneliness. The boy rests one hand on the man's thigh in consolation. The configuration of the boy's raised hands is echoed in a later Blue Period work, *Lady with a Fan* of 1905 [5].

6 Henri Matisse
French, 1869–1954
Pianist and Checker-Players
1924
oil on canvas
29 in x 36 ³/₈ in
(73.7 cm x 92.4 cm)
Collection of
Mr. and Mrs. Paul Mellon
1985.64.25

6

7

7 André Derain
French, 1880–1954
*Charing Cross Bridge,
London*
1906
oil on canvas
31 ⁵/₈ in x 39 ¹/₂ in
(80.3 cm x 1 m)
John Hay Whitney
Collection
1982.76.3

Between 1905 and 1907, a small group of French artists including André Derain and Henri Matisse exhibited canvases of such vibrant color that one critic referred to the artists as wild beasts, or "fauves"—hence the term fauvism. Even the gray River Thames appeared Mediterranean through fauvist eyes, as in Derain's *Charing Cross Bridge, London* [7].

Matisse, like Derain, used arbitrary color and open brushwork, rejecting the slavish imitation of nature which he associated with academic artists. The red patterns of the wallpaper, tablecloth, rug, and terracotta tiles in *Pianist and Checker-Players* of 1924 [6] exemplified Matisse's use of color to unify his joyful compositions. "What I am after, above all," he wrote, "is expression."

Artists of the period admired so-called "primitive" and "naive" art for its expressive power. The antithesis of academic art, it gravitated towards the elements of modern painting: flat perspective, simple shapes, and intense color. One of the most whimsical of the *faux naïfs* was Henri Rousseau, nicknamed Le Douanier—for he was a retired customs-officer. Unfazed by his lack of formal training, he once told his friend and admirer Picasso that they were the greatest painters alive, "I in the modern manner and you in the Egyptian." Le Douanier painted imaginary jungles with wide-eyed wild beasts peeping through a mass of outsized foliage—as seen in *The Equatorial Jungle*, 1909 [8]. Like Delacroix before him, he studied exotic plants and caged animals at the Jardin des Plantes, to capture, as he wrote, "the end of a dream, where fantasy becomes reality."

The whole arrangement of my pictures is expressive. The place occupied by the figures or objects, the empty spaces around them, the proportions, everything plays a part.
HENRI MATISSE

8
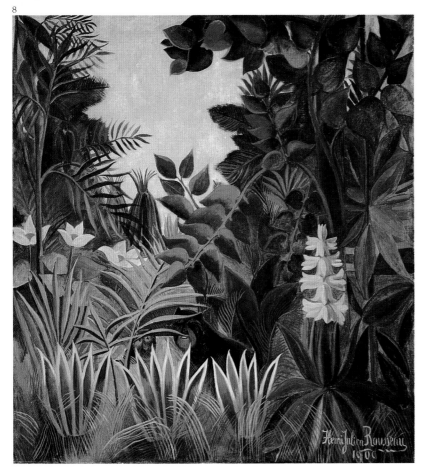

8 Henri Rousseau
French, 1844–1910
The Equatorial Jungle
1909
oil on canvas
55 ¼ in x 51 in (1.41 m x 1.29 m)
Chester Dale Collection
1963.10.213

173

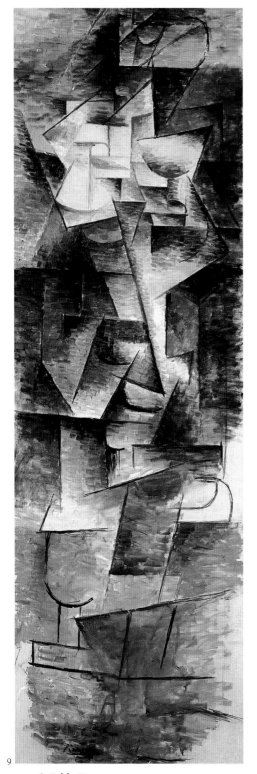

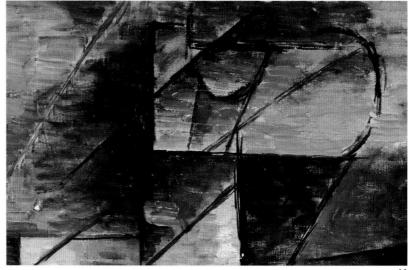

10

*There is no such thing as abstract art...
you must always start with something.*
PABLO PICASSO

In 1911, the poet Guillaume Apollinaire, a friend of Picasso, drew a parallel between the new cubist painting and recent scientific discovery, especially Einstein's theory of relativity: "Now today's scientists have gone beyond the three dimensions of Euclidean geometry," Apollinaire said. "Painters have, therefore, very naturally been led to a preoccupation with those new dimensions of space." The cubists, from Picasso to Georges Braque, explored new ways to depict forms in space that did not rely on Renaissance perspective, derived from Euclidean geometry. They analyzed the structure and components of nature, pulling apart familiar objects as if to see what made nature "tick." Picasso's *Nude Woman* of 1910 [9] exemplifies analytic cubism. Its subject is the female nude, one of the prevailing themes in art since ancient times. And yet her contours are barely discernible; each facet or edge appears to slip away, dissolving into a labyrinth of brushstrokes [10, detail].

The cubists stopped short of total abstraction. Like the first scientists investigating the atomic structure of the universe, the early abstract painters and sculptors sought to distil familiar, everyday forms, like cows, trees, or birds, to their essence. The pioneers of abstract art were from Eastern or Central Europe: Kasimir Malevich, Wassily Kandinsky, František Kupka, and Constantín Brancusi. Although other artists later staked their claim to its invention, the "first" abstract painting was probably a watercolor by the Russian-born artist Kandinsky, dating from 1909.

Kandinsky, having studied law at Moscow University, was an eloquent advocate of abstract art, writing of his own "inner necessity" and illustrating the development of his abstract forms and expressive use of color, inspired by

9

9 Pablo Picasso
Spanish, 1881–1973
Nude Woman
1910
oil on linen
73 ³/₄ in x 24 in (1.87 m x 61 cm)
Ailsa Mellon Bruce Fund
1972.46.1

10 Detail of [9] showing woman's face

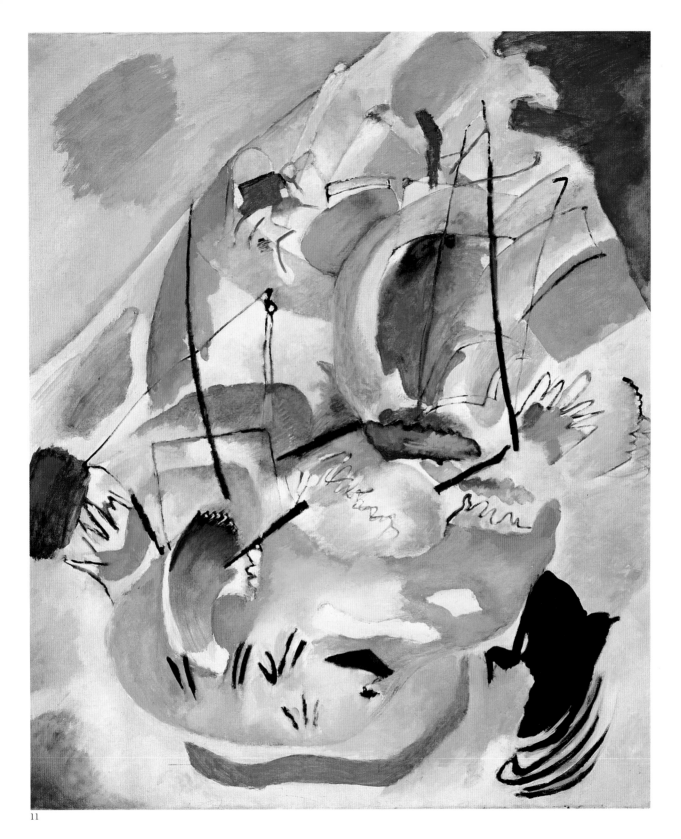

11

sources that varied from Russian folk glass-painting to telegraph poles. Between 1909 and 1913, he painted a series of over forty improvisations. Each large canvas presented a universe of color and calligraphic black lines that for the artist reflected the spiritual struggle of his time. Painted on the eve of World War I, *Improvisation 31, Sea Battle*, 1913 [11] suggests the shapes of two ships

11 Wassily Kandinsky
Russian, 1866–1944
Improvisation 31, Sea Battle, 1913
oil on linen
55 3/8 in x 47 1/8 in (1.41 m x 1.2 m)
Ailsa Mellon Bruce Fund
1978.48.1

12 František Kupka
Czechoslovakian, 1871–1957
Organization of Graphic Motifs II
1912–1913
oil on canvas
78 3/4 in x 76 3/8 in (2 m x 1.94 m)
Ailsa Mellon Bruce Fund and
Gift of Jan and Meda Mladek
1984.51.1

12

with tall black masts flexed against a surging sea of color. During the same period, Kupka painted *Organization of Graphic Motifs II* [12], in which colors radiate from what is probably a reclining nude at the center [13, detail].

13

13 Detail of [12] showing reclining nude at center

In 1917, the Dutch artists Piet Mondrian and Theo van Doesburg founded "De Stijl", or simply "The Style"—a geometric abstract style that Van Doesburg described as an expression of pure, abstract thought. Van Doesburg, a fervent Calvinist, denounced sensuality in painting: "White canvas [is] almost solemn," he wrote. In Mondrian's earliest landscapes painted near Amsterdam, the artist revealed the essential structure of such familiar objects as windmills, trees, piers, and waves, with a web of lines. By 1917, these horizontal, vertical, and oblique strokes evolved into Mondrian's first grid compositions. In the

following year, he painted his first diamond-shaped works animated by modules of primary color, as seen in *Tableau IV; Lozenge Composition with Red, Gray, Blue, Yellow and Black* [14], begun around 1924. The artist repainted it a year later, thickening the black lines of the grid. As Van Doesburg wrote, "Mondrian realizes the importance of line. The line has almost become a work of art in itself."

14 Piet Mondrian
Dutch, 1872–1944
Tableau IV; Lozenge Composition with Red, Gray, Blue, Yellow, and Black
*c.*1924/1925
canvas on hardboard
lozenge: 56 ⅕ in x 56 in
(1.43 m x 1.42 m)
Gift of Herbert and Nannette Rothschild
1971.51.1

To approach the spiritual in art one must use as little as possible of reality, because reality is opposed to the spiritual.
PIET MONDRIAN

14

The reclusive Romanian sculptor Constantín Brancusi settled in Paris in 1904. He lived for over fifty years in his cramped, skylit studio, surrounded by his sculpture, which he referred to as his children. He took over 1700 photographs of his work, individually or in combination, recording their transformation under different light conditions. Brancusi often recreated the same hermetic form in different materials, including wood, marble, concrete, and brass. The polished white marble version of *Bird in Space* [15], dating from 1925, evokes the idea of flight rather than a specific bird. Its soaring arc represents all birds, in the artist's words, "rolled into one." Unlike the Russian constructivists or Italian futurists of the early twentieth century, whose abstractions often glorified technology and the machine, Brancusi fashioned forms from organic models. Although his marble works have a machine-like finish and precision, he worked entirely by hand, using primitive tools.

Realism was an equally powerful spiritual and moral force in the early twentieth century, as artists bore witness to World War I and the Great Depression. In Germany, Käthe Kollwitz, who lived for most of her life in the Berlin ghetto, felt a solidarity with the poor and oppressed. Her drawing of 1903, *Woman with Dead Child* [16], is a universal image of suffering. The German artist Otto Dix was a machine-gunner who fought at Flanders. *The War (Der Krieg)* [17] was a series of prints based on sketches he had made both during and after the war, published in 1924. The series is the most harrowing indictment of war since Goya's *Disasters of War* (see Chapter six).

15 Constantín Brancusi
Romanian, 1876–1957
Bird in Space
1925
marble, stone, and wood
71 ⁵/₈ in x 5 ³/₈ in x 6 ³/₈ in
(1.82 m x 13.7 cm x 16.2 cm)
Gift of Eugene and Agnes E. Meyer
1967.13.3

I have painted facts, which were as valid years ago as they are today and will be tomorrow and always.

OTTO DIX

16

16 Käthe Kollwitz
German, 1867–1945
Woman with Dead Child (Frau mit totem Kind)
1903
engraving and soft-ground etching
retouched with black chalk, graphite, and
metallic gold paint on heavy wove paper
(trial proof)
16 1/2 in x 18 1/2 in (41.7 cm x 47.2cm)
Gift of Philip and Lynn Straus,
in Honor of the 50th Anniversary of the
National Gallery of Art
1988.67.1

17 Otto Dix
German, 1891–1969
Tote vor der Stellung bei Tahuret
1924
series: *Der Krieg (The War)*
etching and aquatint
plate: 7 1/2 in x 10 1/16 in (19 cm x 26 cm)
sheet: 13 11/16 x 18 5/8 in (35 cm x 47 cm)
Print Purchase Fund
(Rosenwald Collection)
1971.10.2

17

The imposing mechanism of the male sexual apparatus lends itself to symbolization by every sort of indescribably complicated machinery.

SIGMUND FREUD (1856–1939)
The Interpretation of Dreams, 1900

18 Francis Picabia
French, 1879–1953
Machine Tournez Vite (Machine Turn Quickly)
1916/1918
gouache and metallic paint on paper;
laid down on canvas
19 ½ in x 12 ⅞ in (49.6 cm x 32.7 cm)
Patrons' Permanent Fund
1989.10.1

19 Joan Miró
Spanish (Catalán), 1893–1983
The Farm
1921–1922
oil on canvas
48 ¾ in x 55 ⅝ in x 1 ⁵⁄₁₆ in
(1.24 m x 1.41 m x 3.3 cm)
Gift of Mary Hemingway
1987.18.1

20 Detail of [19] showing rabbit-warren

Many artists suffered from extreme disillusionment during and after the war, and were unable to draw or paint as before. They resorted to visceral protest—an artistic anarchy known as Dada: "Dada is nothing," their manifesto said. Francis Picabia's *Machine Tournez Vite* of 1916-1918 [18] contradicted the glorification of technology and the machine that preceded the war. He collaborated with Marcel Duchamp, a leader of the Dada movement, whose anthropomorphic machines became legendary.

Picabia was one of the original members of Dada in Zurich, a group that included the Swiss artist Jean (Hans) Arp. Both Picabia and Arp later joined the surrealists, a group of artists who believed in the "primal" expressiveness of the "primitive" unconscious mind as it was revealed in the writings of Sigmund Freud. Surrealism of the 1920s was often related to dreams and hallucinations.

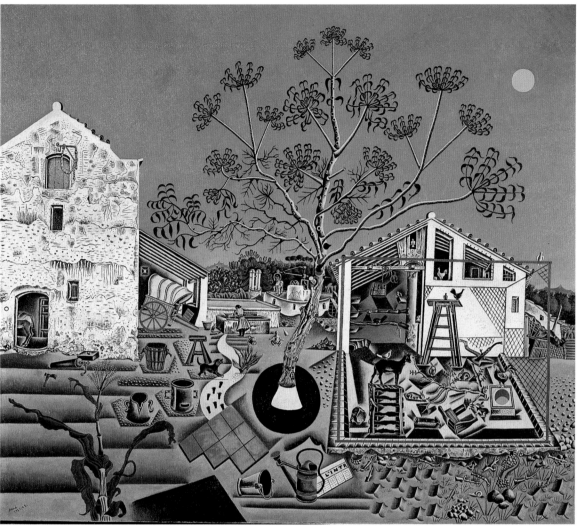

19

It took me practically two years to finish it, not because I had any trouble actually painting it. No, the reason it took so long was that what I saw underwent a metamorphosis ... I had to capture even the smallest detail of that farm I had right there before my eyes in Montroig.

JOAN MIRO
on *The Farm*

Joan Miró, the son of a watchmaker, invented a form of magic realism that first appears in *The Farm*, which he painted at his family farm in the Catalan village of Montroig in 1921/1922 [19]. Central to the composition is a thorn-apple tree, native to Catalonia, with its black shadow forming a perfect circle. The artist reveals more than the eye can see, from the birds inside the coop to the salamander and snail by the underground spring, which leads to the well, where the rooster stands. There is even a rabbit-warren [20, detail]. "I was drawing almost entirely from hallucinations," the artist said, recalling *The Farm*. "I was living on a few dried figs a day..." *The Farm* was one of the inspirations for the poet André Breton's *First Surrealist Manifesto* of 1924, which encouraged artists and writers to allow the unconscious to dictate their art.

20

22

23

21

21 Jean (Hans) Arp
French, 1886–1966
Mirr
1936/1960
marble
6 $^{7}/_{8}$ in x 8 $^{5}/_{8}$ in x 6 in
(17.5 cm x 21.9 cm x 15.3 cm)
Gift of Mr. and Mrs. Burton Tremaine
1977.75.6

22 Jean (Hans) Arp
French, 1886–1966
Shirt Front and Fork
1922
wood
23 in x 27 $^{1}/_{2}$ in x 2 $^{3}/_{8}$ in
(58.4 cm x 70 cm x 6.1 cm)
Ailsa Mellon Bruce Fund
1983.3.1

23 Yves Tanguy
French, 1900–1955
The Look of Amber
1929
oil on canvas
39 $^{3}/_{8}$ in x 31 $^{7}/_{8}$ in x $^{7}/_{8}$ in
(1 m x 81 cm x 2.3 cm)
Chester Dale Fund
1984.75.1

182

Hans Arp's technique of allowing pieces of paper or other objects to fall haphazardly produced the basis for his compositions, including the relief *Shirt Front and Fork* of 1922 [22]. Like other surrealists, he was fascinated by highly evocative, protean forms. Arp's sculpture *Mirr* of 1936/1960 [21] suggests a form that has yet to be born. Its title is poetic but nonsensical, echoing the expressive sounds of Dada. Its eggshell-smooth, sensual shape was typical of the surrealists, from Miró to the British sculptors Henry Moore and Barbara Hepworth. The same shape appears, scattered like beads of mercury across a Martian landscape, in Yves Tanguy's *The Look of Amber* of 1929 [23]. The central object of Alberto Giacometti's sculpture, *The Invisible Object (Hands Holding the Void)* [25] of 1935, is suggested rather than defined. Unlike his existential, reed-like men, seen walking through *The City Square* [24], this hieratic figure, with its large, staring eyes and its hands cupped around an invisible ball, has a mysterious sense of purpose.

24

24 Alberto Giacometti
Swiss, 1901–1966
The City Square
1948/1949
bronze
9 1/2 in x 25 1/2 in x 17 1/8 in (24 cm x 64.7 cm x 43.4 cm)
Gift of Enid A. Haupt
1977.47.3

25 Alberto Giacometti
Swiss, 1901–1966
The Invisible Object (Hands Holding the Void)
1935
bronze with blond patina
60 1/4 in x 12 7/8 in x 11 3/4 in (1.53 m x 32.6 cm x 29.8 cm)
Ailsa Mellon Bruce Fund
1973.27.1

25

Technique do you say? My slats! Say, listen you—
it's in you or it isn't. Who taught Shakespeare technique? . . .
Guts! Guts! Life! Life! That's my technique.

GEORGE LUKS

In America, realism prevailed. Among the most influential artists of the early twentieth century were a group of newspaper artists in Philadelphia who, inspired by the artist Robert Henri, became painters. One member of the group, the artist-reporter and painter John Sloan, described Henri as having "that magic ability as a teacher which inspires and provokes his followers into action." Together they formed the Ashcan School, so-called because they felt compelled to paint America's poor, who were largely ignored or turned into comic figures by many of the illustrated journals of the day. George Luks' large painting, *The Miner* [26], of 1925— inscribed "Pottsville. Pa."—portrays a Pennsylvania worker with the somber realism typical of the Ashcan School. George Bellows, a pupil of Henri, made several paintings and lithographs of amateur prize fights, as in *Both Members of this Club* [27]. He captured the swell of the crowd's brutalized faces with an eye for the grotesque heroics, and possibly racism, of prize fighting.

26 George Benjamin Luks
American, 1866–1933
The Miner
1925
oil on canvas
60 1/4 in x 50 3/8 in (1.53 m x 1.28 m)
Inscriptions: lower right:
George Luks / Pottsville. Pa.
Chester Dale Collection
1954.2.1

27 George Bellows
American, 1882–1925
Both Members of This Club, 1909
oil on canvas
45 1/4 in x 63 1/8 in (1.15 m x 1.6 m)
Chester Dale Collection
1944.13.1

27

28 John Marin
American, 1870–1953
*Echo Lake, Franconia Range,
White Mountain Country*
1927
watercolor and charcoal over
graphite
17 3/8 in x 22 1/4 in
(44 cm x 56.5 cm)
Alfred Stieglitz Collection
1949.2.5

29 John Marin
American, 1870–1953
Woolworth Building, No. 29
1912
watercolor
18 7/8 in x 15 1/2 in
(47.8 cm x 39.4 cm)
Gift of Eugene
and Agnes E. Meyer
1967.13.10

30 Georgia O'Keeffe
American, 1887–1986
Jack-in-the-Pulpit, No. IV, 1930
oil on canvas
40 in x 30 in (1.02 m x 76.2 cm)
Alfred Stieglitz Collection,
Bequest of Georgia O'Keeffe
1987.58.3

28

29

The Armory Show in New York in 1913 introduced the European avant-garde—from Cézanne to Picasso—to a sceptical American public. One exception was the photographer and gallery owner, Alfred Stieglitz, who had already supported abstract artists at home and abroad. From 1905 to 1917, his 291 Gallery (named after its address on Fifth Avenue in New York) exhibited the European artists Cézanne, Matisse, Picasso, Braque, and Brancusi, alongside the Americans Arthur Dove, Marsden Hartley, John Marin [28, 29], and Georgia O'Keeffe. From her earliest paintings of New York's skyscrapers to her later discovery of the adobe buildings, flowers, and skulls of the New Mexico desert, she revealed the essence of what she saw. Her *Jack-in-the-Pulpit* series of 1930 [30] exemplifies biomorphic abstraction— abstracted shapes derived from life forms, an American counterpoint to Brancusi's 1925 white marble sculpture, *Bird in Space*.

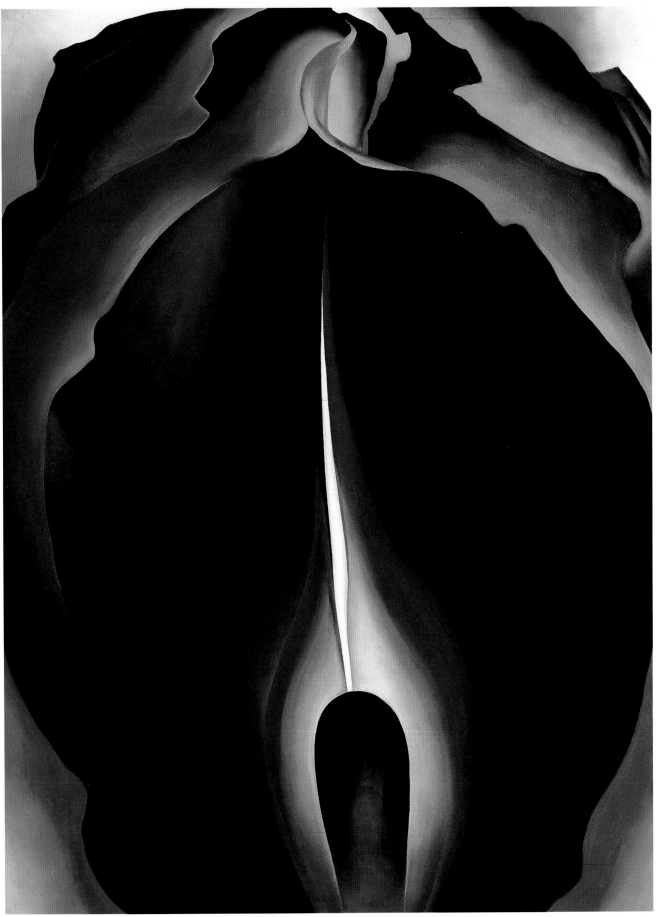

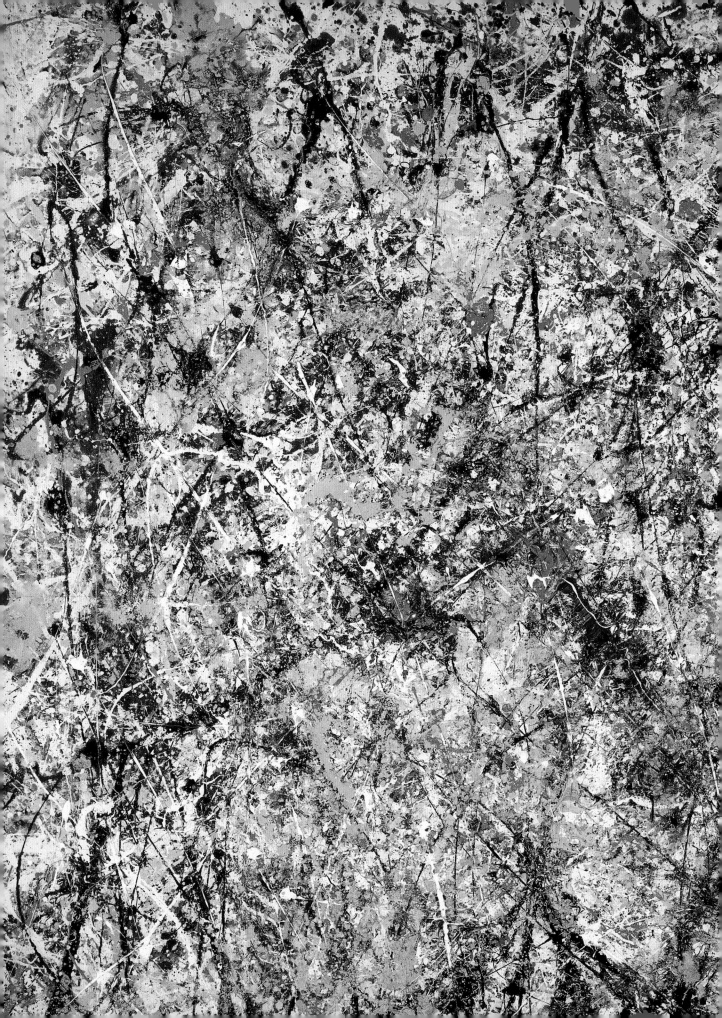

Chapter ten

Mid-20th century

It seems to me that the modern painter cannot express this age
—the airplane, the atom bomb, the radio—
in the old forms of the Renaissance or of any other past culture.
Each age finds its own technique.

JACKSON POLLOCK (1912–1956)
Taped interview, Sag Harbor radio, 1950

1 Detail of [2]

2 Jackson Pollock
American, 1912–1956
Number 1, 1950 (Lavender Mist)
1950
oil, enamel, and aluminum on canvas
87 in x 118 in (2.21 m x 3 m)
Ailsa Mellon Bruce Fund
1976.37.1

1

A fter World War II, New York usurped Paris as the art capital of the western world. From abstract expressionism of the 1940s and 1950s and pop art of the 1960s, modern art had become synonymous with New York, the mythic city of freedom and opportunity.

When an exhibition of the New York School, or abstract expressionists—including Jackson Pollock, Franz Kline, Willem de Kooning, and Mark Rothko—first toured Europe in 1958, critics remarked on the sheer size of the works. Pollock's frameless, all-over canvases reflected an *American* sense of space—*big* painting for a big country. Pollock was born in Cody, Wyoming, the home of Buffalo Bill. According to his brother, he was too weak to work on the farm. After drifting thousands of miles through Wyoming, Arizona, and California, Pollock settled in New York, where he studied at the Art Students' League with Thomas Hart Benton. Benton was a leader of the American regionalist school of the 1930s, whose rural fantasies were, in part, a jingoistic reaction against urban life and European culture. Pollock's virile image recalled the heroic field workers of Benton's midwestern farm scenes.

In 1951, *Life* magazine ran a cover story with the title "Is Jackson Pollock America's Greatest Living Artist?" It played on Pollock's working-man image—chain-smoking and steel-toed, with paint-spattered Levis—but glossed over the revolutionary character of his painting.

2

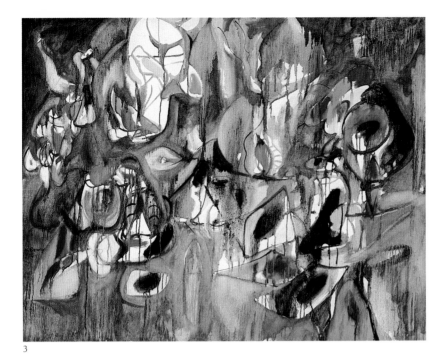

3

3 Arshile Gorky
American, 1904–1948
One Year the Milkweed
1944
oil on canvas
37 in x 47 in (94.2 cm x 1.2 m)
Ailsa Mellon Bruce Fund
1979.13.2

By laying his canvas on the floor, Pollock was free to move around it and, as he said, "literally be *in* the painting." Paint spatters cover the floor of his Long Island studio, now a museum, where he painted *Number 1, 1950 (Lavender Mist)* [1]. Like a sower, he cast thin skeins of paint in wide arcs across the white expanse of canvas. The paint settled in rhythmic waves, enveloping the viewer in a cosmic web. His titles—*One, Autumn Rhythm*—invoke Jung's "collective unconscious" (Pollock spent two years in Jungian analysis). Despite the coincidental appearance of the occasional cigarette end, boot, or hand prints [detail, 2], his "all-over" drip-paintings are wholly abstract.

All abstract expressionists were, to borrow one of Pollock's titles, guardians of the secret, but none more so than the Armenian-born Arshile Gorky. The critic Robert Hughes once described Gorky's brief life as a mature artist as a "Bridge of Sighs between surrealism and America." In the 1940s, Gorky met many of the European surrealists, who were among the thousands of refugees from Nazi-occupied Europe who settled in New York during and after the war. Gorky found a mentor in the surrealist poet André Breton, whose theories of "automatic writing" had inspired artists in the 1920s to paint "with their eyes closed."

Gorky's "inscapes," as he called them, featured a panoply of embryonic forms, as in *One Year the Milkweed* of 1944 [3]. The drifting corpuscular forms of his compositions were influenced by the ghostly masses of the Chilean surrealist painter Roberto Matta. These forms were often concentrated along an imagined horizon, magnetically bound by vertical bands or drips, and punctuated by flame-like bursts of color. His titles were nostalgic in character, carrying snatches of Armenian folk poetry, like voices in the wind. Gorky committed suicide in 1948, just as abstract expressionism was coming into its own.

4 Willem De Kooning
American, 1904–1997
Study for "Woman Number One"
1952
pastel, crayon, and graphite
approx. 9 in x 11 ¹/₄ in (22.9 cm x 28.5 cm)
Andrew W. Mellon Fund
1978.32.1

De Kooning was born in Rotterdam in the same year as Gorky—1904—but outlived him by more than a lifetime. For De Kooning, painting, to borrow a title from one of his first major works, was a form of *excavation*, penetrating beneath the surfaces of things to the core. His favorite subjects were woman, landscape and the sea. A pastel, crayon, and graphite drawing of 1952, *Study for "Woman Number One"* [4], reveals the versatility of his line, at once edgy and sensual. In 1963, he moved to Long Island, where his painting radiated the color and light of the sand and sea, in an infinite variety of multi-layered brushstrokes.

David Smith, machine worker and iron welder, translated the abstract expressionist ideal of forceful expression into sculpture. He turned sculpture inside-out—to see into its guts, its thickness—just as the painters of his generation exposed the elements of painting—brushstroke and canvas. It is as if Smith had made the hole at the center of Picasso's revolutionary cubist sculpture, *Guitar* of 1912, the subject of the *Circle* series [5] of 1962. His *Cubi X* series [6] were brushed steel figures the artist himself grouped together like small armies. Outdoors, their surfaces, etched like metallic De Koonings, glint in the sun.

4

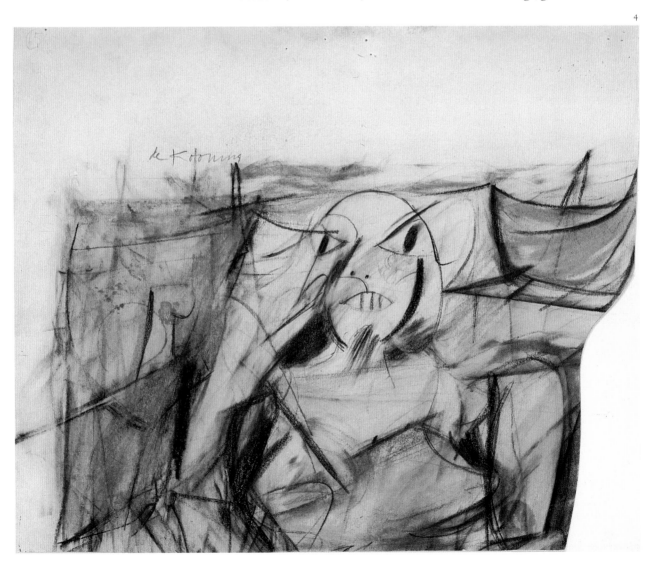

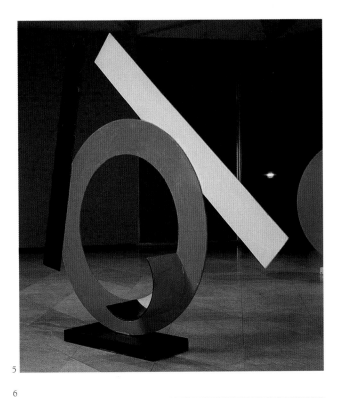

5 David Smith
American, 1906–1965
Circle II
1962
painted steel
105 1/2 in x 110 3/4 in x 23 5/8 in
(2.7 m x 2.8 m x 60 cm)
Ailsa Mellon Bruce Fund
1977.60.2

5

6

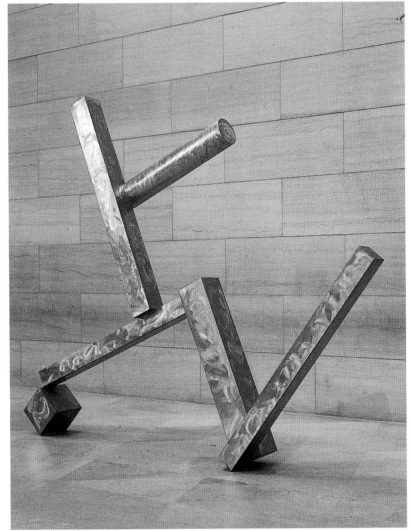

6 David Smith
American, 1906–1965
Cubi XXVI
1965
steel
119 1/2 in x 151 in x 25 7/8 in
(3.03 m x 3.83 m x 65.6 cm)
Ailsa Mellon Bruce Fund
1978.14.1

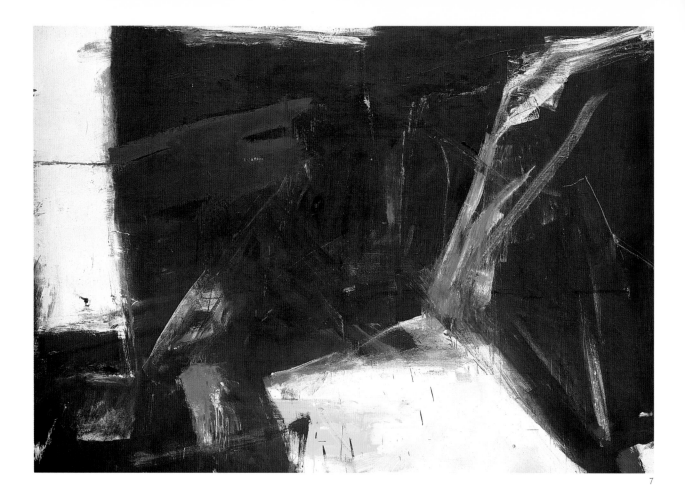

7 Franz Kline
American, 1910–1962
C & O
1958
oil on canvas
77 in x 110 in (1.96 m x 2.8 m)
Gift of Mr. and Mrs. Burton Tremaine
1971.87.4

8 Detail of [8] showing brushstrokes where black meets white

Like Smith, the painter Franz Kline created abstract motifs firmly rooted in the machine age. His stepfather was chief of the railway round-house in the coalmining town of Wilkes-Barre, Pennsylvania, and Kline's earliest landscapes were of the Pennsylvania railroad and the armature of its iron bridges. His later abstract works were inspired in part by details of these landscape paintings, enlarged by a Bell-Optikon projector, a technique he adopted from De Kooning. Kline's large, black-and-white painting from 1958, *C & O* [7] is named after the pioneering railroad line. He wielded his brush with an explosive force evident in the final work's spatters and uninterrupted brushstrokes—bold gestures that the critic Harold Rosenberg identified as "Action Painting" in 1952. But Kline was judiciously slow "between acts", and evidence of reworking can be seen along the borders of the calligraphic shape, where black chafes against white [8, detail]. This ambiguity creates an impression of dynamism, as the background and foreground shapes flip-flop in space.

Rosenberg's "Action Painting" is a misleading term, for it underestimates the hours, even years of deliberation involved. The abstract expressionist Robert Motherwell, once a student of philosophy, compared his work with the ancient discipline of Zen calligraphy. *Reconciliation Elegy* of 1978 [9] was the culmination of thirty years' exploration. It began with one calligraphic ink sketch that he made in 1948, which spawned over 170 variations known as the *Elegy* series.

For this mural-sized painting, commissioned especially for I.M. Pei's East Building of the National Gallery of Art, Motherwell wanted to create the impression of "a very spontaneous painting"—"as though a giant or cyclops had painted it from beginning to end in a few minutes." Once the canvas was ready—after a year of preparation—his sense of anticipation was almost unbearable: "My heart pounded so hard that I could feel my torso shaking." His brushes bound to hockey-stick handles, he stepped in his socks onto the canvas and began painting "very rapidly with liquid paint."

> The brush was as long and heavy as a wet mop.
> I felt like a sailor mopping a ship's deck under a black starry sky...
> calm anxiety, anxious solitude.
> The canvas was so big underfoot, and beginning to stir,
> like a white whale...

As art critic Harold Rosenberg had written in 1952, "The American vanguard painter took to the white expanse of the canvas as Melville's Ishmael took to the sea."

A surprising, delicate infusion of color entered the abstract expressionist landscape with Helen Frankenthaler, whose serene compositions were created by pouring or *blotting* thinned, colorful paint onto highly absorbent, unprimed canvas. In this variation on Pollock's "hands-off" dripping technique,

9 Robert Motherwell
American, 1915–1991
Reconciliation Elegy
1978
acrylic on canvas
120 in x 364 in (3.05 m x 9.24 m)
Gift of the Collectors' Committee
1978.20.1

9

10 Helen
Frankenthaler
American, b.1928
Wales
1966
oil on canvas
113 1/4 in x 45 in
(2.88 m x 1.14 m)
Anonymous Gift
1981.86.1

11 Morris Louis
American,
1912–1962
Beta Kappa
1961
acrylic on canvas
103 1/4 in x 173 in
(2.62 m x 4.39 m)
Gift of Marcella Louis
Brenner
1970.21.1

12 Mark Rothko
American,
1903–1970
Orange and Tan
1954
oil on canvas
81 1/4 in x 63 1/4 in
(2.06 m x 1.61 m)
Gift of Enid A. Haupt
1977.47.13

10

she created waves and rivulets of color as natural as the traces in the sand left by the receding tide, as in *Wales* [10].

Morris Louis also attained a sense of openness and plenitude in his paintings by allowing as much as three-quarters of the canvas to remain blank, as in *Beta Kappa* of 1961 [11]. He created his distinctive fan-like compositions by pouring colorful streams of paint—of a greater opacity than Frankenthaler's—across the white canvas.

Color field painting of the 1950s and 1960s brought the field of color so close to the picture plane that it gave the viewer the sense of standing in a pool of light. Mark Rothko, one of the original abstract expressionists, was a pioneer of color field painting, which he considered neither abstract nor representational. He was concerned with the transcendental power of art to help bridge the gulf he perceived between human beings. As he wrote in 1947, "It was really a matter of ending this silence and solitude." His most powerful compositions consisted of two or three horizontal bands of color across a large canvas, as in *Orange and Tan*, 1954 [12].

11

12

*The most important tool the artist fashions through
constant practice is faith in his ability to produce miracles
when they are needed.*

MARK ROTHKO

13 Mark Rothko
American, 1903–1970
Untitled (black and gray)
1969
acrylic on canvas
90 3/8 in x 69 1/4 in (2.3 m x 1.76 m)
Gift of the Mark Rothko Foundation
1986.43.164

14 Mark Rothko
American, 1903–1970
Untitled (black and gray)
1969
acrylic on canvas
54 1/4 in x 68 5/16 in (1.39 m x 1.74 m)
Gift of the Mark Rothko Foundation
1986.43.165

13

14

198

15

16

Not all of his paintings were luminous or inviting; his series of 1969, called *Untitled (black and gray)* [13, 14], are monochromatic, evoking ashen soil and black sky. They were painted in 1969, the year man first landed on the moon. The following year, 1970, Rothko committed suicide.

Rothko's nearly exact contemporary Barnett Newman also believed in the power of painting "to make contact with mystery—of life, of men, of nature, of the hard, black chaos that is death, or the grayer, softer chaos that is tragedy." *Stations of the Cross* of 1958 to 1966—from first [15] to last [16]—have the cumulative effect of staring into the sun. The title refers to Christ's Passion, but is open to interpretation. His titles are mythic—*Achilles, Dionysius, The Name II*—and above all, evocative. His stripes, or *zips*, are his signature, running the full length (or width) of the canvas as if to infinity.

Around 1960 a new generation of artists, impatient with the lofty ideas of the abstract expressionists, resolved to bring art back to earth. The postwar economic boom in America produced a born-again materialism. Pop artists adopted machine-like techniques to process images, as they mimicked this age of reproduction. They based their art on anonymous, cheap, mass-media imagery—elevating advertisements, glossy magazines, tabloid newspapers, and comic strips to the realm of art.

"Pop art," the artist Roy Lichtenstein said, "is an involvement with what I think to be the most brazen and threatening characteristics of our culture."

15 Barnett Newman
American, 1905–1970
Stations of the Cross (Lema Sabachthani)
First Station
1958
magna on canvas
77 7/8 in x 60 1/2 in (1.98 m x 1.54 m)
Robert and Jane Meyerhoff Collection
1986.65.1

16 Barnett Newman
American, 1905–1970
Stations of the Cross (Lema Sabachthani)
Fourteenth Station
1965/1966
acrylic and Duco on canvas
78 in x 59 15/16 in (1.98 m x 1.52 m)
Robert and Jane Meyerhoff Collection
1986.65.14

17 Roy Lichtenstein
American, 1923–1997
Look Mickey
1961
oil on canvas
48 in x 69 in (1.22 m x 1.75 m)
Dorothy and Roy Lichtenstein, Partial and
Promised Gift of the Artist,
in Honor of the 50th Anniversary of the
National Gallery of Art
1990.41.1

18 Detail of [17] showing Benday dots on
Donald Duck's eyes

*I'd been working in a more abstract expressionist idiom before this . . .
This was the first time I decided to make a painting
really look like commercial art.
The approach turned out to be so interesting that eventually it became
impossible to do any other kind of painting.*

ROY LICHTENSTEIN
1993, on *Look Mickey*

Lichtenstein made popular culture more intelligible and less threatening. His comic-strip style began with *Look Mickey* in 1961 [17]—a painting based on a bubble-gum wrapper. He copied the comic-strip style lettering and broad, black outlines of the Disney characters Donald Duck and Mickey Mouse, as if to deny himself a personal style. Ironically, since the 1960s, the comic-strip style in painting has been identified with Lichtenstein, rather than Disney or other cartoonists. The artist imitated, in his words, "cheap, commercial printing techniques" and the coarse Benday dots used in *Look Mickey* [18, detail] became his signature. Lichtenstein created a cartoon-style history of art, from the pyramids of Egypt to the billboards of Times Square, recasting masterpieces of impressionism, cubism, surrealism, and even abstract expressionism [19] into pop.

19

19 Roy Lichtenstein
American, 1923–1997
Yellow Brushstroke
published 1985
photo etching
plate: 23 ½ in x 12 ⅞ in (59.7 cm x 32.7 cm)
Gift of Gemini G.E.L. and the Artist
1989.55.50

20 Claes Oldenburg
American, b.1929
Soft Drainpipe—Red (Hot) Version
1967
vinyl, styrofoam, canvas, metal
drainpipe: 120 in x 60 in x 45 in
(3.05 m x 1.52 m x 1.14 m)
height with stand: 96 in (2.4 m)
Robert and Jane Meyerhoff Collection,
Gift in Honor of the 50th Anniversary of the National Gallery of Art

20

Since the late 1950s, Claes Oldenburg has made sculpture and monuments in the form of hamburgers, slices of cake, lipsticks, clothespins—and even the humble drainpipe. "I am for the art that a kid licks, after peeling away the wrapper," he wrote in 1961. In 1965, he proposed a colossal Good Humor ice cream for the site of the Pan Am Building in Manhattan. This chocolate-coated bar, in his sketch for the proposal, is upended and melting on the pavement, with a bite taken out of it to allow for the traffic on Park Avenue. His soft sculpture *Soft Drainpipe—Red (Hot) Version* [20], made of shiny red vinyl, lies slumped like an elephant's trunk on the floor. It is one of several models and sketches from 1967 for a monument, complete with heliport and swimming pool, proposed for Toronto.

21 Andy Warhol
American, 1928–1987
Green Marilyn
1962
silkscreen on synthetic polymer paint on canvas
20 in x 16 in (50.8 cm x 40.6 cm)
Gift of William C. Seitz and Irma S. Seitz, in Honor of the 50th Anniversary of the National Gallery of Art
1990.139.1

Andy Warhol grew up in blue-collar Pittsburgh during the Depression. He trained as a commercial artist, decorating department store windows and illustrating fashion magazines, before opening The Factory, a multimedia studio in downtown Manhattan, in the 1960s. There he created icons of tabloid and commercial images, mimicking the techniques of mass-production, from his Campbell's soup cans—arranged row upon row, as in the supermarket aisle—

22

to his celebrity portraits of Marilyn Monroe [21], Liz Taylor, and Jackie Kennedy [22]. With his relentlessly repetitive imagery gleaned from the mass media, Warhol seemed to be taking inventory of the material world.

It may appear that for pop artists, nothing was sacred. And yet, at the auction of Warhol's possessions held at Sotheby's after his death in 1987, there, among his unpacked shopping bags and cookie jars, were Byzantine icons.

22 Andy Warhol
American, 1928–1987
Jackie I
1966
screenprint in silver
24 in x 20⅛ in (61 cm x 51.1 cm)
Wunsche 1981, 3
Print Purchase Fund (Rosenwald Collection)
1971.10.3

Chapter eleven
Late 20th century

The artist brings to paper what makes him speechless.

GÜNTER GRASS (b.1927)
Cloud Clenched in a Fist above Forest

1 Donald Judd
American, 1928–1994
Untitled, 1965
galvanized iron and Plexiglas
6 in x 27 in x 24 in
(15.2 cm x 68.6 cm x 61 cm)
The Dorothy and Herbert Vogel Collection,
Ailsa Mellon Bruce Fund,
Patrons' Permanent Fund and Gift of
Dorothy and Herbert Vogel
1991.241.49

2 Ad Reinhardt
American, 1913–1967
Black Painting No. 34
1964
oil on canvas
60 ¼ in x 60 ⅛ in (1.53 m x 1.53 m)
Gift of Mr. and Mrs. Burton Tremaine
1970.37.1

Never before has art come so close to being invisible. From the mid-1960s onwards, minimal and conceptual artists stripped art to its bare essentials, and questioned all its conventions, from style to process, pedestal, and frame. The American artist Donald Judd abandoned painting in 1964, and devoted himself to minimal sculpture. *Untitled,* 1965 [1], is one of his first "units," in which he reduced sculpture to its essence—the use of space. "Actual space is intrinsically more powerful and specific," he wrote in 1965, "than paint on a flat surface." Judd's boxes were constructed to his specifications by factory workers, and made of galvanized iron, aluminum, or Plexiglas. Among his hallmarks were the smooth perfection of the surfaces and edges, and the total absence of "the artist's touch."

Judd believed that it was impossible to use forms from the past: "They become symbols," he said, "and not profound ones either." Together, a new generation of artists aimed to expunge art history.

A flat surface proved equally compelling in the radical black canvases of Ad Reinhardt [2], "the last painting," he said, "which anyone can make." Frank Stella named several of his "Black Paintings" of the late 1950s after the cynical slogans, such as *Arbeit Macht Frei* (Work makes you Free), that were displayed at Nazi concentration camps.

The one standard in art is oneness and fineness,
rightness and purity, abstractness and evanescence.

DONALD JUDD

2

Abstract painting is not just another school or movement or style, but the first truly unmannered and untrammeled and unentangled, styleless, universal painting.

AD REINHARDT

3 Frank Stella
American, b. 1936
Chyrow II, 1972
mixed media
112 in x 100 in (2.85 m x 2.54 m)
Gift of the Collectors' Committee
1979.29.1

4 Frank Stella
American, b. 1936
Jarama II
1982
mixed media on etched magnesium
126 in x 100 in x 24 ³/₄ in
(3.2 m x 2.54 m x 62.8 cm)
Gift of Lila Acheson Wallace
1982.35.1

5 Frank Stella
American, b. 1936
The Fountain, 1993
67-color woodcut, etching, aquatint,
relief and screenprinted natural Gampi
fiber, handmade paper collage elements
3 parts. Left, center, and right:
91 in x 124 ¹/₂ in (2.31 m x 3.16 m)
91 in x 290 in (2.31 m x 7.37 m)
Gift of Tyler Graphics Ltd.
1994.67.16.a-c

Stella's nihilist works declared the centuries-old traditions of art, from Renaissance perspective to the representation of the human figure, to be obsolete. During this period, he worked in a studio without windows and barred all signs of nature from his painting with impenetrable black enamel stripes of equal width. From this point, he explored new possibilities, inventing irregular-shaped supports for his canvases, and using metallic paint and incandescent color. His "Protractor" series of the 1960s were semi-circular compositions; he also made canvases based on rhomboids and sloping parallelograms. He constructed the painting *Chyrow II* in 1972 [3] from several geometric shapes layered in three-dimensional relief.

Beginning with his "Exotic Bird" series of the mid-1970s, Stella developed a new, ebullient art of relief painting, with sinuous shapes made of honeycomb aluminum or etched magnesium, coated with glitter, diamond dust, and swirling brushstrokes. From his early "Black Paintings" to such multi-colored reliefs as *Jarama II,* 1982 [4], named after the Grand Prix racetrack outside Madrid, Stella's twentieth-century perspective acts like a boomerang, shooting back from oblivion into the viewer's space. The artist's monumental prints of the 1990s include *The Fountain* [5], a triptych spanning 22 feet, which fuses together the multi-layered perspectives of Stella's reliefs.

3

4

5

6 Ellsworth Kelly
American, b. 1923
White Curve VIII
1976
oil on canvas
96 1/₁₆ in x 76 15/₁₆ in (2.44 m x 1.95 m)
Gift of Mr. and Mrs. Joseph Helman
1984.105.1

7 Carl Andre
American, b. 1935
Nine Steel Rectangle
1977
hot rolled steel (nine units)
each: 8 1/₄ in x 7 1/₄ in x 1/₄ in
(21 cm x 18.4 cm x .6 cm),
overall: 24 3/₄ in x 21 3/₄ in x 1/₄ in
(62.9 cm x 55.3 cm x .6 cm)
The Dorothy and Herbert Vogel Collection,
Ailsa Mellon Bruce Fund,
Patrons' Permanent Fund and
Gift of Dorothy and Herbert Vogel
1991.241.6

8 Sol LeWitt
American, b. 1928
Wall Drawing 681 C
1993
colored ink washes (wall installation)
120 in x 444 in (3.05 m x 11.28 m)
The Dorothy and Herbert Vogel Collection,
Gift of Dorothy Vogel and Herbert Vogel,
Trustees
1993.41.1

6

Stella's truths about flatness and order within art were echoed in the so-called "hard-edge" abstractions of his contemporaries. Ellsworth Kelly's signature-works are large canvases saturated with bright color. He also worked in black and white, evoking lunar or arctic landscapes. In *White Curve VIII* of 1976 [6], Kelly articulated the central theme of minimalist painting, the ineluctable flatness of the painted image.

7

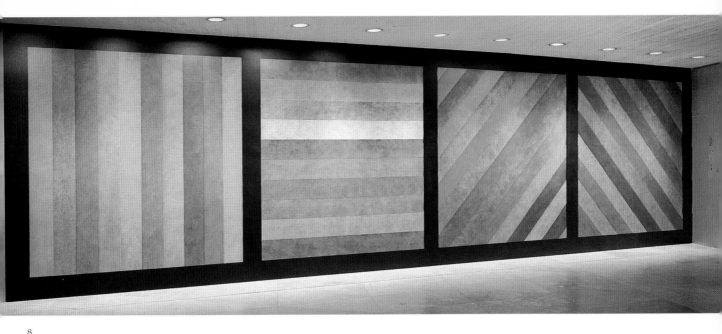

8

This sense of economy also translated into sculpture, as seen in the work of Carl Andre. While working for the Pennsylvania Railroad, the artist was profoundly influenced by the landscape around him, which he described as "an enormous plain with the long lines of freight cars lined up in the freight yard…" In 1954, at the age of nineteen, he visited Europe to see Stonehenge and other neolithic sites and was moved by their sacred alignments. His *Nine Steel Rectangle*, from 1977 [7], emulates this sense of order and measure. In other works, Andre created patterns using bricks and tiles laid out in rows on gallery floors. Visitors, accustomed to keeping a respectful distance from works of art, are invited to walk across them.

Conceptual art evolved alongside minimalism, complementing its simple forms with a theory of art that is often obscured by unnecessary jargon. Conceptual artists proposed that the *idea*—not the art object—was paramount. They attempted to circumvent the art market by creating works that were, theoretically, impossible to buy, sell, or collect.

The conceptual artist's aim is to address his or her audience without artifice. Sol LeWitt sent a fax to the National Gallery of Art with instructions for a team of assistants to execute his *Wall Drawing No. 681 C* in 1993 [8]. Its lush bands of color, applied with ink washes, will eventually be painted over, as the artist intended. It is an immaterial form of art: theoretically, anyone can recreate it by following the artist's instructions. A certificate, rather than the artist's touch or signature, authenticates the work. Sol Lewitt has remained true to his pledge of 1969: "Conceptual artists are mystics rather than rationalists. They leap to conclusions that logic cannot reach…" "Ideas alone," he said, "can be works of art." Conceptual artists, in their idealism, demystified the art object and removed it from its pedestal, and then, stepped down themselves.

A white page, a blank canvas— so many possiblities.
STEPHEN SONDHEIM

Only art is capable of dismantling the repressive effects
of a senile social system that continues to totter along the deathline …

JOSEPH BEUYS

10

Another concerted attempt to free art from the past led to an art almost impossible to preserve—called Performance Art, inspired in part by the German artist Joseph Beuys. Beuys' performances and teachings profoundly influenced a post-war generation of artists. He believed it was artists, not politicians, who could heal the wounds of war.

Beuys' influential "happenings," some of which were filmed, are plotless, scriptless improvisations with a common theme: hope in the face of despair. In the film of his 1965 happening, *How to Explain Art to a Dead Hare*, Beuys sits in a cell-like chamber with a dead hare cradled in his arms, murmuring inaudibly for hours. A videotape of Beuys' exhibits and performances, *Transformer: A Television Sculpture*, reveals how much the late twentieth-century artist's sense of authorship has changed. Beuys' fingerprint and signature appear on the plastic case of the tape [9], suggesting that the videotape itself is a work of art, as the title indicates. As artists like Beuys acquired saint-like status, their works took on the symbolic and fragmentary quality of relics.

By the 1980s and 1990s, postmodernism and its kaleidoscope of styles from all periods surged to fill the pictorial void of minimal and conceptual art of the late 1960s and 1970s. The German artist Gerhard Richter has espoused a postmodern approach to painting, actually switching from style to style, from photorealism to abstract expressionism, giving the viewer the impressi on of channel surfing. For him, postmodernism represents democratic freedom; as an art student in Dresden during the Cold War, he was actually forbidden from painting in the Western abstract style. His *Abstract Painting 780-1*, one of a series painted in 1992 [10], mimics abstract expressionism of the 1950s, but only in the generic sense. His has been a dispassionate approach to painting, maintained by photography and other forms of reproduction. He erases all traces of authorship, preferring the anonymity advocated by the conceptual artist.

Like Richter, Sigmar Polke and Anselm Kiefer were students of Beuys, who taught at the Kunstakademie in Düsseldorf between 1961 and 1972. Polke also "appropriates" images from various sources, layering them visibly on his canvas as in *Hope Is: Wanting to Pull Clouds* from 1992 [11], which expresses the idealism that Beuys imbued in his students. As Richter wrote in 1982, "Art is the highest form of hope." Polke's introduction of the figure was a radical departure from the orthodoxy of modern abstract painting.

9 Joseph Beuys
German, 1921–1986
Transformer: A Television Sculpture
1988
videotape
Anonymous Gift

10 Gerhard Richter
German, b.1932
Abstract Painting 780-1
1992
oil on canvas
unframed: 102 3/8 in x 78 3/4 in (2.6 m x 2 m)
Gift of the Collectors' Committee
1993.62.1

11 Sigmar Polke
German, b.1941
Hope Is: Wanting to Pull Clouds
1992
polyester resin and acrylic on fabric
unframed: 118 1/8 in x 197 in (3 m x 5 m)
Gift of the Collectors' Committee
1993.59.1

11

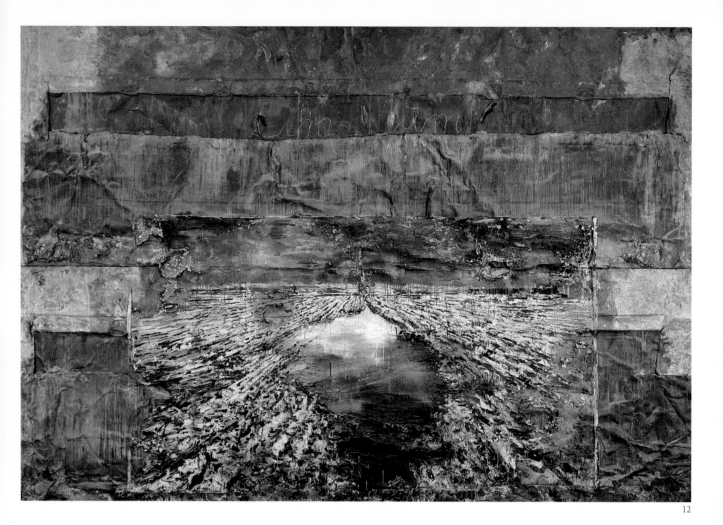

12 Anselm Kiefer
German, b.1945
Zim Zum
1990
acrylic, emulsion, crayon, shellac, ashes, and
canvas on lead
149 ¾ in x 220 ½ in (3.8 m x 5.6 m)
Gift of the Collectors' Committee
1990.82.1

Anselm Kiefer was born in 1945, just months before VE Day, in the northern town of Donaueschingen. Unlike Richter, who witnessed the bombing of Dresden as a child, Kiefer had no personal experience of the war, but devoted his art to the preservation of the cultural memory of the war and the Holocaust, which had become taboo in Germany.

Zim Zum, from 1990 [12], appears to have been exhumed rather than painted. It is one of his monumental "earth paintings," created in his studio in Germany, a space so large it resembles an aircaft hangar. *Zim Zum*'s fragile surface of oil paint and ashes resembles blackened, scorched earth. It has an extraordinary depth of field, its distant horizon skirting a seemingly boundless earth and sky. The title refers to the moment before creation, as heaven and earth are about to cleave, as it is written in the Kabbalah, the Judaic mystical text.

Kiefer's landscape paintings are often based on creation myths. Yet while he is celebrated as a visionary painter, the motifs of field and forest are based on the landscape of his native northern Germany—the abandoned fields of the industrial belt around Düsseldorf, the no-man's-land that divided East and West Germany during the Cold War. Kiefer taps ancient myth and history to connect the past with the present.

Most "earth art" of the 1970s could not be accommodated by museums, except in documentary form. Photographs are all that survive of Robert Smithson's legendary earthwork, *Spiral Jetty* of 1970, whose coil length was 1500 feet, and which has since been submerged in the Great Salt Lake in Utah. "Museums, like asylums and jails, have wards and cells," wrote Smithson. "A work of art when placed in a gallery loses its charge…"

The British artist Richard Long, who created the *Whitechapel Slate Circle* [13], has also made stone paths that extend for hundreds of miles through the English countryside. Since the 1970s, the American conceptual artist Christo has wrapped historic buildings and bridges, and installed gigantic white objects—umbrellas or curtains—in the open country. The artist documents the lifespan of his works, from their inception to their inevitable destruction. In

13 Richard Long
British, b.1945
Whitechapel Slate Circle
1981
slate
diameter: 15 ft (4.57 m)
Gift of the Collectors' Committee
1994.76.1

13

VALLEY CURTAIN (PROJECT FOR COLORADO) GRAND HOGBACK, 7 miles NORTH FROM RIFLE; HEIGHT: 185'0" AT CENTER / 365'0" AT MAIN SUPPORT; WIDTH 1250'0"; 1368'0

Valley Curtain, Project for Rifle, Colorado, 1971 [14], he records the progress of this monumental work with blueprints and drawings, and with an inscription worthy of a surveyor: "Valley Curtain/Project for Colorado/Grand Hogback, 7 miles, North from Rifle ..." In *Package 1974* [15], the artist wrapped a mysterious object in tarpaulin and rope, creating a sense of curiosity.

14 Christo
American, b.1935
Valley Curtain, Project for Rifle, Colorado
Collage 1971
colored crayon and graphite on photostat, fabric, and two blueprints,
mounted together on paperboard
27 13/16 in x 22 in (70.7 cm x 55. 9 cm)
The Dorothy and Herbert Vogel Collection, Ailsa Mellon Bruce Fund,
Patrons' Permanent Fund and Gift of Dorothy and Herbert Vogel
1992.7.1

15 Christo
American, b.1935
Package 1974
1974
tarpaulin, rope, and wood
24 in x 19 1/2 in x 15 in
(60.9 cm x 49.5 cm x 38.1 cm)
The Dorothy and Herbert Vogel Collection,
Ailsa Mellon Bruce Fund,
Patrons' Permanent Fund and
Gift of Dorothy and Herbert Vogel
1992.7.1

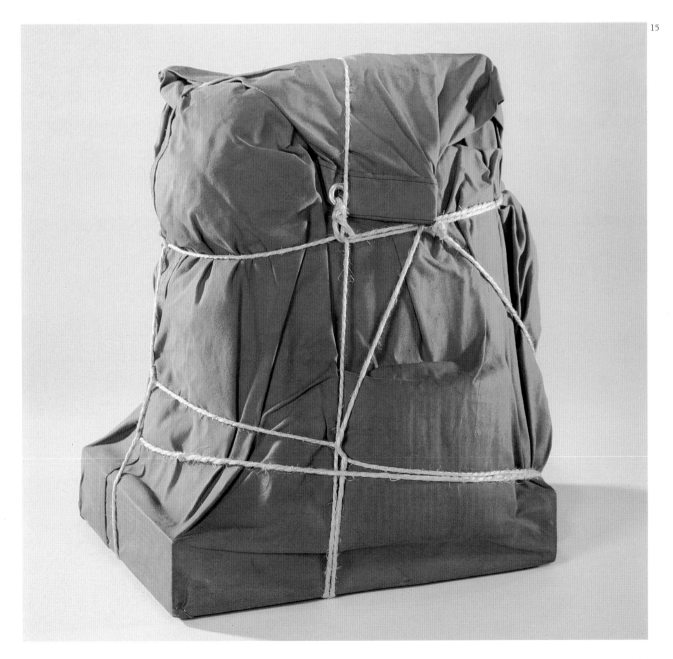

15

16 James Turrell
American, b.1943
Deep Sky
1984
portfolio of 7 aquatints in black on BFK
Rives paper, bound text,
title page, and colophon
image: 12 ⅝ in x 19 ⁷⁄₁₆ in
(32.1 cm x 49.4 cm)
Gift of the Collectors' Committee
1996.76.2

17 As [16], 1996.76.3

18 As [16], 1996.76.7

James Turrell's ongoing project *Roden Crater*, like the cathedrals of the past, may never be completed. Since 1974, the artist has been tunneling and reshaping the volcanic shell into an observatory. "What interests me," he said, "is the quality of light inhabiting a space." As the crater is 5000 feet above sea level in the Painted Desert, near Flagstaff, Arizona, few people have made the pilgrimage, but there are several series of abstract prints, such as *Deep Sky* [16–18], representing a dark, floating world of stars, night sky, and shadows. There are also finely crafted boxes containing relics from this work in progress.

Roden Crater is but one of many mammoth projects of late twentieth-century art that are impossible to contain within a museum. They have transformed the viewing of art into something even larger, leading the eye beyond the art object and this small planet to the universe beyond. Turrell, like the builders of Stonehenge thousands of years ago, has created a visual key to the skies, from the southernmost moonrise to the northernmost rising of the sun. At the end of the millennium, art reenters the celestial sphere.

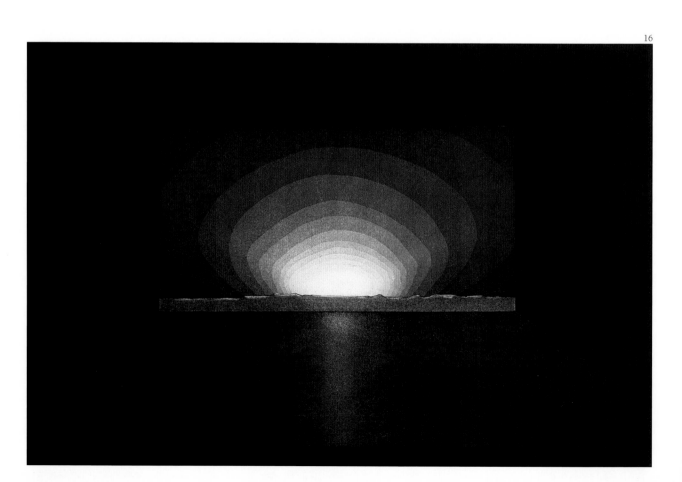

17

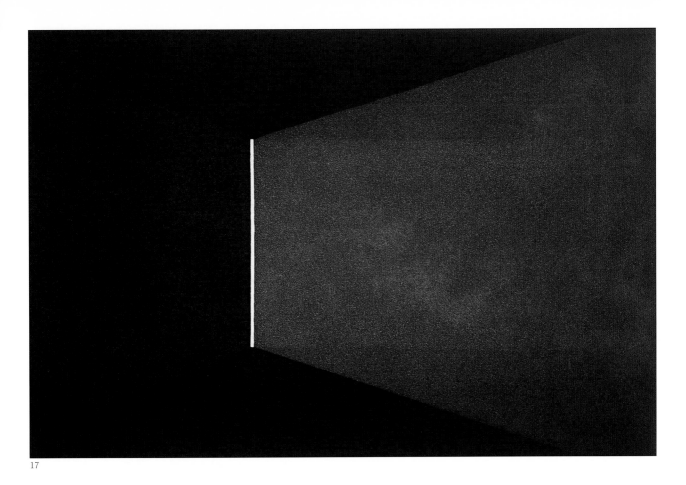

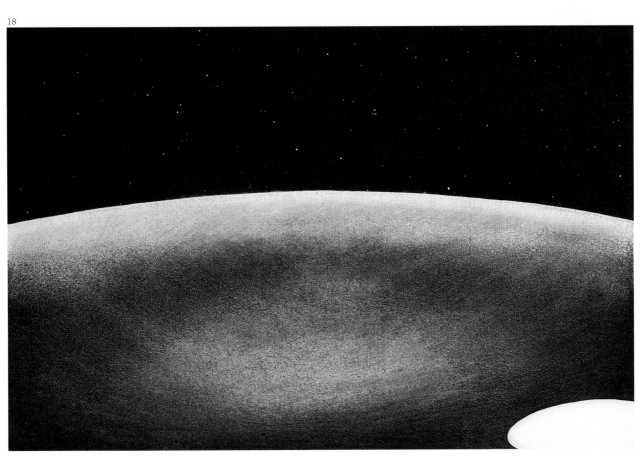

Glossary of Terms

Abstract Expressionism Established New York, late 1940s. Movement in painting incorporating various styles, all of which emphasized the maximum freedom of expression and execution.

Abstraction Development in early twentieth-century art eclipsing representational subject matter. Created new emphasis on the foundations of painting: canvas, paint, color, line, form.

Academic Art Term for style and subject-matter as taught and exhibited by the Académie des Beaux-Arts in Paris or the Royal Academy of London; occasionally used perjoratively in the nineteenth century.

Action Painting Term coined in 1952 by New York critic Harold Rosenberg to describe the dramatic, physical nature of one form of *Abstract Expressionism*.

Arabesque Intricate form of decoration inspired by Islamic art, which used intertwined spirals, tendrils, and other plant forms.

Arcadia As represented in painting, an imaginary, idealized landscape inspired by classical myth.

Ashcan School Founded New York, 1908. Group of painters and former newspaper artists who portrayed the realities of urban life.

Baroque A dynamic, illusionistic, and emotive style that dominated seventeenth-century European art.

Byzantine Icons Sacred images of Christ, the Virgin and saints, sanctioned by the Eastern Orthodox Church, with hieratic figures and gold backgrounds symbolizing the heavenly realm.

Chiaroscuro The use of very strong contrast of light and dark for dramatic effect, perfected by Caravaggio and most common in Baroque painting and sculpture.

Conceptual Art Movement of the late 1960s which challenged the institutions of art, declaring the idea—rather than the object—as paramount.

Contrapposto Dynamic stance, visualizing naturalistic weight shifting of the body, exemplified by classical Greek and Roman sculpture and revived during the *Renaissance*.

Cubism Style developed by Picasso and Braque in Paris around 1907. It rendered objects in space as fractured and complex, breaking the conventions of perspective.

Dada European artists' nonsensical performances and bizarre art forms symbolizing their disillusionment as a result of the First World War.

Engraving Any type of reproduction achieved by cutting a design into wood or metal, followed by inking the plate and then printing an image.

Enlightenment Philosophical reform movement of eighteenth-century Europe, especially France, in which reason and scientific inquiry were paramount, often at the expense of tradition and faith.

Etching A form of printmaking that involves waxing a metal plate, drawing through the wax, and then biting (etching) the plate with acid.

Fauvism French style created by Matisse, Derain and others, 1905–1908, who were called "Les Fauves" ("Wild Beasts"), referring to their use of pure color and "primitive" handling of paint.

Fluxus European movement of the 1960s embracing transitory and incidental forms, in the spirit of *Dada*, inspiring performance art.

Frieze A horizontal band in classical architecture, frequently decorated with relief sculpture.

Genre The art of painting the events of daily life, most notably the domestic scenes portrayed in Dutch seventeenth-century painting.

Gothic Art From the early twelfth to the mid-fifteenth century, Christian imagery, from sculpture and painting to stained-glass windows and manuscript illumination, characterized by lyrical forms and cascading drapery.

Hieratic Term derived from the Greek (*hieros*, sacred) for the use of formal, linear, and stylized forms for religious or sacred imagery.

Humanism Study of ancient Roman and Greek history, philosophy, art and religion as the means to an understanding of nature and the individual, which infused the *Renaissance*.

Illumination The art of illustrating and decorating handwritten manuscripts.

Impressionism Established Paris, 1870s. Freely painted canvases, using pure, unmixed color, based on open-air studies of nature and the transitory effects of light and atmosphere.

International Style Also known as International Gothic. Around 1400 a new emphasis on naturalistic detail and elegance in court art began in France, spreading rapidly to Italy and elsewhere. Gentile da Fabriano among most notable painters.

Linear Perspective Method developed by Renaissance artists for creating the illusion of depth from a two-dimensional plane, by charting the line of sight from a single fixed viewpoint.

Lithography A form of printmaking in which the artist draws directly onto a stone with a crayon, giving maximum flexibility of line and tone.

Luminism Style named after the spiritual quietude of certain nineteenth-century American landscape paintings, allied with a sense of measure and precision of form.

Maiolica Italian tin glazed earthenware, usually with elaborate pictorial decorations.

Mannerism Late *Renaissance* style characterized by twisting, elongated forms.

Miniature A tiny painting, very often a portrait (also used for manuscript illumination).

Minimalism Art form developed in the 1960s, eschewing expression or illusion. Usually three-dimensional, simple geometric shapes. Associated with Carl Andre.

Nabis (Hebrew prophets). Group of French artists, including Bonnard and Vuillard, active 1890s, influenced by Gauguin's use of expressive, rather than realistic, color.

Naturalism Faithfulness to natural appearances, based on the observation of life, capturing the liveliness and unique qualities of living things.

Neoclassicism Eighteenth-century European revival of classical art and architecture, as well as edifying themes from ancient history, identified with the *Enlightenment*.

Performance Art International art form of the 1960s, later adopted by video artists, involving artists in plotless, unpredictable happenings.

Pointillism Style developed by the French painter Georges Seurat in the 1880s, based on color theory. It involved juxtaposing "points" or "dots" of primary color.

Pop Established New York and London, 1960s. An urban style based on commercial imagery, from comics to advertizing, often mimicking mass-printing techniques.

Postimpressionism Term used to encompass the styles, originating in France in the 1880s and 1890s, of painters responding to impressionism, led by individualists, from Cézanne to Van Gogh, rather than a group or school.

Postmodernism Philosophical and artistic movement of the 1970s and 1980s which questioned fundamental beliefs of the modern tradition, often blending or juxtaposing styles in defiance of convention.

Primitivism Conscious attempt by early twentieth-century artists in France to emulate non-academic, non-Western art (such as African tribal masks).

Realism A political and artistic movement of mid-nineteenth-century France which led artists to portray modern life, in a style without romantic color or idealization.

Relief Sculpture that emerges from a background, rather than free-standing.

Renaissance Rebirth of the arts in Italy and the North during the fifteenth and sixteenth centuries, introducing new techniques—perspective, oil painting—characterised by an unprecedented degree of naturalism and illusion.

Rococo Eighteenth-century decorative style, named after "rocaille", the shell-and-pebble mosaics of the grottoes at Versailles, which spread from the decorative arts in France to painting and architecture across Europe.

Romanesque (manuscript illumination). International, 1000–1200. Revival of the simplified, clearly outlined forms and pure color associated with ancient Roman and Carolingian art.

Romanticism Artistic and literary movement of early nineteenth-century Europe, which embraced the poetic imagination, vibrant color, and exotic subjects.

Sfumato Literally "smoked" in Italian, a Renaissance technique involving the subtle blending of tones creating a hazy atmosphere, helping to create an illusion of distance.

Silverpoint The art of drawing on a prepared paper with a silver tool, producing a very delicate line.

Stijl, De ("The Style"). Founded Holland, 1917. Abstract style advocated by Van Doesburg, a Calvinist who believed in restricting painting to a single plane, with lines punctuated by blocks of primary color, as perfected by Mondrian.

Sublime Poetic ideal of the eighteenth century defined by British philosopher Edmund Burke, later associated with the sense of awe before Nature which inspired many American nineteenth-century landscape painters.

Surrealism International, 1924–1945. Inspired in the 1920s by André Breton's *First Manifesto of Surrealism* (1924) and by Sigmund Freud's *The Interpretation of Dreams* (1900), encouraging artists to allow their unconscious to dictate the form and content of their art.

Trompe-l'oeil French for "deceive the eye". The use of illusionistic devices to give the viewer the impression of looking at real, rather than painted, objects.

Zackenstil South German expressive style of the thirteenth century, using jagged, knotted lines to accentuate pain and anxiety, associated with cathartic images of Christ and the saints.

Index

Page numbers in *italic* refer to the illustrations